The Art of
Drawing & Painting
Horses

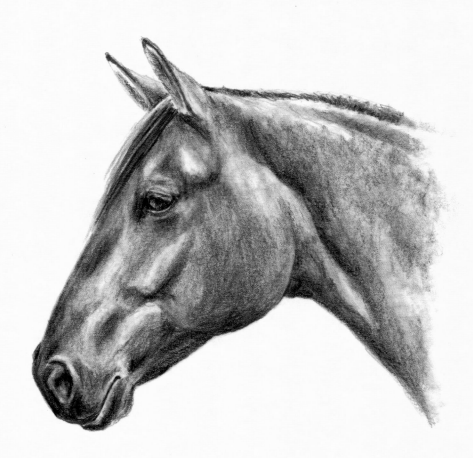

Artwork on pages 8 (top left) by Walter T. Foster; © 1989, 1998, 2003 Walter Foster
Publishing. Artwork on pages 1, 3, 8 (bottom), 9 (bottom), 10 (bottom), and 12–43 © 2010
Patricia Getha. Artwork on back cover and pages 9 (top), and 44–81 © 2010 Janet Griffin-
Scott. Artwork on pages 7 and 82–93 © 1998 Cindy Larimore. Artwork on front cover (right)
and pages 8 (top right), 10 (top and center), 11, and 94–115 © 2005 Elin Pendleton. Artwork
on front cover (left) and pages 115–140 © 2011 Lesley Harrison.

10 9 8 7 6 5 4 3 2

The Art of
Drawing & Painting
Horses

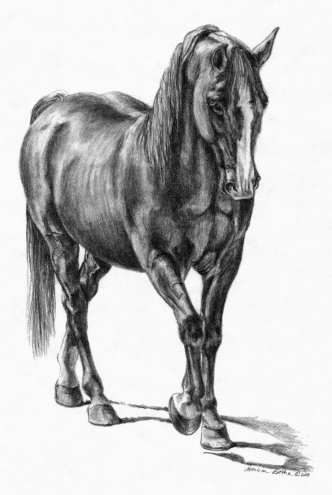

by Patricia Getha, Janet Griffin-Scott, Lesley Harrison,
Cindy Larimore, and Elin Pendleton

www.walterfoster.com
Walter Foster Publishing, Inc.
3 Wrigley, Suite A
Irvine, CA 92618

Contents

INTRODUCTION TO
Drawing & Painting Horses

Welcome to the exciting world of drawing and painting horses! This compilation of simple projects provides inspiration and instruction for creating a variety of horses and ponies in pencil, watercolor, oil, and acrylic. From the fundamentals of drawing and basic horse anatomy to special tips and advanced techniques in the different media, *The Art of Drawing & Painting Horses* is filled with step-by-step demonstrations to guide aspiring artists through the creative process. You'll find plenty of helpful tips on tools and materials, shading, and breed color palettes. Detailed examples of individual horse features will help guide you through the most challenging aspects of depicting equine subjects. Discover how fun and easy drawing and painting horses can be!

The Elements of Drawing

Drawing consists of three elements: line, shape, and form. The shape of an object can be described with simple one-dimensional line. The three-dimensional version of the shape is known as the object's "form." Variations in *value* (the relative lightness or darkness of black or a color) describe form, giving an object the illusion of depth. In pencil drawing, values range from black (the darkest value) through different shades of gray to white (the lightest value). Colors also have a range of values. To make a two-dimensional object appear three-dimensional, you must pay attention to the values of the highlights and shadows. When shading a subject, you must always consider the light source, as this is what determines where your highlights and shadows will be.

MOVING FROM SHAPE TO FORM

The first step in creating an object is establishing a line drawing or outline to delineate the flat area that the object takes up. This is known as the "shape" of the object. The four basic shapes—the rectangle, circle, triangle, and square—can appear to be three-dimensional by adding a few carefully placed lines that suggest additional planes. By adding ellipses to the rectangle, circle, and triangle, you've given the shapes dimension and have begun to produce a form within space. Now the shapes are a cylinder, sphere, and cone. Add a second square above and to the side of the first square, connect them with parallel lines, and you have a cube.

ADDING VALUE TO CREATE FORM

A shape can be further defined by showing how light hits the object to create highlights and shadows. First note from which direction the source of light is coming. (In these examples, the light source is beaming from the upper right.) Then add the shadows accordingly, as shown in the examples below. The *core shadow* is the darkest area on the object and is opposite the light source. The *cast shadow* is what is thrown onto a nearby surface by the object. The *highlight* is the lightest area on the object, where the reflection of light is strongest. *Reflected light,* often overlooked by beginners, is surrounding light reflected into the shadowed area of an object.

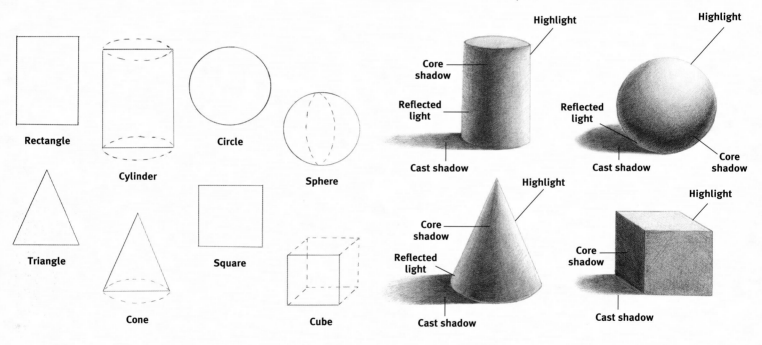

CREATING VALUE SCALES

Just as a musician uses a musical scale to measure a range of notes, an artist uses a value scale to measure changes in value. You can refer to the value scale so you'll always know how dark to make your dark values and how light to make your highlights. The scale also serves as a guide for transitioning from lighter to darker shades. Making your own value scale will help familiarize you with the different variations in value. Work from light to dark, adding more and more tone for successively darker values (as shown at upper right). Then create a blended value scale (shown at lower right). Use a tortillon to smudge and blend each value into its neighboring value from light to dark to create a gradation.

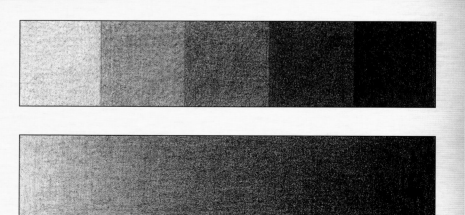

Building up Horse Forms

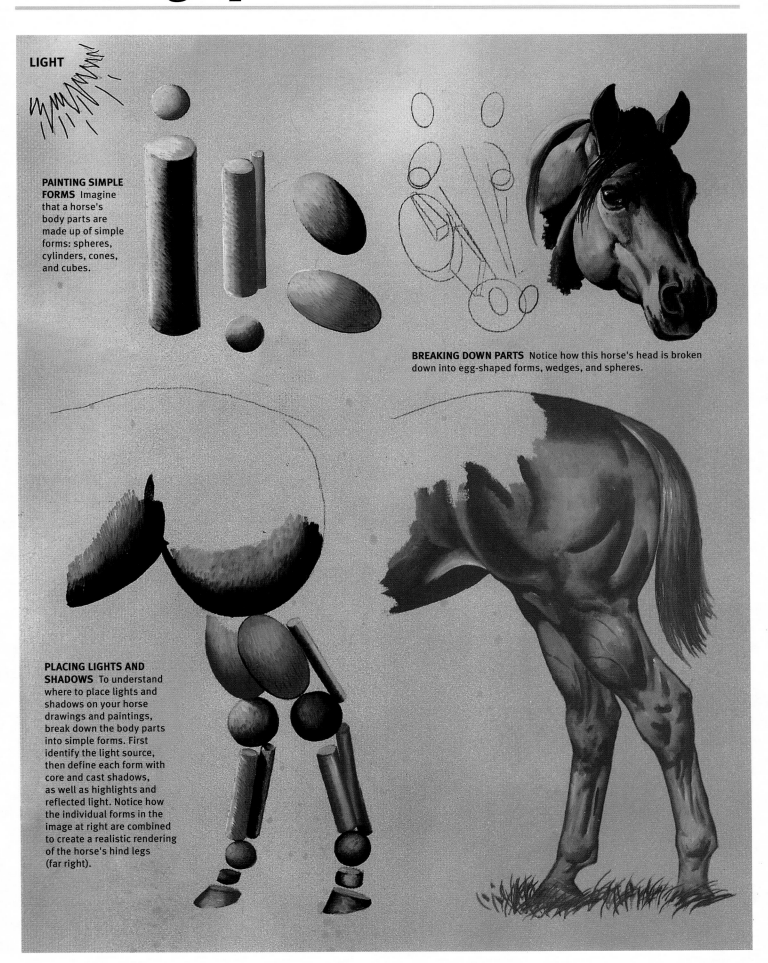

LIGHT

PAINTING SIMPLE FORMS Imagine that a horse's body parts are made up of simple forms: spheres, cylinders, cones, and cubes.

BREAKING DOWN PARTS Notice how this horse's head is broken down into egg-shaped forms, wedges, and spheres.

PLACING LIGHTS AND SHADOWS To understand where to place lights and shadows on your horse drawings and paintings, break down the body parts into simple forms. First identify the light source, then define each form with core and cast shadows, as well as highlights and reflected light. Notice how the individual forms in the image at right are combined to create a realistic rendering of the horse's hind legs (far right).

Basic Anatomy and Proportion

Before you begin, it's a good idea to review the basic anatomy of the horse. For example, an understanding of the underlying shapes of the horse's musculature—and the effect those shapes have on the placement of highlights and shadows—will result in more realistic depictions of the horse's form. In addition, it's important to start with a good grasp of the horse's basic body parts and their proportions. Proportion refers to the proper relation of one part to another or to the whole—particularly in terms of size or shape—and it's a key factor in achieving a good likeness of your subject.

MEASURING PROPORTION For drawing animals and people, artists often use head size as a measuring unit for determining the length of other body parts. For example, the body of the horse is about four times the length of its head. Utilizing this kind of approximation will help you draw the horse in correct proportion.

PLACING THE FEATURES It is as important to draw the features in proportion to the head as it is to draw the head in proportion to the body (shown in the diagram at left). Place the facial features by dividing the length of the head into thirds. Note that the eyes are about a third of the way down the head.

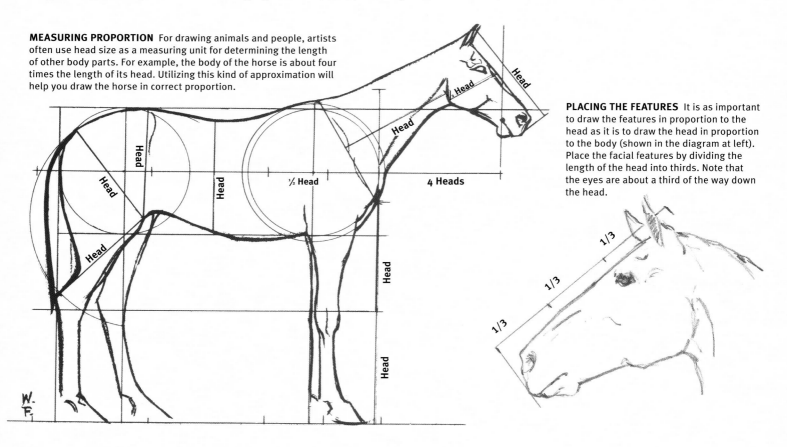

SEEING THE STRUCTURE The bones inside a horse are the very foundation of its impressive size and strength. It is important for artists to understand exactly what the anatomy looks like under the shiny hide and sculpted muscles. This helps you understand where the bony structures are, how the joints come together, and the basic underlying shapes. For instance, the elbow joint of the horse always causes a big shadow in paintings because the bone is really close to the ground.

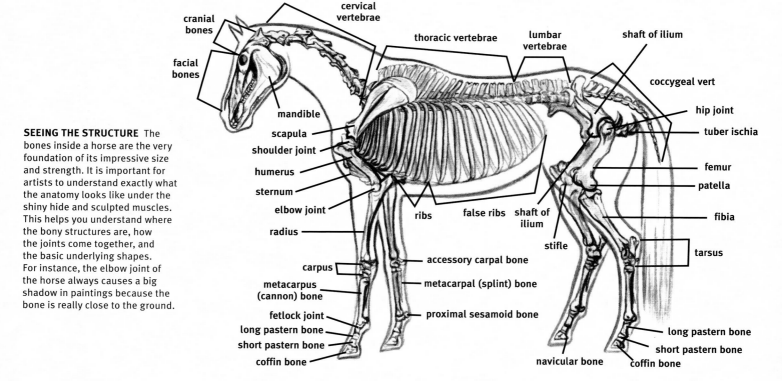

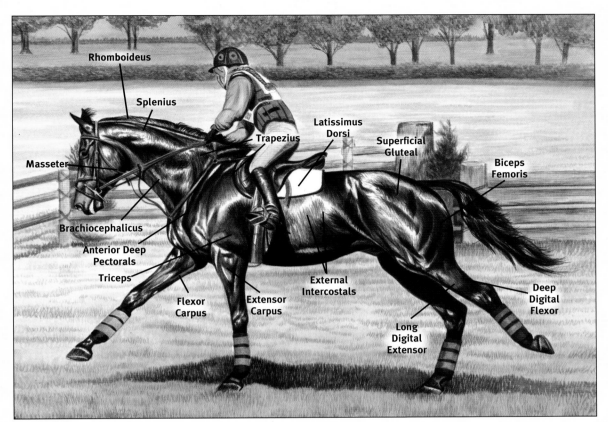

UNDERSTANDING ANATOMY
This painting shows the main muscle groups. As an artist, you should learn these groups and how they relate to the equine form so you can use them in your work. It is important to know what the muscle groups are, where they are located, and how they enable the horse's range of motion. Notice how this horse's defined muscles create shadows and highlights in various intensities.

Labels on the top image:
Rhomboideus · Splenius · Masseter · Trapezius · Latissimus Dorsi · Superficial Gluteal · Biceps Femoris · Brachiocephalicus · Anterior Deep Pectorals · Triceps · Flexor Carpus · Extensor Carpus · External Intercostals · Deep Digital Flexor · Long Digital Extensor

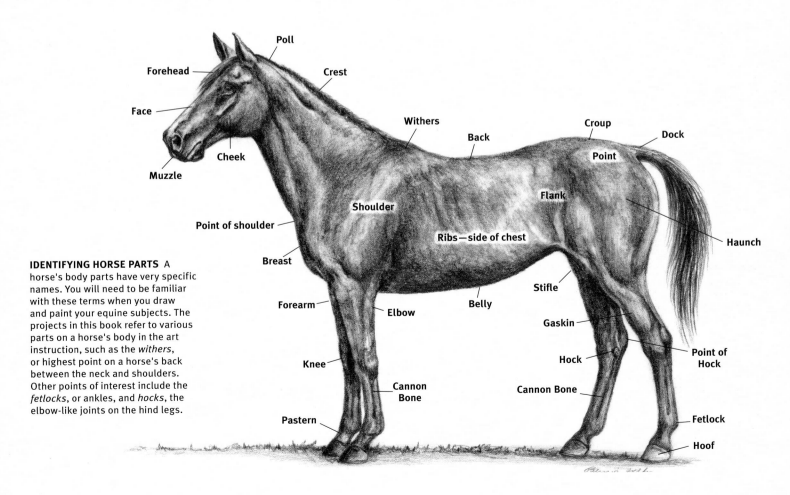

IDENTIFYING HORSE PARTS A horse's body parts have very specific names. You will need to be familiar with these terms when you draw and paint your equine subjects. The projects in this book refer to various parts on a horse's body in the art instruction, such as the *withers*, or highest point on a horse's back between the neck and shoulders. Other points of interest include the *fetlocks*, or ankles, and *hocks*, the elbow-like joints on the hind legs.

Labels on the bottom image:
Poll · Forehead · Crest · Face · Muzzle · Cheek · Withers · Back · Croup · Dock · Point · Shoulder · Flank · Point of shoulder · Ribs—side of chest · Haunch · Breast · Forearm · Elbow · Belly · Stifle · Knee · Gaskin · Hock · Point of Hock · Cannon Bone · Cannon Bone · Pastern · Fetlock · Hoof

Identifying Colors

Almost every horse's coat color begins with one of two base colors—red or black. A few of these color and pattern variations are illustrated and explained here to help you distinguish one "brown" horse from another. Such knowledge goes a long way toward creating realistic paintings!

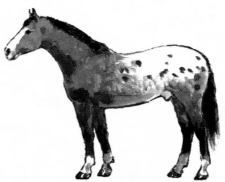

CREAM Although creams may appear white, they actually have light, milky colored hair. Sometimes it's possible to see faint, white markings on a cream.

APPALOOSA Appaloosas have varied pattern, most with spots. This blanket appaloosa has a smoky buckskin body with spots and a bald face marking.

CHESTNUT The chestnut has a red body without black points. It may have white markings, like the white stockings shown here.

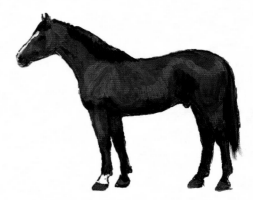

RED ROAN Roans have hair consisting of more than one color, such as this mix of white and red. Their manes and tails are always variations of the body color.

BUCKSKIN Buckskins have light, tan coats and black legs, manes, and tails. Duns also have a black stripe along the back.

BAY The bay is red like the chestnut, but its coloring is darker. There are both light and dark variations of bay coloring, but every bay has black points (legs, mane, and tail).

Comparing Body Types

You can easily see the difference in types of horses through simple line drawings like these. Some horses such as the Percheron, Clydesdale, Shire, and Belgian are heavy-boned draft breeds with thick necks and muscling over their bodies. The Arabian and Thoroughbred are fine-boned horses that are bred for stamina and speed.

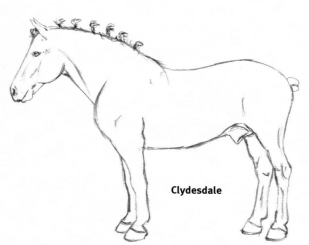

Clydesdale

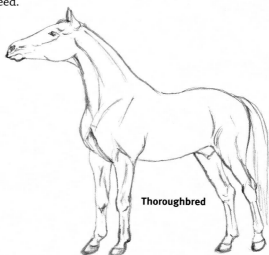

Thoroughbred

Focusing on Individual Features

Making small "practice" sketches, or *studies*, is a great way to gain an understanding of horse anatomy while you get comfortable with your art tools. First pay careful attention to the studies in this chart, noting how shapes and forms change with the viewing angle. Then practice creating the same elements. Start by sketching the general shape of each feature; then fill in the shapes with broad strokes, using your finer pencils or smaller brushes to define the details. Breaking down the horse's anatomy into small vignettes is an effective way to practice conveying the expression of an eye, capturing the position of the ears, or depicting the exact curvature of the hoof—all resulting in more accurate and expressive final drawings and paintings.

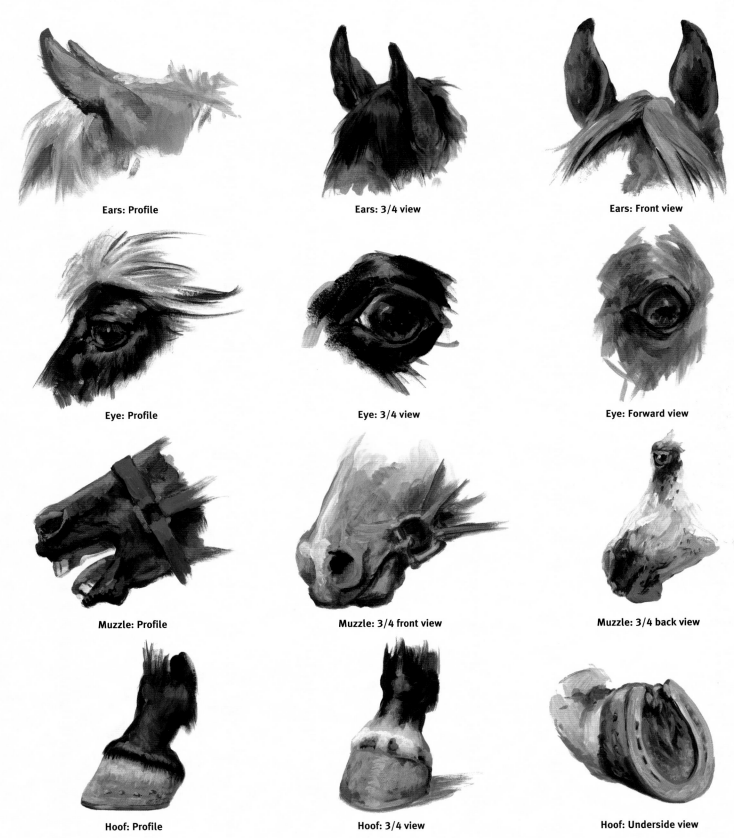

Ears: Profile

Ears: 3/4 view

Ears: Front view

Eye: Profile

Eye: 3/4 view

Eye: Forward view

Muzzle: Profile

Muzzle: 3/4 front view

Muzzle: 3/4 back view

Hoof: Profile

Hoof: 3/4 view

Hoof: Underside view

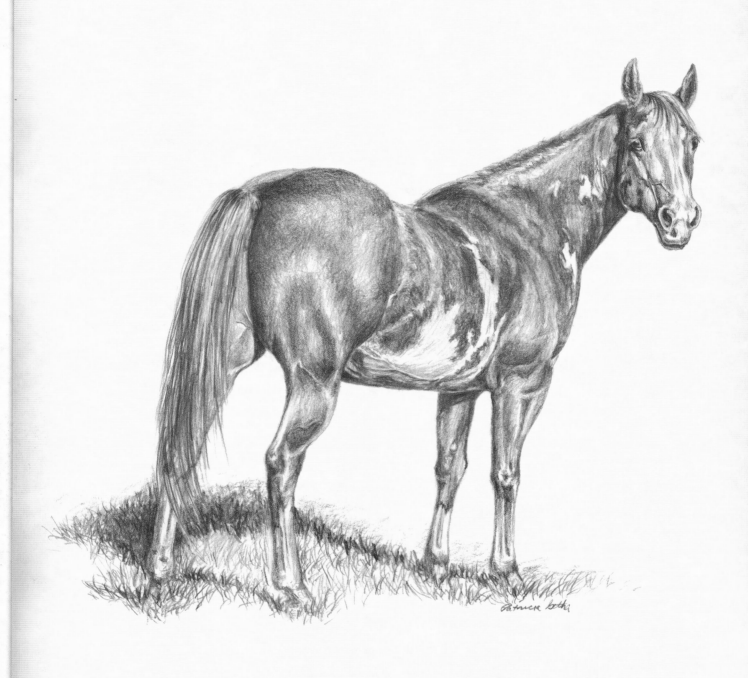

Drawing Lifelike Horses

with Patricia Getha

Now that you have learned how to draw basic horse profiles and bodies, you can focus on capturing lifelike features and textures. In these lessons, you will build upon previous skills in observing horse anatomy and proportion, then delve into special graphite pencil techniques, and explore how to enhance your drawings with charcoal and watercolor washes. From a grazing Appaloosa and an Arabian portrait to a Standardbred Trotter in action, discover how to draw a variety of horses in lifelike detail.

Drawing Tools & Materials

One of the nicest things about drawing with pencil, charcoal or black wash is the fact that the materials are simple and very portable so they can be taken with you in the field. They are not terribly expensive either! As you experiment with various drawing techniques, you will find what works best for you. Feel free to experiment with other tools, papers and techniques. There is always more than one way to draw.

BRUSH This inexpensive brush (A) is typically used for brushing sauces on meat before cooking and can be picked up in any grocery store. Use it to brush away eraser crumbs and other debris from the surface of the paper. It works very well!

BLENDING TOOLS Tortillons (D), sometimes called blending stumps, are used for blending shades of graphite or charcoal and for softening edges. When the tip gets dirty, you can clean it by rubbing it on a kneaded eraser.

KNEADED ERASER A kneaded eraser (E) is a very useful tool. It can be shaped to get into tight places or can be flattened to lift graphite or charcoal from the paper, and it won't damage the surface of the paper. It also doesn't leave annoying crumbs.

ERASING SHIELD Use this shield (F) for protecting areas that you do not want to erase.

WHITE PLASTIC ERASER Useful for erasing larger surface areas, this eraser (G) does a nice job of lifting out darker values. Use it with care so you don't damage the paper.

STICK ERASER A refillable stick eraser (B) is useful for getting into tight places. You may want to use it in conjunction with the erasing shield.

PENCIL EXTENDER Get the most out of your pencils! Use a pencil extender (C) to lengthen short pencils.

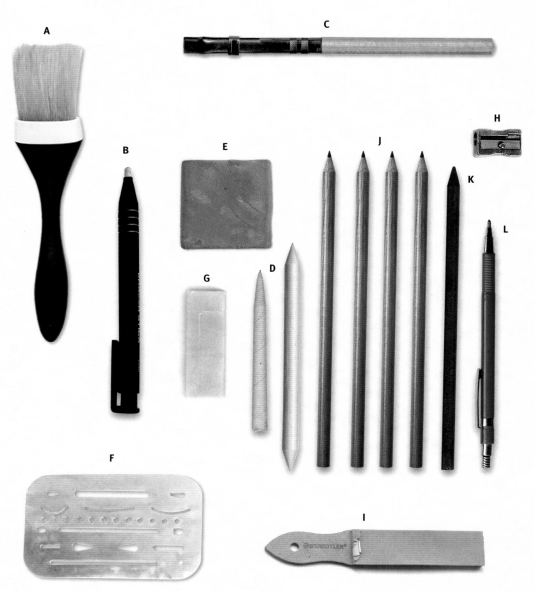

SHARPENERS A hand-held sharpener (H) will give your pencils sharp tips. You can use the fine point for thin lines and details, and you can use the side for shading with broad strokes. A sandpaper block (I) gives you more control over the shape of the point. Gently roll the pencil tip over the block for a round, even point—or flatten the lead into a blunt, squared tip.

PENCILS Pencils come in a vast array of options. You can try different kinds to find those that work best for your drawing style. Some of the types available are wood-cased (J), woodless (K), and mechanical (L). Pencils also come in varying degrees of hardness. H pencils are hard and are best for light sketches, and B pencils are softer and suitable for shading different areas of your subject. The higher the number preceding the letter, the harder or softer the pencil will be. For example, a 4H pencil is very hard and produces a light shade of graphite, whereas a 9B is very soft and yields a dark, rich mark.

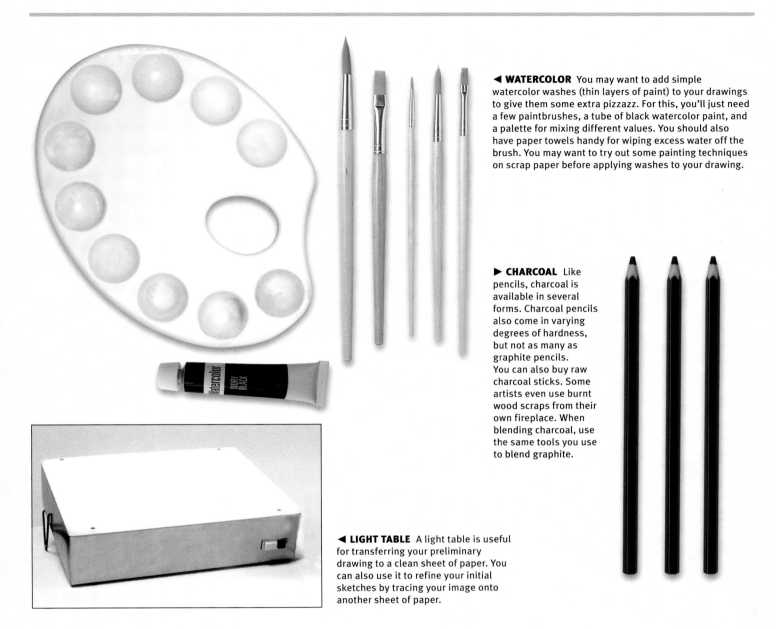

◄ **WATERCOLOR** You may want to add simple watercolor washes (thin layers of paint) to your drawings to give them some extra pizzazz. For this, you'll just need a few paintbrushes, a tube of black watercolor paint, and a palette for mixing different values. You should also have paper towels handy for wiping excess water off the brush. You may want to try out some painting techniques on scrap paper before applying washes to your drawing.

► **CHARCOAL** Like pencils, charcoal is available in several forms. Charcoal pencils also come in varying degrees of hardness, but not as many as graphite pencils. You can also buy raw charcoal sticks. Some artists even use burnt wood scraps from their own fireplace. When blending charcoal, use the same tools you use to blend graphite.

◄ **LIGHT TABLE** A light table is useful for transferring your preliminary drawing to a clean sheet of paper. You can also use it to refine your initial sketches by tracing your image onto another sheet of paper.

PAPER

Paper plays the most important role in the quality of your drawings. Purchase a small sketchbook for drawing on location or sketching out ideas. For the final drawing, use an acid-free paper that is suitable for graphite or charcoal. Acid-free papers withstand the test of time, provided they are stored and framed properly. Most papers can be purchased by the sheet or in pads.

If you will be incorporating watercolor washes into your drawings, look for cotton rag paper, which accepts watercolor and graphite or charcoal very well. Hot-press paper (as opposed to cold-press) has a smooth, almost slick surface that allows for flawless washes that are easy to control. Thicker papers work better for watercolor and will not curl as easily. Another option is to purchase a watercolor block, which is a pad of paper that is bound on all four sides to keep it from curling. When you are finished with your drawing, simply slip a dull knife under the edges to separate the top sheet from the block.

The tooth of the paper, or the roughness of the surface, is another important aspect to consider. "Toothy" papers can hold a lot of graphite or charcoal but do not hold up for wet media like watercolor. The more tooth the paper has, the less durable it is when it comes to erasing. The fibers will get worn with repeated erasing, so be careful not to overwork areas.

Another thing to note when choosing paper is whether you plan to reproduce your drawings. The texture of the paper will sometimes reproduce when printed, which can be undesirable in some cases. Paper in its natural state typically has a yellow cast to it, which can be difficult to eliminate when reproducing the drawing. Scanners sometimes read the texture or color cast as a value or shades of gray, which will affect the overall contrast of your drawing. I use a bright white paper for drawings that are going to be reproduced. These papers are often bleached or have special whiteners added to them in the manufacturing process.

Lifelike Drawing Techniques

Techniques for graphite and charcoal are very similar to those for watercolor paint. There are more shading techniques than the ones covered here, but these are used for drawing realistic animals. One of the most important rules is to shade in the direction in which the hair grows, as it makes your drawings look more realistic. Note that graphite is easier to blend than charcoal and is also easier to erase or lift from the paper. For each technique shown below, you'll see an example in graphite at the far left and an example in charcoal at the near left.

GRADATION Start with a soft pencil such as a 6B and turn the pencil on its side. With a good amount of pressure, lay in the darkest value, gradually lessening the pressure as you move down. You may switch to a harder pencil as you move to the lighter values. You can also blend strokes by layering them on top of one another.

HAIR Using a sharp graphite or charcoal pencil and a sweeping stroke, quickly move your hand in an arc, lifting the pencil from the paper at the end of the stroke. You can lift the pencil at the end of the hair (from the darkest to lightest). Experiment to find out what works for you. With a little practice, you will master the art of drawing hair.

BLENDED GRADATION Create gradated (or graduated) values, and then blend and soften them with a tortillon. This technique works well for moving tones into a lighter area.

WATERCOLOR TECHNIQUES

 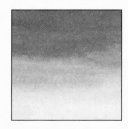 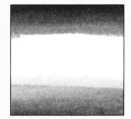

DRYBRUSHING Load your brush with a wash of paint and dab the bristles on a paper towel. Pull the brush lightly across the paper for a texture that suggests mane and tail hair.

GRADATION Pull a horizontal band of a wash across the top of the paper. Add more water to the brush as you stroke down, creating a transition from dark to light that suggests form.

WET-ON-WET Paint wet color onto dry paper or over a dry layer of color. This gives you a good amount of control over the paint's spread, which is great for painting details.

ERASING These examples show how tone can be lifted from the page using a kneaded eraser (such as for creating highlights). A kneaded eraser is very effective for lifting out tone, because it can be molded to fit small areas or flattened out for larger areas. Remember that charcoal is harder to lift out than graphite.

PENCIL HARDNESS Here are examples of how pencil hardness affects value. The banding indicates where a harder pencil was used to shade. By varying the amount of pressure, you can achieve a wide range of values in your drawings.

CROSSHATCHING These samples illustrate the way that layering in different directions creates texture and adds interest. If you use this technique, it should be used throughout the drawing for consistency. If you want to achieve lifelike results, this technique is not recommended for final drawings, but it works well in preliminary drawings.

TECHNIQUES FOR EQUINE FEATURES

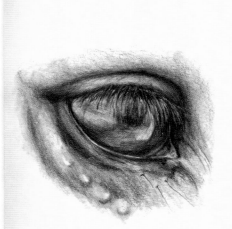
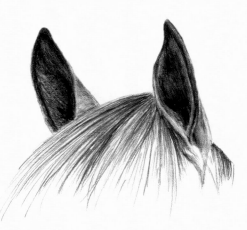
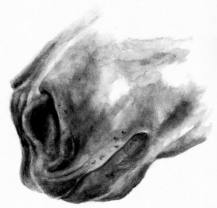

HIGHLIGHTING THE EYE To create a highlight and give the eye an appearance of reflectiveness, lift out small areas of graphite with a kneaded or stick eraser. This adds dimension and realism to your drawing, especially as the eye is often the focal point of a drawing.

EARS The ears of the horse are one of the most expressive parts of the anatomy. You can often gauge a horse's mood by the position and movement of the ears. This drawing shows an ear that has been trimmed free of hair. The darkest shading will be in the deepest part of the ear, blending to a lighter value.

MUZZLE In the summer, the muzzle is often devoid of hair and appears shiny, especially in professional photos. Light oil is often applied to the eye and muzzle to accentuate these areas. You can reflect this in your drawings by carefully blending these areas and using the kneaded eraser to lift out graphite for highlights.

Common Breed Profiles

The following five profile drawings are a small sampling of the differences in some common breeds. Note the shape of each profile; many times the profile of the head is characteristic of a particular breed.

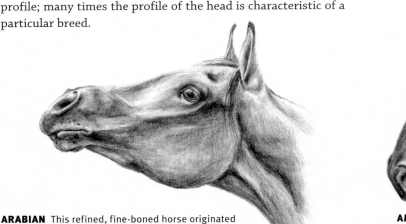

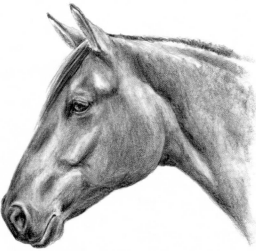

ARABIAN This refined, fine-boned horse originated in the deserts of the Arabian Peninsula. Known for its speed and stamina in extreme conditions, the Arabian's beauty and grace are unparalleled. Arabian bloodlines have long been used to establish new breeds, as their qualities are very desirable.

AMERICAN QUARTER HORSE A compact breed originating in North America, the American Quarter Horse is known for its speed and durability at a quarter-mile sprint. Primarily bred as a work horse and often used in ranch work, today's Quarter Horse is found across the globe.

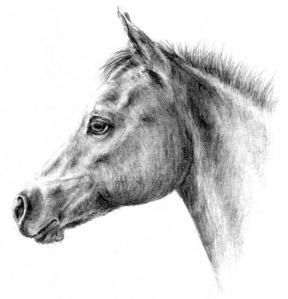

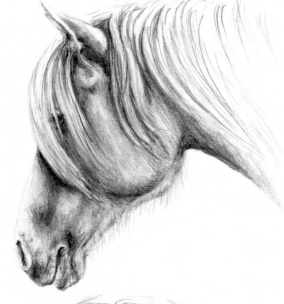

HAFLINGER Native to Austria, the Haflinger evolved in the Tyrolean area of the Alps. The breed takes its name from the village of Hafling, which is now part of Italy. Believed to be a horse with Arabian influence, the Haflinger is small in stature but mighty in heart. Its stocky build has made it a good workhorse as well as a good mount for numerous disciplines. Always chestnut in color, varying in shade from blonde to dark chocolate, its mane and tail are long, thick, and flaxen to white in color.

PONY OF THE AMERICAS This foal is a miniature version of the larger Appaloosa horse. The pony possesses the same characteristics as its larger cousin, including spots, but the pony measures between 46 and 56 inches, making it the perfect size for children to mount.

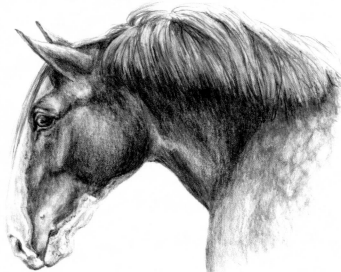

SHIRE A large, big-boned draft breed specifically bred for heavy work, this horse originated in the Shires of England and is one of the world's largest breeds. It can be black, brown, or gray in color. Today's Shires make beautiful parade horses, pulling large, decorative wagons, and can still be seen in their traditional roles in England.

Profiles

This project includes the horse's tack, which adds interest and intricacy to the composition. This horse has also been completed in charcoal, which offers a richer range of values (and therefore more contrast) than graphite, allowing you to lay in tone quickly without having to apply multiple layers. However, charcoal does not erase easily, so it's more difficult to lift out highlights and remove smudges. A charcoal drawing must be carefully planned and treated with care from start to finish.

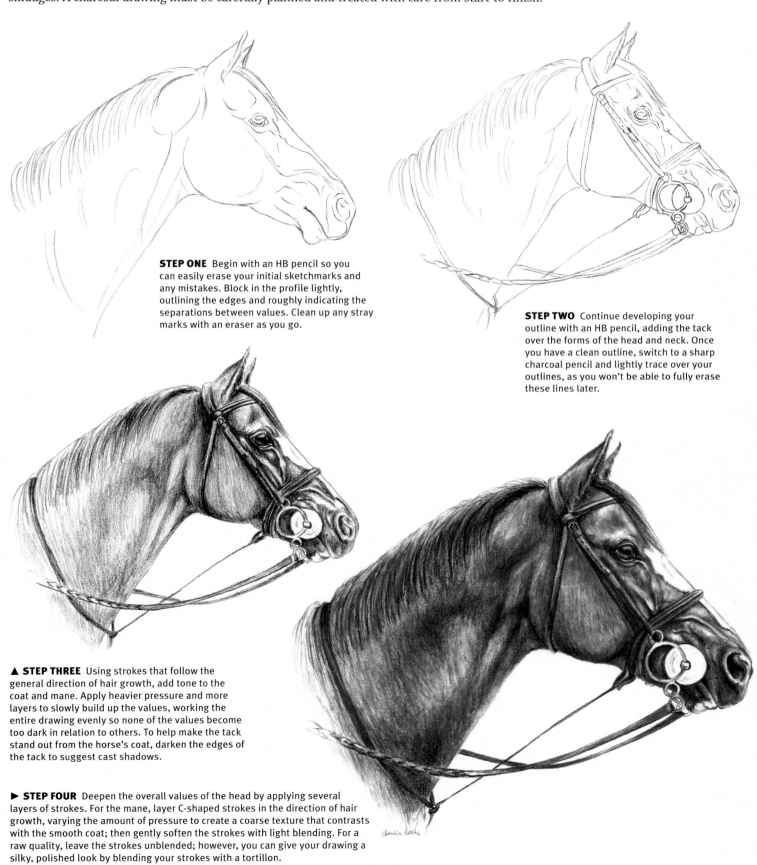

STEP ONE Begin with an HB pencil so you can easily erase your initial sketchmarks and any mistakes. Block in the profile lightly, outlining the edges and roughly indicating the separations between values. Clean up any stray marks with an eraser as you go.

STEP TWO Continue developing your outline with an HB pencil, adding the tack over the forms of the head and neck. Once you have a clean outline, switch to a sharp charcoal pencil and lightly trace over your outlines, as you won't be able to fully erase these lines later.

▲ **STEP THREE** Using strokes that follow the general direction of hair growth, add tone to the coat and mane. Apply heavier pressure and more layers to slowly build up the values, working the entire drawing evenly so none of the values become too dark in relation to others. To help make the tack stand out from the horse's coat, darken the edges of the tack to suggest cast shadows.

▶ **STEP FOUR** Deepen the overall values of the head by applying several layers of strokes. For the mane, layer C-shaped strokes in the direction of hair growth, varying the amount of pressure to create a coarse texture that contrasts with the smooth coat; then gently soften the strokes with light blending. For a raw quality, leave the strokes unblended; however, you can give your drawing a silky, polished look by blending your strokes with a tortillon.

Arabian Portrait

When searching for a reference, remember that you aren't limited to just one photo; using multiple sources is an effective option. You can use *artistic license* (the artist's prerogative to change a subject or scene) to combine aspects of different photos. For example, if you find one reference with a pleasing composition but can't make out the details, you can use other shots that are better suited to provide this information.

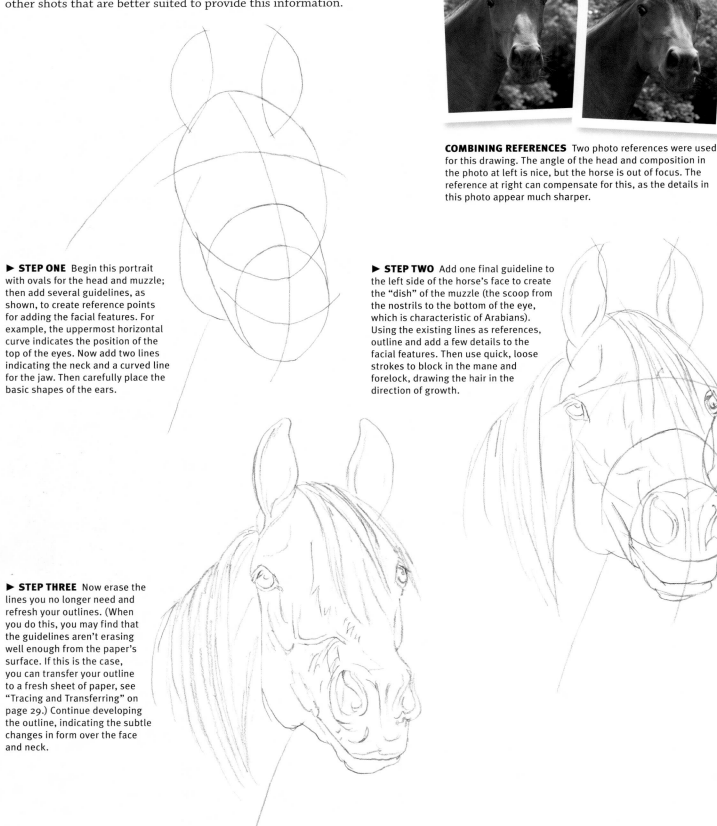

COMBINING REFERENCES Two photo references were used for this drawing. The angle of the head and composition in the photo at left is nice, but the horse is out of focus. The reference at right can compensate for this, as the details in this photo appear much sharper.

▶ **STEP ONE** Begin this portrait with ovals for the head and muzzle; then add several guidelines, as shown, to create reference points for adding the facial features. For example, the uppermost horizontal curve indicates the position of the top of the eyes. Now add two lines indicating the neck and a curved line for the jaw. Then carefully place the basic shapes of the ears.

▶ **STEP TWO** Add one final guideline to the left side of the horse's face to create the "dish" of the muzzle (the scoop from the nostrils to the bottom of the eye, which is characteristic of Arabians). Using the existing lines as references, outline and add a few details to the facial features. Then use quick, loose strokes to block in the mane and forelock, drawing the hair in the direction of growth.

▶ **STEP THREE** Now erase the lines you no longer need and refresh your outlines. (When you do this, you may find that the guidelines aren't erasing well enough from the paper's surface. If this is the case, you can transfer your outline to a fresh sheet of paper, see "Tracing and Transferring" on page 29.) Continue developing the outline, indicating the subtle changes in form over the face and neck.

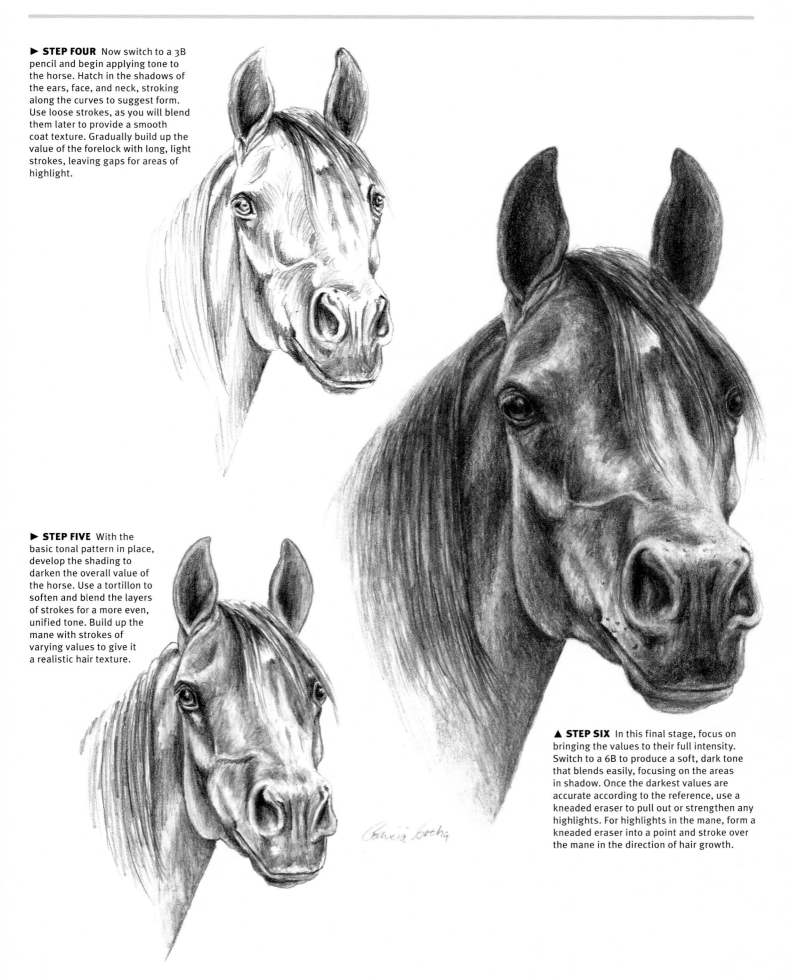

► **STEP FOUR** Now switch to a 3B pencil and begin applying tone to the horse. Hatch in the shadows of the ears, face, and neck, stroking along the curves to suggest form. Use loose strokes, as you will blend them later to provide a smooth coat texture. Gradually build up the value of the forelock with long, light strokes, leaving gaps for areas of highlight.

► **STEP FIVE** With the basic tonal pattern in place, develop the shading to darken the overall value of the horse. Use a tortillon to soften and blend the layers of strokes for a more even, unified tone. Build up the mane with strokes of varying values to give it a realistic hair texture.

▲ **STEP SIX** In this final stage, focus on bringing the values to their full intensity. Switch to a 6B to produce a soft, dark tone that blends easily, focusing on the areas in shadow. Once the darkest values are accurate according to the reference, use a kneaded eraser to pull out or strengthen any highlights. For highlights in the mane, form a kneaded eraser into a point and stroke over the mane in the direction of hair growth.

Appaloosa

The Appaloosa is an American breed descendant from the Spanish horses that were imported by the conquistadores of the 16th century. These unique horses feature four identifying characteristics: a spotted coat pattern, mottled skin, white sclera around the eye, and striped hooves. However, a horse needs only two of these characteristics to be registered as an Appaloosa.

This project demonstrates the *grid method*, which uses simple squares as reference points for transferring a reference to your drawing paper. After following the steps in this project, you'll know how to apply this method to your own reference photographs.

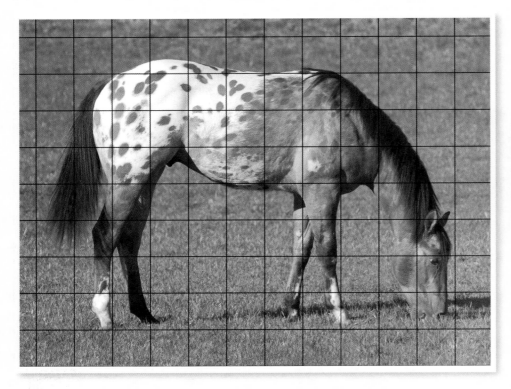

◄ **STEP ONE** To re-create this photograph, use the grid method, which uses simple squares as reference points for transferring an image to drawing paper. Begin by placing a grid of one-inch squares over a photocopy of the reference using a pencil and a ruler. Refer to this as you place the outline in your hand-drawn grid in step three.

▲ **STEP TWO** Using an HB pencil and very light pressure, create a grid on the paper that has the same number of rows and columns as the one placed over the reference. (Remember: If you want your final drawing to be larger than the reference, make the squares of the grid larger; if you want your final to be smaller, make the squares smaller.)

> ⇥ T I P ⇤
>
> *Appaloosas have several different spotting patterns, including an all-over "leopard" pattern of spots on a white body, a "snowflake" pattern of white spots or flecks on a dark body, and a white "blanket" over the hips with spots that match the rest of the body color (as shown in this drawing).*

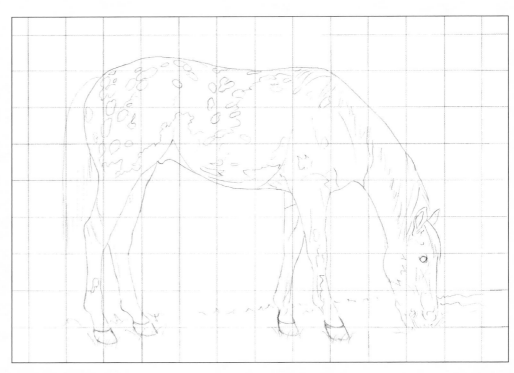

STEP THREE Now simply create the outline of the horse by copying what you see in each square of the reference into each square of your drawn grid. (You may choose to keep the outline simple and basic, as you can always refine it after erasing the grid—or you can give yourself a thorough guide by adding the facial features and coat patterns.)

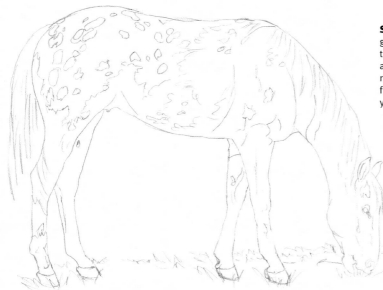

STEP FOUR Using an eraser, gently rub away the grid lines. Try not to rub too hard, as you don't want to damage the surface of the paper. Then redraw any areas of the lines that have been accidentally erased, restoring the outline as you go. If you have trouble fully erasing the grid lines, you may want to transfer your outline to a fresh sheet of paper.

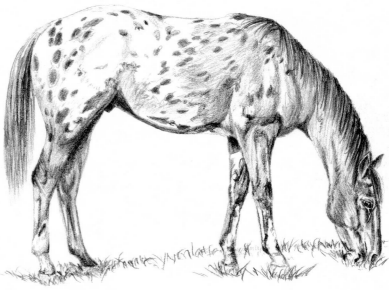

STEP FIVE Now begin working tone into the shadows and across the body using 3B and 6B pencils. Use layers of graphite to build the drawing slowly—start out with light pressure, and then use heavier strokes to develop the muscles and other details. Notice that some of the spots aren't solid—some even contain spots themselves. Noting and capturing these subtleties will add realism to your finished drawing.

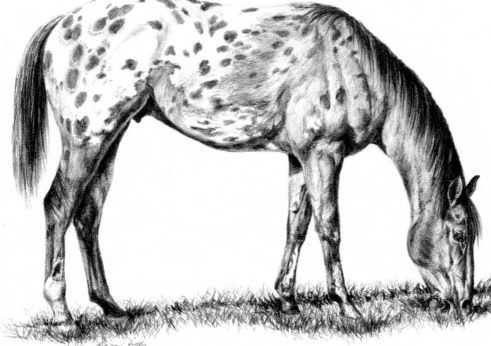

STEP SIX Continue adding value to the horse and grass, working evenly across the drawing. For the light areas of the horse, use a very light layer of tone to make it stand out from the white of the background. Leave only the brightest highlights free of tone; if you happen to cover them with tone, simply pull out the graphite with an eraser.

Cantering Foal

By the time a foal is one year old, many of the baby characteristics are gone, but it is still obvious that the horse is a youngster. Most horses will reach full maturity by the age of five. By their second birthday, many breeds are already under saddle—and some breeds, such as the Thoroughbred and Standardbred, start their racing careers at two years of age. These horses have universal birth dates of January 1st, regardless of their birth month, so the foals are frequently born in the early months of the year to give them a slight advantage over those born in later months.

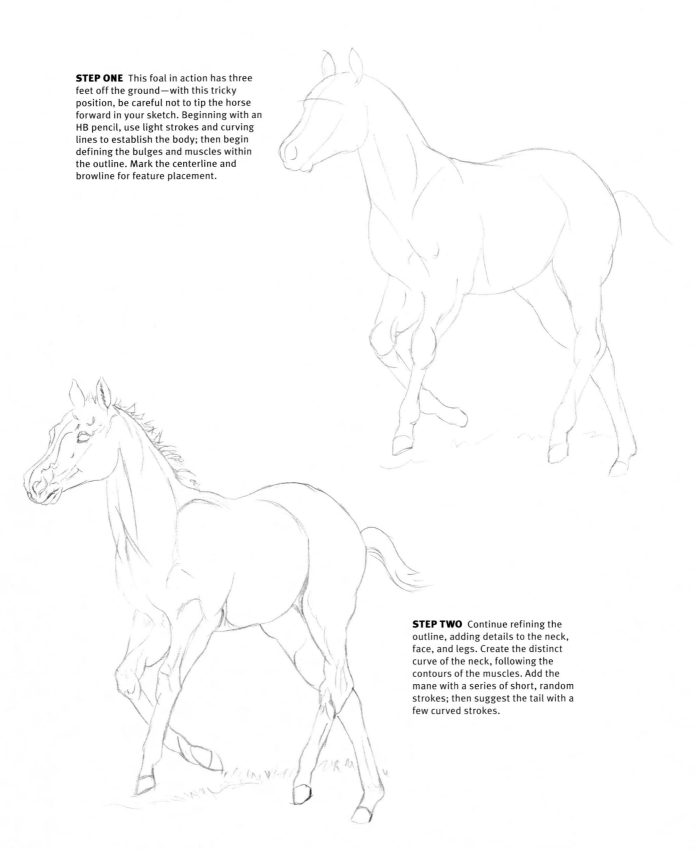

STEP ONE This foal in action has three feet off the ground—with this tricky position, be careful not to tip the horse forward in your sketch. Beginning with an HB pencil, use light strokes and curving lines to establish the body; then begin defining the bulges and muscles within the outline. Mark the centerline and browline for feature placement.

STEP TWO Continue refining the outline, adding details to the neck, face, and legs. Create the distinct curve of the neck, following the contours of the muscles. Add the mane with a series of short, random strokes; then suggest the tail with a few curved strokes.

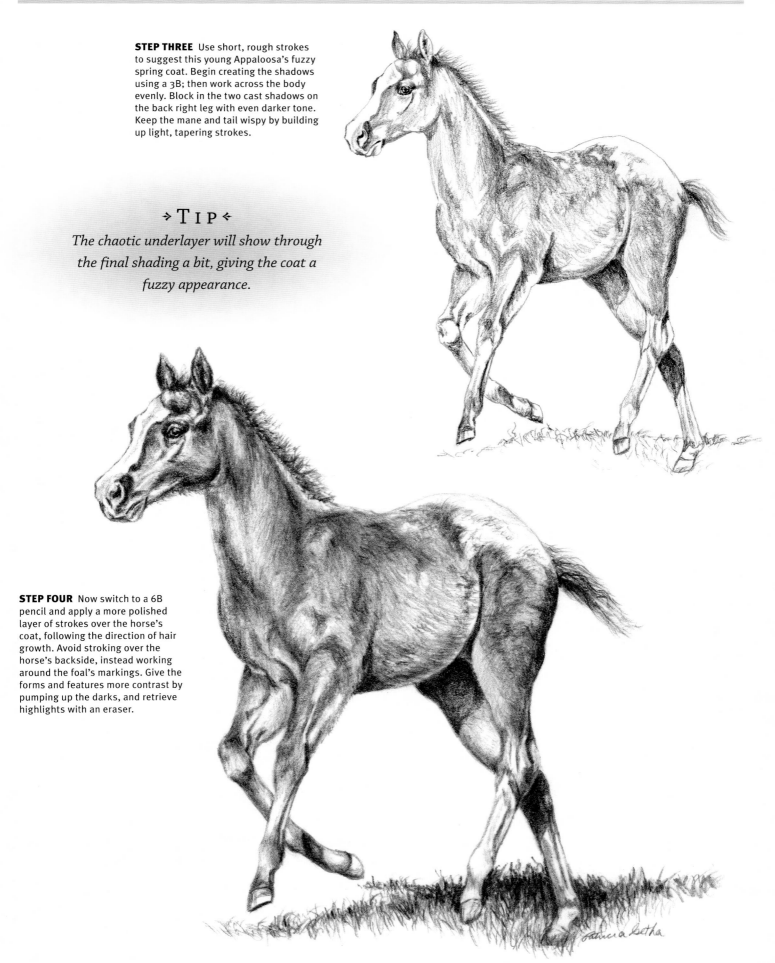

STEP THREE Use short, rough strokes to suggest this young Appaloosa's fuzzy spring coat. Begin creating the shadows using a 3B; then work across the body evenly. Block in the two cast shadows on the back right leg with even darker tone. Keep the mane and tail wispy by building up light, tapering strokes.

✦ T I P ✦

The chaotic underlayer will show through the final shading a bit, giving the coat a fuzzy appearance.

STEP FOUR Now switch to a 6B pencil and apply a more polished layer of strokes over the horse's coat, following the direction of hair growth. Avoid stroking over the horse's backside, instead working around the foal's markings. Give the forms and features more contrast by pumping up the darks, and retrieve highlights with an eraser.

Standardbred Trotter

This project depicts a Standardbred trotter during a warmup—it is working at a moderate speed, and its body is not fully extended.

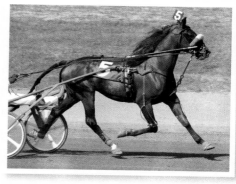

STEP ONE Establish the basic outline of the horse using an HB pencil and loose strokes. In this early stage, keep your lines light, erasing and adjusting as necessary. Add a few lines to block in the forms of the muscles, indicating where the light and dark values meet.

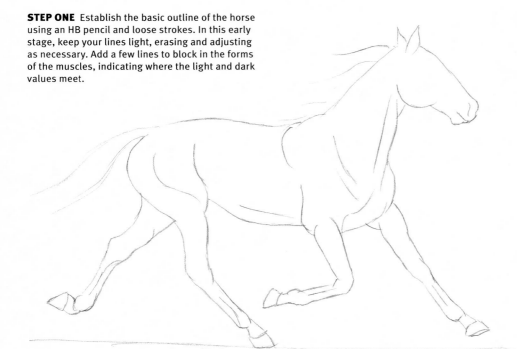

DEFINING THE MUSCLES Because this drawing depicts a competitive horse, it's important to emphasize the fine musculature. Keep the croup flat and the haunches well defined to indicate the propelling power of the hindquarters.

> → T I P ←
> *The Standardbred is known for its skill in harness racing. It is the fastest trotting breed of horse in the world.*

STEP TWO Once you are satisfied with the basic outline, refine your lines to carefully depict the subtle curves and angles of the subject, and use long, tapering strokes to begin rendering the mane and tail. Then develop the outline to show the muscles, tendons, ligaments, and facial features. As you progress, note the details in the reference that make this active pose unique. Notice how one ear is tipped back to listen for cues from the driver, whereas the other is facing forward to listen ahead. Also, the visible nostril is slightly flared from the physical activity.

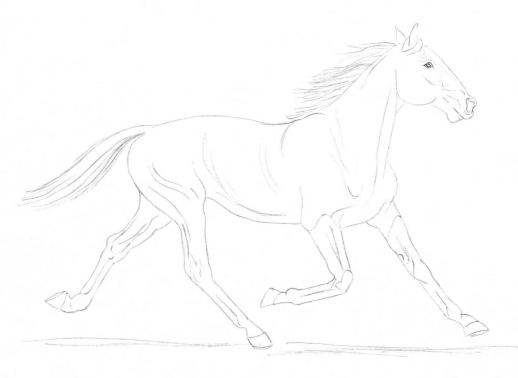

STEP THREE At this point, switch to a 3B and begin shading the horse to add form. Build up the tone evenly over the horse, starting with the shadows and gradating to the lighter areas. To suggest movement in the horse, avoid blending to keep your shading rough and sketchy.

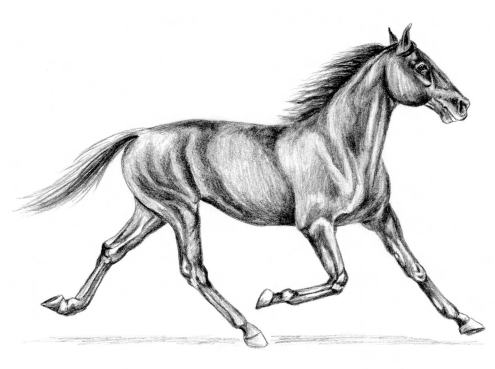

→ T I P ←

As you shade, you'll want to minimize the chance of smearing the graphite: If you're right-handed, work left to right; if you're left-handed, work right to left.

STEP FOUR In this final step, focus on punching up the values. Stick with HB and 2B pencils to shade within the lighter areas, but change to a 6B for darker values. It's important to use the softest pencils for the darkest areas, as harder pencils can burnish the graphite, causing odd reflections or even damage to the paper's surface.

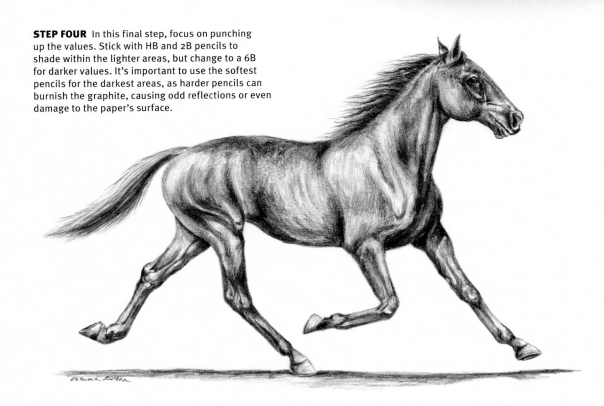

American Saddlebred & Rider

The exaggerated and animated gaits of the Saddlebred are delightful to draw. The feet of this breed are specially shod with heavy shoes and longer horns, which help enhance the action and give this horse a graceful, stately look. To convey the elegance of this breed and rider, use fluid washes of black watercolor to add more depth to your drawing.

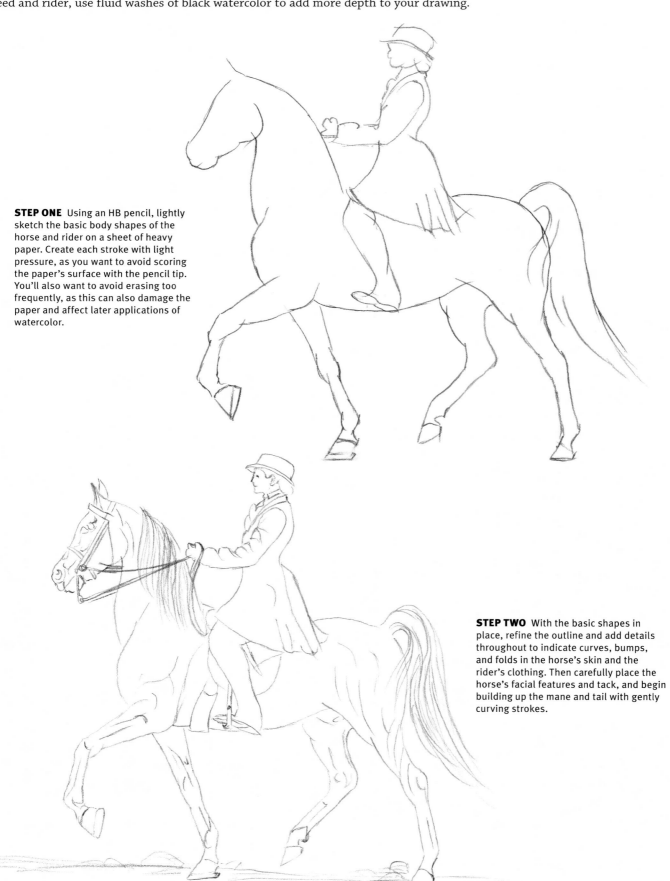

STEP ONE Using an HB pencil, lightly sketch the basic body shapes of the horse and rider on a sheet of heavy paper. Create each stroke with light pressure, as you want to avoid scoring the paper's surface with the pencil tip. You'll also want to avoid erasing too frequently, as this can also damage the paper and affect later applications of watercolor.

STEP TWO With the basic shapes in place, refine the outline and add details throughout to indicate curves, bumps, and folds in the horse's skin and the rider's clothing. Then carefully place the horse's facial features and tack, and begin building up the mane and tail with gently curving strokes.

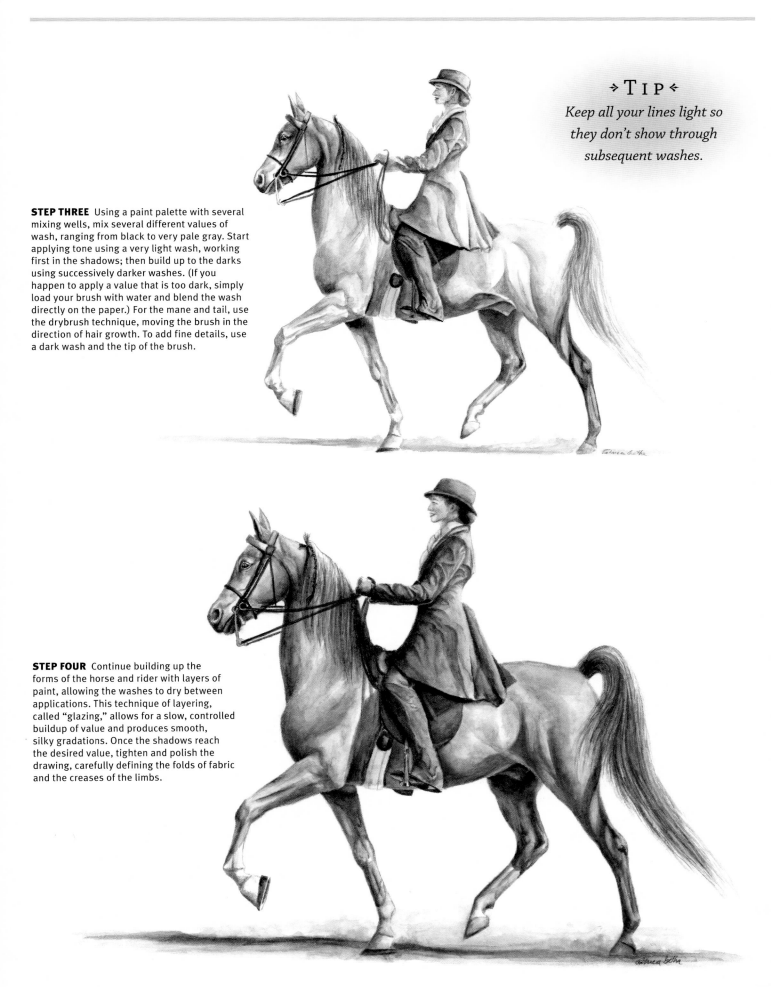

> ⇢ T I P ⇠
>
> *Keep all your lines light so*
> *they don't show through*
> *subsequent washes.*

STEP THREE Using a paint palette with several mixing wells, mix several different values of wash, ranging from black to very pale gray. Start applying tone using a very light wash, working first in the shadows; then build up to the darks using successively darker washes. (If you happen to apply a value that is too dark, simply load your brush with water and blend the wash directly on the paper.) For the mane and tail, use the drybrush technique, moving the brush in the direction of hair growth. To add fine details, use a dark wash and the tip of the brush.

STEP FOUR Continue building up the forms of the horse and rider with layers of paint, allowing the washes to dry between applications. This technique of layering, called "glazing," allows for a slow, controlled buildup of value and produces smooth, silky gradations. Once the shadows reach the desired value, tighten and polish the drawing, carefully defining the folds of fabric and the creases of the limbs.

Gypsy Vanner

The "Gypsy Horse," known in America as the Gypsy Vanner, is a hardy horse bred by Gypsy Travelers to pull their ornate caravans and carts. This type of horse may also be called the Gypsy Cob, Irish Cob, and Romany Horse. They can be any color and generally have long, thick manes and tails, along with an abundant amount of leg feathering. They have a stout, muscular body type like larger draft breeds but are much smaller in stature. Still rare in the United States, the Gypsy Vanner is gaining popularity with horse enthusiasts around the world.

This project depicts a Gypsy Vanner stallion. Notice his thick neck, muscular body, and long mane and tail. His feathering, common with many larger draft breeds, starts just below the knee joint and completely covers the hoof.

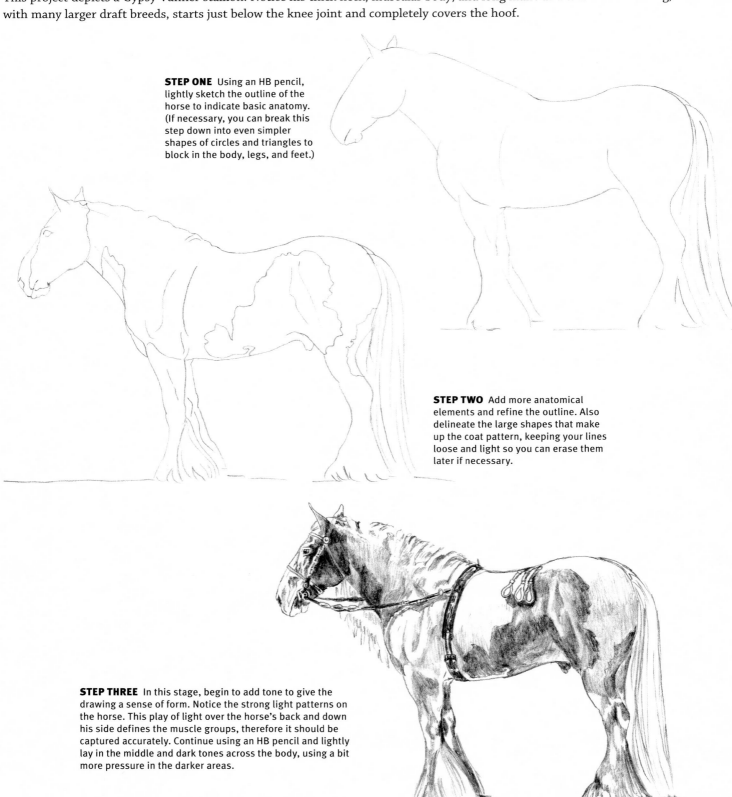

STEP ONE Using an HB pencil, lightly sketch the outline of the horse to indicate basic anatomy. (If necessary, you can break this step down into even simpler shapes of circles and triangles to block in the body, legs, and feet.)

STEP TWO Add more anatomical elements and refine the outline. Also delineate the large shapes that make up the coat pattern, keeping your lines loose and light so you can erase them later if necessary.

STEP THREE In this stage, begin to add tone to give the drawing a sense of form. Notice the strong light patterns on the horse. This play of light over the horse's back and down his side defines the muscle groups, therefore it should be captured accurately. Continue using an HB pencil and lightly lay in the middle and dark tones across the body, using a bit more pressure in the darker areas.

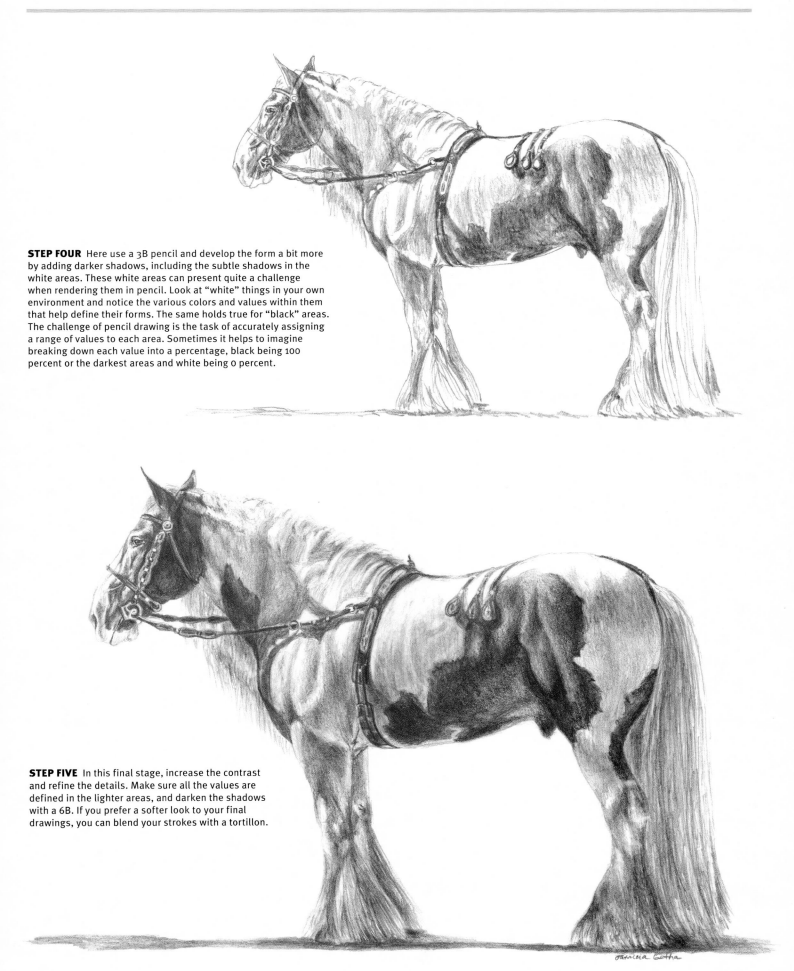

STEP FOUR Here use a 3B pencil and develop the form a bit more by adding darker shadows, including the subtle shadows in the white areas. These white areas can present quite a challenge when rendering them in pencil. Look at "white" things in your own environment and notice the various colors and values within them that help define their forms. The same holds true for "black" areas. The challenge of pencil drawing is the task of accurately assigning a range of values to each area. Sometimes it helps to imagine breaking down each value into a percentage, black being 100 percent or the darkest areas and white being 0 percent.

STEP FIVE In this final stage, increase the contrast and refine the details. Make sure all the values are defined in the lighter areas, and darken the shadows with a 6B. If you prefer a softer look to your final drawings, you can blend your strokes with a tortillon.

American Paint Horse

The American Paint Horse Association (APHA) is the second-largest breed registry in the United States based on the number of horses registered annually. One of the most notable traits of the American Paint is the presence of a colorful coat, which is one of three patterns: overo, tovero, and tobiano. The American Paint Horse has a stocky build, similar to that of the American Quarter Horse. This project shows a stocky Paint mare, which exhibits the overo coat pattern. Her body is slightly foreshortened through the barrel. Remember that sometimes a camera lens can make the head appear too large. If you work from photographs, it is important that you do not transfer this distortion to your drawings, as they are more obvious in artwork than in photographs.

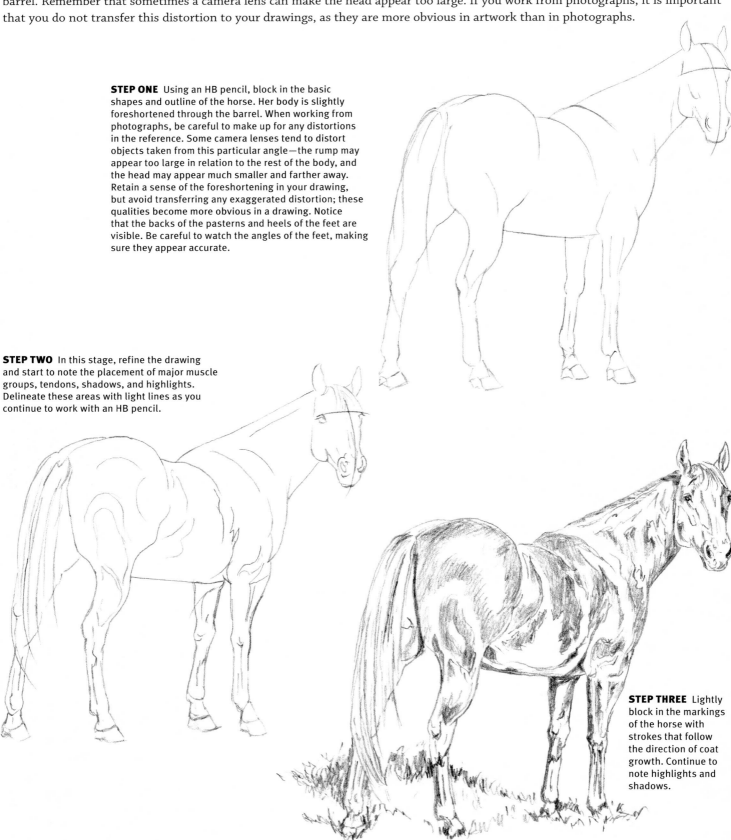

STEP ONE Using an HB pencil, block in the basic shapes and outline of the horse. Her body is slightly foreshortened through the barrel. When working from photographs, be careful to make up for any distortions in the reference. Some camera lenses tend to distort objects taken from this particular angle—the rump may appear too large in relation to the rest of the body, and the head may appear much smaller and farther away. Retain a sense of the foreshortening in your drawing, but avoid transferring any exaggerated distortion; these qualities become more obvious in a drawing. Notice that the backs of the pasterns and heels of the feet are visible. Be careful to watch the angles of the feet, making sure they appear accurate.

STEP TWO In this stage, refine the drawing and start to note the placement of major muscle groups, tendons, shadows, and highlights. Delineate these areas with light lines as you continue to work with an HB pencil.

STEP THREE Lightly block in the markings of the horse with strokes that follow the direction of coat growth. Continue to note highlights and shadows.

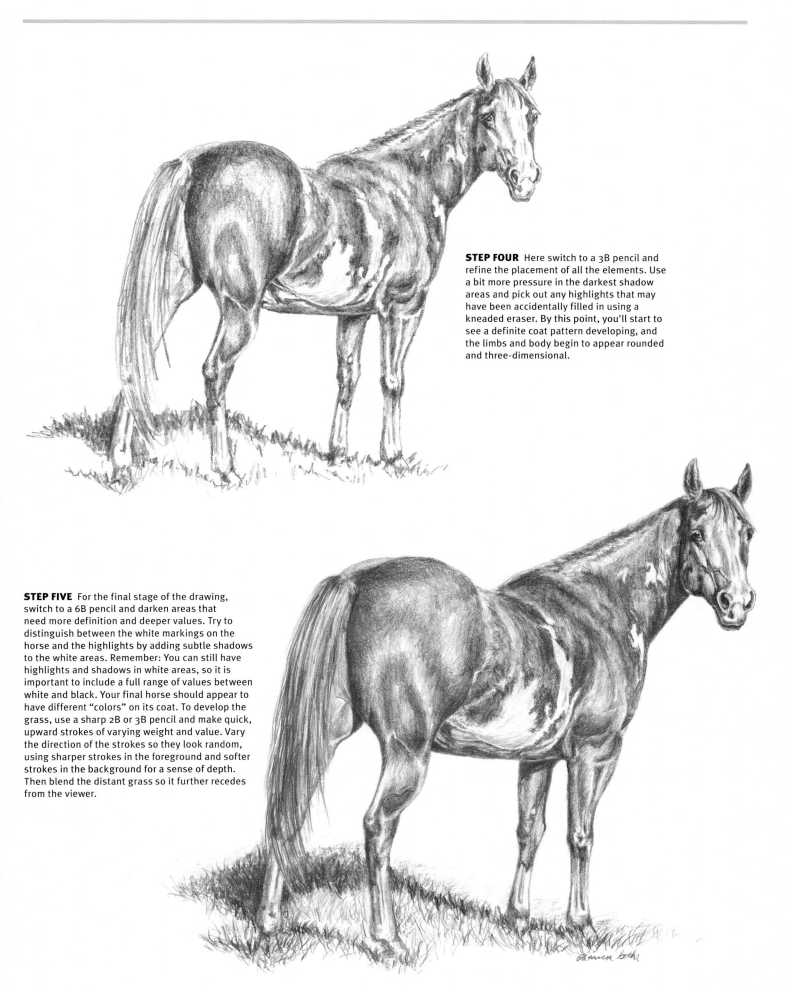

STEP FOUR Here switch to a 3B pencil and refine the placement of all the elements. Use a bit more pressure in the darkest shadow areas and pick out any highlights that may have been accidentally filled in using a kneaded eraser. By this point, you'll start to see a definite coat pattern developing, and the limbs and body begin to appear rounded and three-dimensional.

STEP FIVE For the final stage of the drawing, switch to a 6B pencil and darken areas that need more definition and deeper values. Try to distinguish between the white markings on the horse and the highlights by adding subtle shadows to the white areas. Remember: You can still have highlights and shadows in white areas, so it is important to include a full range of values between white and black. Your final horse should appear to have different "colors" on its coat. To develop the grass, use a sharp 2B or 3B pencil and make quick, upward strokes of varying weight and value. Vary the direction of the strokes so they look random, using sharper strokes in the foreground and softer strokes in the background for a sense of depth. Then blend the distant grass so it further recedes from the viewer.

Pinto Pony

Ponies can present some unique challenges to the working artist. Some are so hairy that you can't see their features—it's a wonder they can see where they are going at all! Others are very fat with short legs and hair that hides everything else. The pony in this project is a pinto—not any special breed, but cute all the same. Here, the pinto reaches around to scratch his rear pastern.

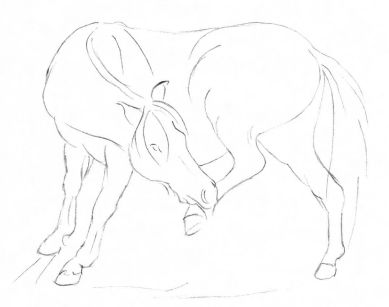

STEP ONE Start this drawing by lightly blocking in the outline of the body. Indicate the lines in the neck so that when you start shading and adding the mane, you will understand how the anatomy would look under all that hair. It is not often that one has the opportunity to sketch a horse in this position, therefore it is important to study the anatomy whenever possible so you can render it accurately. While creating the outline, notice how various parts of the body line up with one another and compare in size; for example, the withers are the same height as the rump. Picking up on details like this will help you achieve an accurate initial sketch.

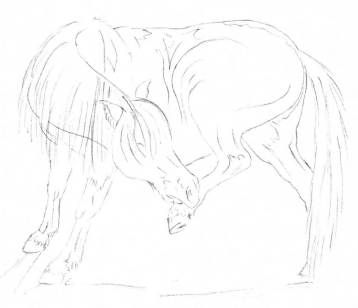

STEP TWO Continue to block in the muscle groups, tendons, markings, and shadows. Also indicate where color changes occur and lightly rough in the mane and forelock, stroking in the direction of hair growth. Keep your lines fairly light so you can easily erase or draw over them where necessary.

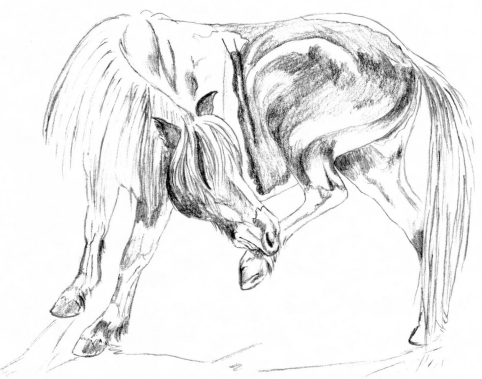

STEP THREE In this step, lightly block in the basic values with quick strokes that follow the natural flow of the coat and hair. Pay particular attention to where the direction changes course, such as in the hip area, to keep it as realistic as possible. Keep in mind that there is a very strong light source illuminating the back and top of the withers, creating highlights that will help define the muscles, wrinkles, and anatomy of the pony. Re-creating these effects of backlighting adds contrast and drama to the scene.

STEP FOUR Continue to develop the shadows with a 3B pencil. Because of the strong light on the withers, you won't find a lot of detail in this area, but still lightly indicate what should be there and suggest the top line of the neck. Using a very sharp 2B pencil, refine the mane with long, tapering strokes of varying pressure, keeping the lightest areas free of tone. (You may choose to blend this area and soften the strokes with a tortillon.) If the strokes get too dark, pick them out with a kneaded eraser. Keep on hand a simple, inexpensive barbecue brush (purchased at a grocery store) to brush away any eraser crumbs. You can also use a clean sheet of paper to cover areas of the drawing you've worked on to prevent the graphite from smudging, especially in the darker areas.

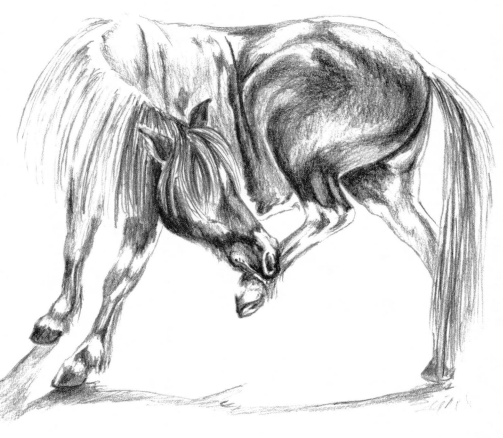

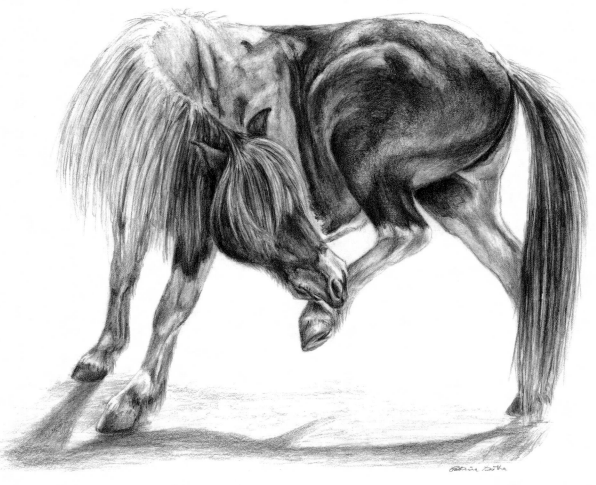

STEP FIVE Finish the drawing by darkening all the shadow areas using a 6B pencil. As you create the cast shadow, keep in mind that it should always reflect the texture of the surface it appears on. If the surface is rough, the shadow should appear rough as well. If the surface is smooth, blend the shadow to reflect a smooth, uniform texture. As you shade the body, be especially careful not to lose the nice wrinkles caused by the long stretch of the neck and the body folding in on itself. You'll often see horses hike up a hind leg and scratch an ear with the hoof like a dog. They must accomplish this while standing, so it is somewhat comical to watch—you would think that a horse would not be able to do this without hurting itself!

American Morgan Horse

The American Morgan Horse dates back to 1789 when a man named Justin Morgan purchased a bay colt named Figure, which became the foundation sire for the breed. His offspring influenced many other breeds, such as the American Saddlebred, American Quarter Horse, and the Standardbred Trotter. Known for their beauty, strength, speed, endurance, and gentle disposition, the Morgan horse quickly grew in popularity and spread around the young nation. They were used as Calvary horses in the Civil War and carriage horses in everyday life. Today's Morgans compete in many disciplines, from combined driving and carriage events to dressage.

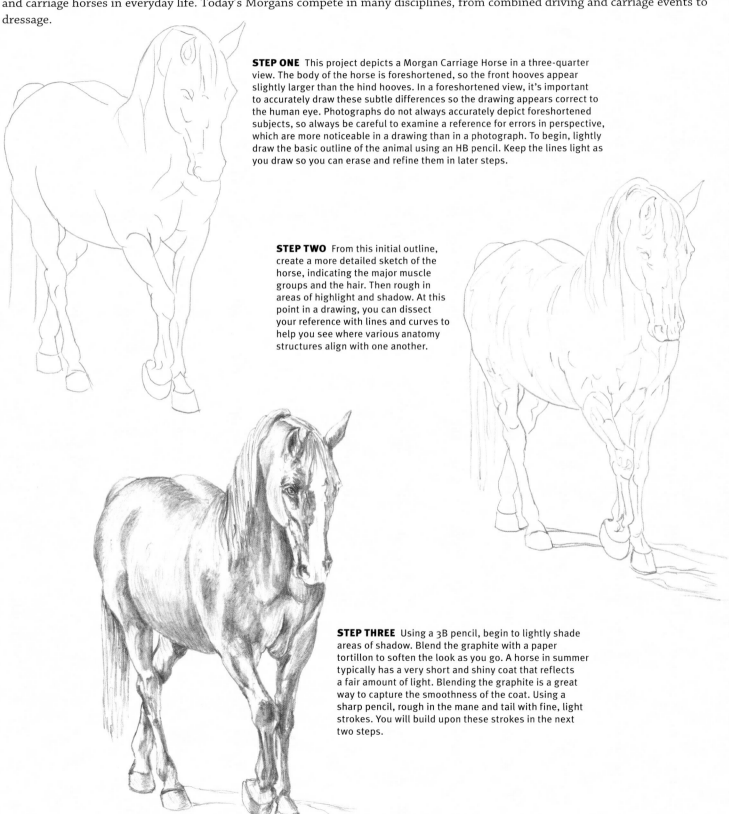

STEP ONE This project depicts a Morgan Carriage Horse in a three-quarter view. The body of the horse is foreshortened, so the front hooves appear slightly larger than the hind hooves. In a foreshortened view, it's important to accurately draw these subtle differences so the drawing appears correct to the human eye. Photographs do not always accurately depict foreshortened subjects, so always be careful to examine a reference for errors in perspective, which are more noticeable in a drawing than in a photograph. To begin, lightly draw the basic outline of the animal using an HB pencil. Keep the lines light as you draw so you can erase and refine them in later steps.

STEP TWO From this initial outline, create a more detailed sketch of the horse, indicating the major muscle groups and the hair. Then rough in areas of highlight and shadow. At this point in a drawing, you can dissect your reference with lines and curves to help you see where various anatomy structures align with one another.

STEP THREE Using a 3B pencil, begin to lightly shade areas of shadow. Blend the graphite with a paper tortillon to soften the look as you go. A horse in summer typically has a very short and shiny coat that reflects a fair amount of light. Blending the graphite is a great way to capture the smoothness of the coat. Using a sharp pencil, rough in the mane and tail with fine, light strokes. You will build upon these strokes in the next two steps.

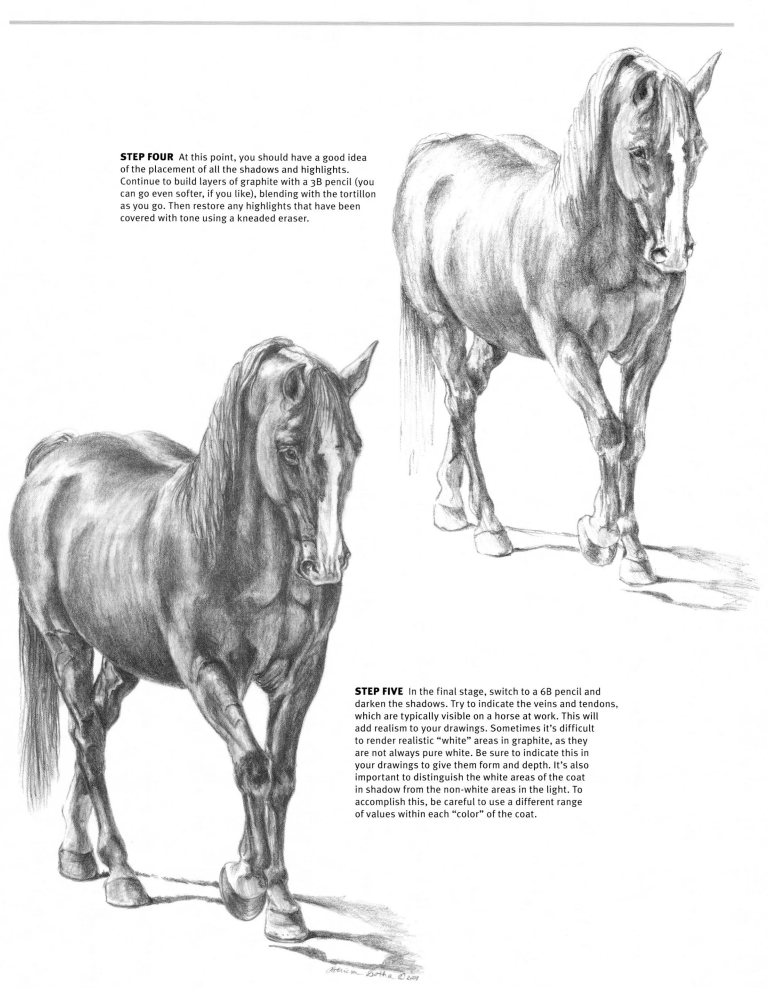

STEP FOUR At this point, you should have a good idea of the placement of all the shadows and highlights. Continue to build layers of graphite with a 3B pencil (you can go even softer, if you like), blending with the tortillon as you go. Then restore any highlights that have been covered with tone using a kneaded eraser.

STEP FIVE In the final stage, switch to a 6B pencil and darken the shadows. Try to indicate the veins and tendons, which are typically visible on a horse at work. This will add realism to your drawings. Sometimes it's difficult to render realistic "white" areas in graphite, as they are not always pure white. Be sure to indicate this in your drawings to give them form and depth. It's also important to distinguish the white areas of the coat in shadow from the non-white areas in the light. To accomplish this, be careful to use a different range of values within each "color" of the coat.

Dappled Pony

This pony presents somewhat of a challenge to the artist: He is a bit overweight and has a dappled coat pattern. An overweight animal hides underlying skeletal and muscular structures, so it becomes difficult for the artist to render areas where these structures exist, altering the way light reflects off the animal. As your knowledge of the anatomy grows, so will your drawing skills for rendering areas of the body—and you will become familiar with the way certain bones, ligaments and muscles should appear. You can use this knowledge to "fake in" areas that may not be apparent in your reference.

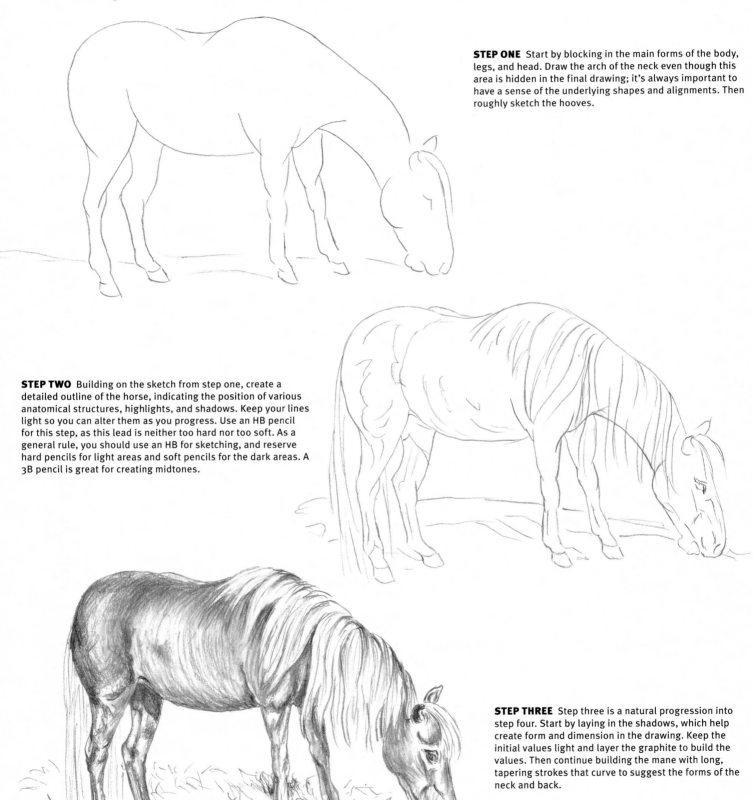

STEP ONE Start by blocking in the main forms of the body, legs, and head. Draw the arch of the neck even though this area is hidden in the final drawing; it's always important to have a sense of the underlying shapes and alignments. Then roughly sketch the hooves.

STEP TWO Building on the sketch from step one, create a detailed outline of the horse, indicating the position of various anatomical structures, highlights, and shadows. Keep your lines light so you can alter them as you progress. Use an HB pencil for this step, as this lead is neither too hard nor too soft. As a general rule, you should use an HB for sketching, and reserve hard pencils for light areas and soft pencils for the dark areas. A 3B pencil is great for creating midtones.

STEP THREE Step three is a natural progression into step four. Start by laying in the shadows, which help create form and dimension in the drawing. Keep the initial values light and layer the graphite to build the values. Then continue building the mane with long, tapering strokes that curve to suggest the forms of the neck and back.

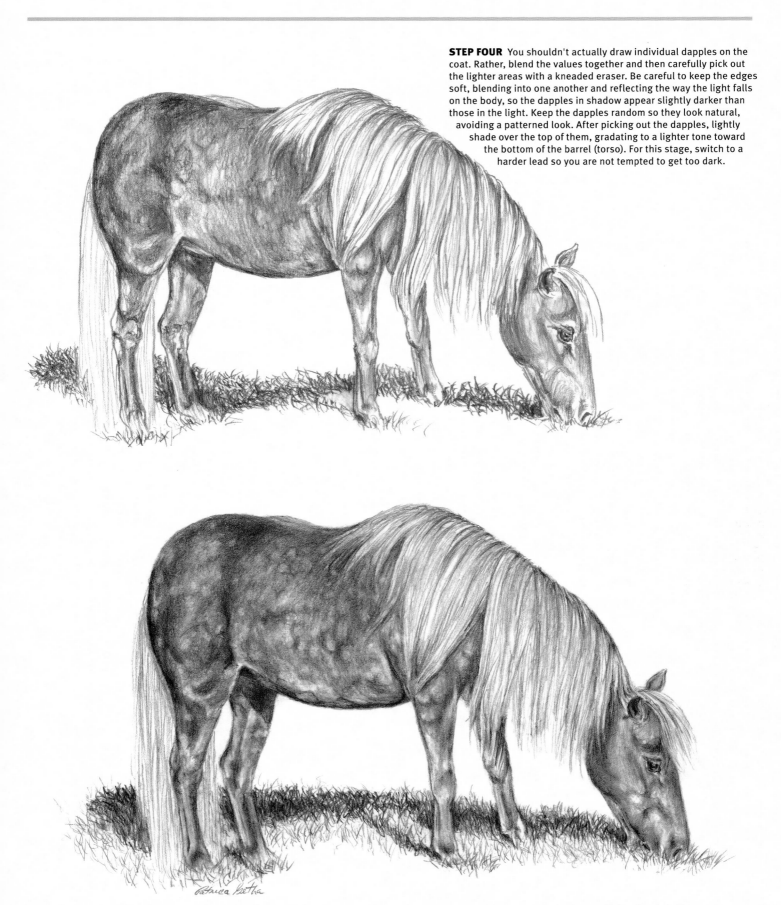

STEP FOUR You shouldn't actually draw individual dapples on the coat. Rather, blend the values together and then carefully pick out the lighter areas with a kneaded eraser. Be careful to keep the edges soft, blending into one another and reflecting the way the light falls on the body, so the dapples in shadow appear slightly darker than those in the light. Keep the dapples random so they look natural, avoiding a patterned look. After picking out the dapples, lightly shade over the top of them, gradating to a lighter tone toward the bottom of the barrel (torso). For this stage, switch to a harder lead so you are not tempted to get too dark.

STEP FIVE Continue adding dimension to your drawing by lightly shading the areas receiving little or no light. Clearly indicate the direction of the light by developing the cast shadow on the grass. Using a sharp pencil, lay in quick, upward strokes of varying values and direction to indicate the texture of the grass. The mane and tail are much lighter than the body, so be careful to maintain this distinction by leaving areas of lighter strokes intermixed with darker ones. The top of the mane does not have as much light shining on it, so use slightly darker strokes along this area.

Friesian

An ancient breed with Spanish influence, the Friesian is an elegant, large-boned horse originating from the Friesland region of the Netherlands. The Friesian is almost always black with minimal (if any) white. A pure white Friesian has recently been bred and is the product of Arabian bloodlines that have been introduced with special permission from the Breed Association. These versatile horses were originally used in farming, the circus, and war. Today's Friesian is a popular performance horse known for its proud carriage, arched neck, and high-stepping action. While this drawing can seem intimidating due to the amount of hair, breaking the hair down into several steps will make it much easier. The first step involves seeing what is not there: the curvature of the neck. Establishing this curve provides a reference point for the rest of the drawing. Shapes and lines help develop the form of the horse; they provide the guidelines for creating form through shading.

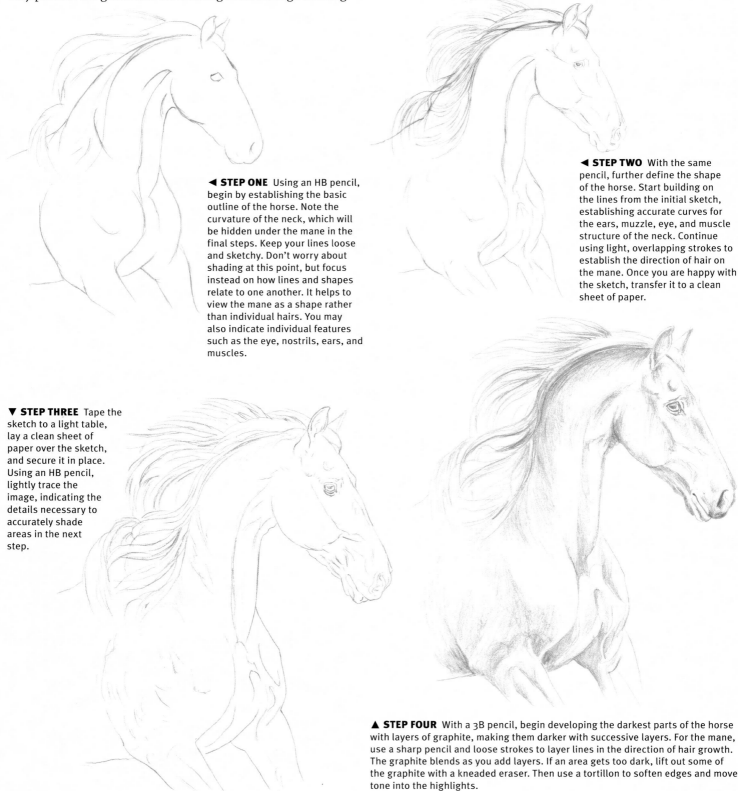

◄ **STEP ONE** Using an HB pencil, begin by establishing the basic outline of the horse. Note the curvature of the neck, which will be hidden under the mane in the final steps. Keep your lines loose and sketchy. Don't worry about shading at this point, but focus instead on how lines and shapes relate to one another. It helps to view the mane as a shape rather than individual hairs. You may also indicate individual features such as the eye, nostrils, ears, and muscles.

◄ **STEP TWO** With the same pencil, further define the shape of the horse. Start building on the lines from the initial sketch, establishing accurate curves for the ears, muzzle, eye, and muscle structure of the neck. Continue using light, overlapping strokes to establish the direction of hair on the mane. Once you are happy with the sketch, transfer it to a clean sheet of paper.

▼ **STEP THREE** Tape the sketch to a light table, lay a clean sheet of paper over the sketch, and secure it in place. Using an HB pencil, lightly trace the image, indicating the details necessary to accurately shade areas in the next step.

▲ **STEP FOUR** With a 3B pencil, begin developing the darkest parts of the horse with layers of graphite, making them darker with successive layers. For the mane, use a sharp pencil and loose strokes to layer lines in the direction of hair growth. The graphite blends as you add layers. If an area gets too dark, lift out some of the graphite with a kneaded eraser. Then use a tortillon to soften edges and move tone into the highlights.

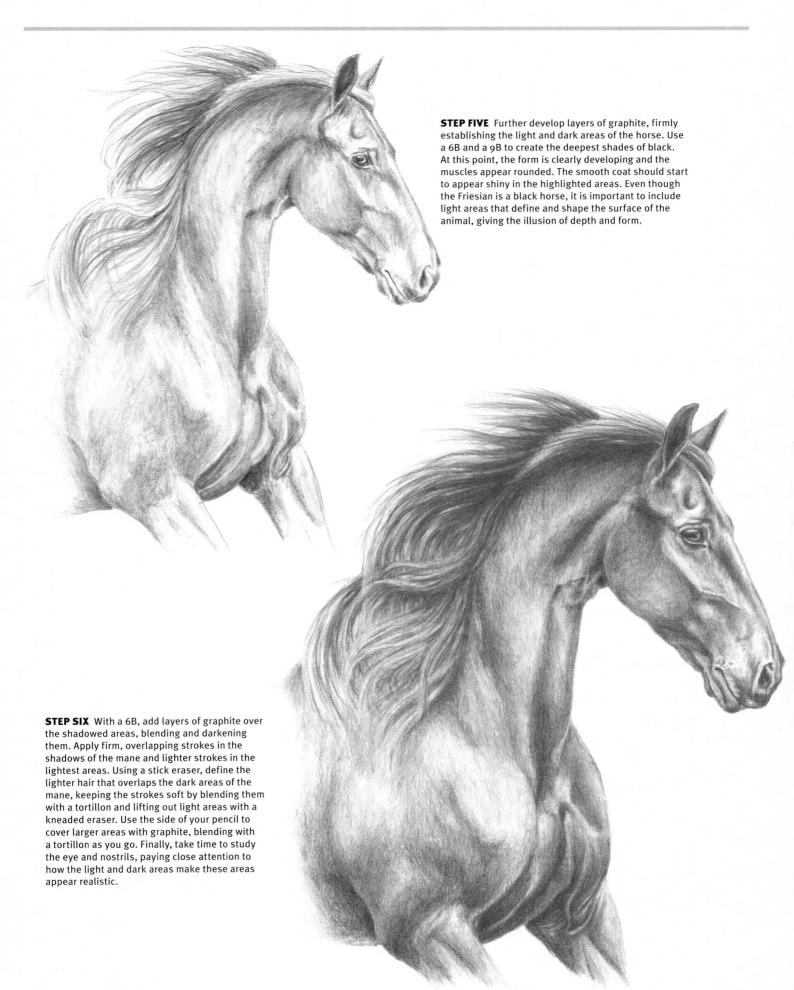

STEP FIVE Further develop layers of graphite, firmly establishing the light and dark areas of the horse. Use a 6B and a 9B to create the deepest shades of black. At this point, the form is clearly developing and the muscles appear rounded. The smooth coat should start to appear shiny in the highlighted areas. Even though the Friesian is a black horse, it is important to include light areas that define and shape the surface of the animal, giving the illusion of depth and form.

STEP SIX With a 6B, add layers of graphite over the shadowed areas, blending and darkening them. Apply firm, overlapping strokes in the shadows of the mane and lighter strokes in the lightest areas. Using a stick eraser, define the lighter hair that overlaps the dark areas of the mane, keeping the strokes soft by blending them with a tortillon and lifting out light areas with a kneaded eraser. Use the side of your pencil to cover larger areas with graphite, blending with a tortillon as you go. Finally, take time to study the eye and nostrils, paying close attention to how the light and dark areas make these areas appear realistic.

Andalusian/Lusitano

The Andalusian/Lusitano horse is one of the oldest breeds in the world, having been depicted in cave paintings dating back 25,000 years. Originating from the Iberian Peninsula, which includes the modern-day countries of Andorra, Portugal, Spain, and Gibraltar, this horse was used in war and was greatly admired by the Greeks and Romans. Today's Andalusian and Lusitano horses are not only beautiful, but their natural ability and grace make them the ultimate riding horse.

This is a gray horse, so the values are much lighter except where bare skin is showing. Many gray horses have darker dappling over the rump and on the legs. Even though this horse will likely turn lighter with age, it has dark skin, which is apparent on the muzzle, around the eyes, and in the groin area. Use these values to your advantage by accentuating them to create contrast.

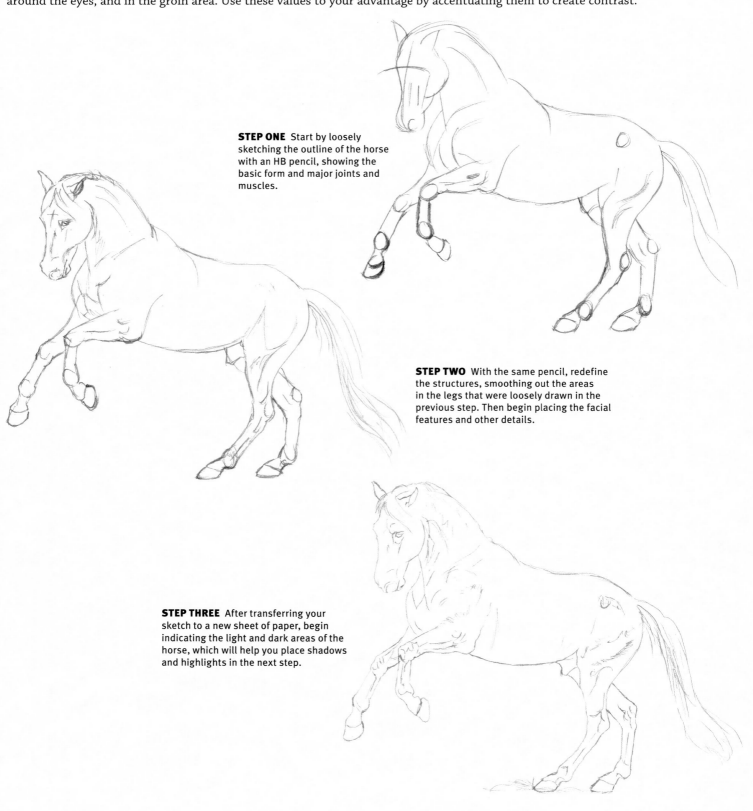

STEP ONE Start by loosely sketching the outline of the horse with an HB pencil, showing the basic form and major joints and muscles.

STEP TWO With the same pencil, redefine the structures, smoothing out the areas in the legs that were loosely drawn in the previous step. Then begin placing the facial features and other details.

STEP THREE After transferring your sketch to a new sheet of paper, begin indicating the light and dark areas of the horse, which will help you place shadows and highlights in the next step.

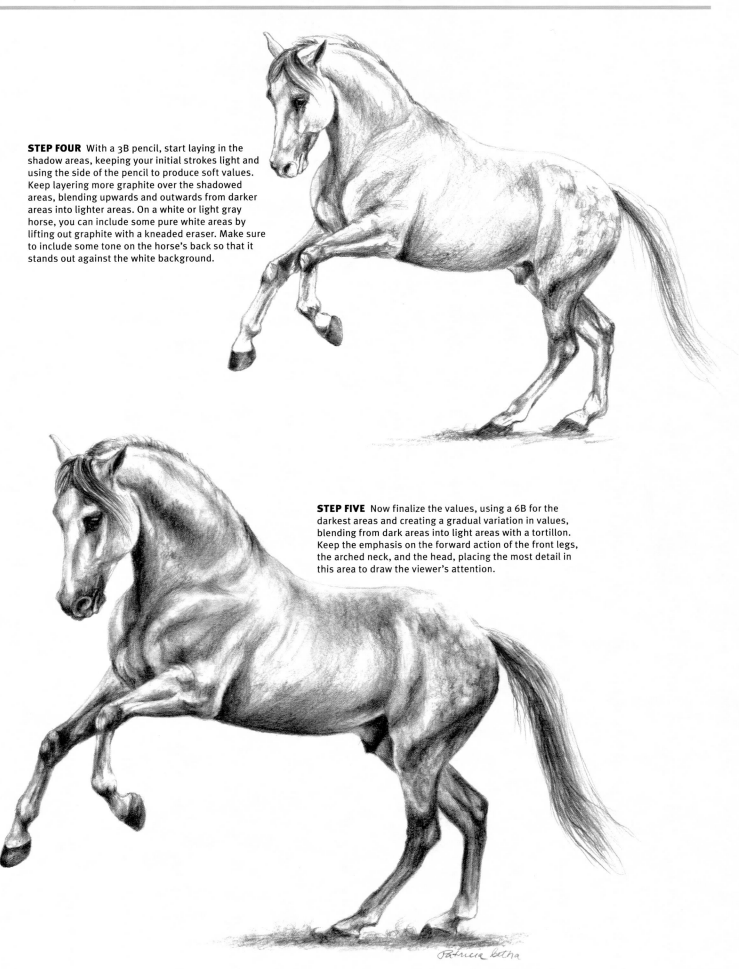

STEP FOUR With a 3B pencil, start laying in the shadow areas, keeping your initial strokes light and using the side of the pencil to produce soft values. Keep layering more graphite over the shadowed areas, blending upwards and outwards from darker areas into lighter areas. On a white or light gray horse, you can include some pure white areas by lifting out graphite with a kneaded eraser. Make sure to include some tone on the horse's back so that it stands out against the white background.

STEP FIVE Now finalize the values, using a 6B for the darkest areas and creating a gradual variation in values, blending from dark areas into light areas with a tortillon. Keep the emphasis on the forward action of the front legs, the arched neck, and the head, placing the most detail in this area to draw the viewer's attention.

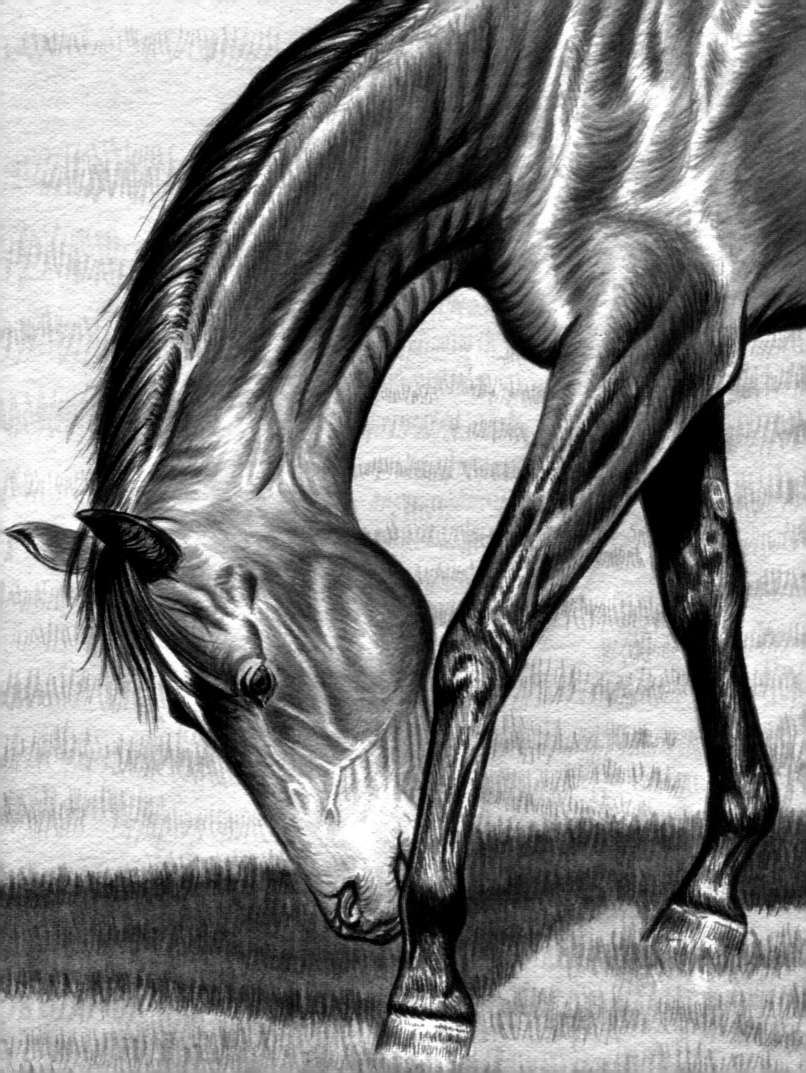

Horses in Watercolor

with Janet Griffin-Scott

Watercolor is a fascinating and dynamic medium. Because watercolor has a transparent quality that allows the white of the paper to shine through the paint, it is easy to capture the brilliant highlights on a horse's sleek body. In addition, you can build up layers of colors and values to depict the gorgeous variations in different breed coats. In the following lessons, you'll be guided step by step through the process of bringing horses to life in luminous watercolor. You'll progress from painting a simple profile to painting horses and riders in scenic pasture and farm settings. As you master a light-to-dark layering technique, you'll bring more realism and detail to your work. Horse enthusiasts looking for a new way to explore their passion will delight in this chapter on portraying these majestic animals in watercolor.

Watercolor Tools & Materials

A bit of reading before you hit the art supply store will give you a rough idea of what you'll need. At the store, don't hesitate to ask the clerks for help. Most of them are also artists, and their experience can save you time and money.

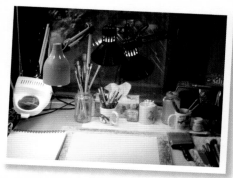

PAINTS

There are many schools of thought that suggest using only limited color palettes and mixing all other colors, but, because horses are brown, gray, and black, you should start with a larger palette. You are going to be mixing colors a lot, and it will save time if you already have the colors you need. It is always better to have really good quality paint, the best you can afford. The less expensive student brands are fine for beginners.

In the 11 projects in this chapter, you will use the following 16 colors in either watercolor or gouache, a more opaque paint that is also a water-based medium. You can choose to use both types in your paintings, but you only need one.

alizarin crimson	cerulean blue	titanium white
bright green	Hooker's green	ultramarine blue
burnt sienna	lamp black	viridian green
burnt umber	magenta	yellow ochre
cadmium red	Payne's gray	
cadmium yellow	raw umber	

PAINTBRUSHES

While it is ideal to purchase the best paint you can afford, sometimes you can save on paintbrushes. An art store's generic brands that are synthetic and much less expensive than brushes with natural hair usually work just as well. Synthetic brushes hold a point nicely, and when they do wear out, they are still useful for applying masking fluid. They are also cheap to replace.

As with all artists, you will likely go through some trial and error figuring out what works and what doesn't work for you. Artists should keep an open mind and try brushes that might not even look like the right tools for the job. For instance, Chinese calligraphy brushes work really well for washes and flat areas of color, but they are not intended for this purpose.

Art supply stores always have a watercolor brush kit for beginners and these inexpensive kits are a great way to try out a lot of different brushes. For the projects in this chapter, you will use smaller round-tip brushes (sizes 0, 1, 2, and 3) for details, such as a rider's face. Larger round-tip brushes (sizes 6 and 7) are crucial for large washes of color. Again, experimenting with various shapes and brush sizes will help you determine what works best for you.

PALETTE

Palettes come in different materials (plastic, glass, china, or metal) and in varied shapes (round, oval, rectangular, and square). Plastic is lightweight and less expensive than porcelain, but be sure to get a heavier plastic that will last longer. You'll want enough smaller wells to hold the colors you are going to use the most. For paintings with large areas of color, your palette will also need mixing areas big enough to hold large amounts of paint. It's even possible to use a white dinner plate for mixing colors.

WATERCOLOR PAPER

You can choose from *hot-press* paper, that has a smooth texture, or *cold-press* paper, which has a medium texture. Watercolor paper also comes in different weights, designated in pounds. The higher the number, the heavier the paper. The 140-lb paper is popular and suitable for beginners, but a heavier paper is less likely to warp.

OTHER MATERIALS

In addition to the painting tools on page 46, you'll also need the following:

Plenty of Light

Try to paint in an area that offers a lot of natural light. You can also choose from a variety of fluorescent and incandescent lighting options.

Jars of Water

Between color applications, rinse your brushes in water. To avoid damaging the bristles, don't let them stand in the water for too long.

Pencils and Erasers

Use a 2B pencil for initial sketches; the lead is not too soft and is very easy to erase. Keep a few kneaded erasers handy, as they are invaluable for removing masking fluid and pencil lines without leaving crumbs.

Tissues, Cotton Swabs, and Blotting Paper

Before you put a brush to the surface you're working on, first blot it on a spare piece of paper, such as the backside of scratch printer paper. This gets the paint flowing evenly so big gobs of water don't drip on the painting. Tissues are also great for blotting, and cotton swabs work well for cleaning and lifting out color in small areas.

Masking Fluid

Using masking fluid helps protect the areas of your paintings that will use lighter color or show the white highlight of the paper. Apply masking fluid on top of your pencil sketch using an old brush. You'll need to wash the brush with soap and water to remove the rubbery residue. Once the painting is finished or nearly finished, you can remove the masking fluid by carefully rubbing with a kneaded eraser, cotton swab, or clean finger. You can also use *paper frisket*, a clear adhesive you cut with scissors or a utility knife and adhere to your painting surface.

PREPARING THE PAPER

It is best to stretch your paper the old fashioned way, although pre-stretched watercolor paper is available in stores. To stretch your paper, you'll need a piece of plywood, a light duty staple gun, and a pair of beveled pliers. You may also want to use a lamp (not fluorescent) or hair dryer to speed the drying process.

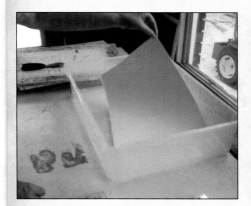

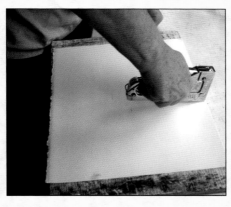

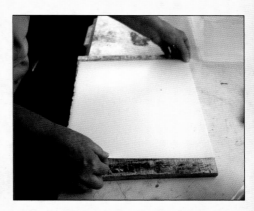

STEP ONE Begin by soaking the paper in tepid water in a large tray for about 10 minutes. To remove the paper, grab it by one corner and hold it up to let the excess water drain.

STEP TWO Place the paper on the plywood and blot with paper towels. Gently pull the paper diagonally across the long sides and place two staples near the center on the outer edge of each short side.

STEP THREE Grab one corner and pull diagonally. Hold the paper in place and put one staple on each side of the corner. Repeat for the other three corners.

STEP FOUR Continue stapling along the outer edges until you've placed about eight staples per 14-inch side.

STEP FIVE Gently blot more water out of the paper and place it somewhere to dry for about 24 hours before you begin painting. Once your finished painting is dry, gently remove the staples with your pliers. Trim off the stapled edges with a paper cutter.

Introduction to Equine Photography

No matter how familiar you are with horses, the importance of working from photos cannot be overstated. Photos provide a stationary reference of the needed details, from a horse's anatomy, coloring, and tack to a rider's expression, pose, and apparel. If you're not a horse owner, don't worry. Horses are everywhere! Take a look around and take some photos at a summer fair, a rodeo, a horse show, or even in crowded city streets, where you might find a horse-drawn carriage or a mounted police officer. Digital photography allows you to take a large number of photos at once, so you have plenty of choices when later selecting an image to paint. I'll easily take 100 to 150 shots when photographing a horse I plan to paint. Here are several examples from a photo shoot for my painting titled "Portrait of Terra and Marian."

ICON GUIDE

This photo would make a good painting.

This photo would not make a good painting.

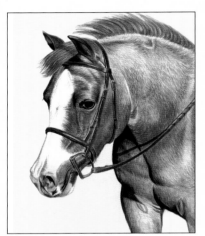

I removed the distracting background, shadow, and the visible parts of the rider and saddle for the painting.

This photo is from too low a vantage point.

> ✦ T I P ✦
>
> *If you find a photo on the Internet that you want to paint, obtain permission from the photographer before using it as a reference.*

When taking photos, try different angles and heights. Ask the owner to step into the photo and pose with or ride the horse at varying gaits. Think about composition and lighting. Can you clearly see the correct coloring of the horse? Are shadows obstructing any details? The primary purpose of the photo is to capture a good likeness of the horse and rider. You can always change the background for your painting, as I did in these two examples. Remember, memorable photos make memorable paintings!

For a head and neck photo, full profiles are not as attractive as three-quarter profiles. If you were going to paint this background, notice that a tree seems to sprout from the horse's neck.

This shot is too head-on, and you are getting too many dark shadows on the neck.

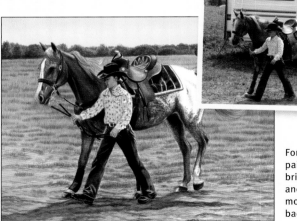

For the painting, I used brighter tones and added a more serene background.

This is an attractive three-quarter profile. Her ears are up, she has a nice expression, and the sun is reflecting off her bright, shiny coat.

Photo Composites

Computer composites are a fast, easy, and accurate way to make a nearly perfect photo reference even better. I use photo editing software, such as Photoshop®, to combine elements from various photos, add a more appealing background, or even to mix and match different parts of the horse from different images. For my painting titled *Autumn Splendor*, I took several photos of my Arabian horse Copper as he frolicked in his paddock. Since I didn't capture the perfect photo that I wanted to paint, I created one on the computer from the two photos below.

SELECTING PHOTOS FOR A COMPOSITE

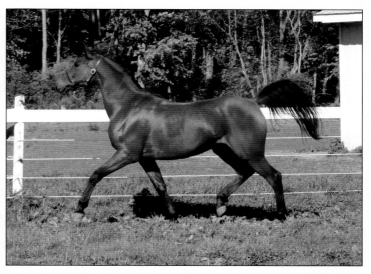

In this photo, I love the expression on Copper's face and the way tendrils from his mane fly up and over the crest of his neck. I also love the look of his tail and the reflections on the black hair. The beautiful autumn colors create a perfect background. What I don't love is the position of his legs. It is always more flattering when the front leg in the foreground is extended.

This second photo gives me the leg extension I am looking for, but I do not like that his head is slightly tilted away from the camera. In this instance, I decide to paste the bottom half of Copper from this photo onto the first photo above.

CREATING THE COMPOSITE

Now that I've selected the two photos I want to use, it's time to merge them. I open them both in Photoshop. In the second image, I roughly outline the bottom half of Copper that I want to transfer using the lasso tool. I copy this selected area and move over to the first photo, where I paste it in as a new layer. This first photo now has two layers, one with the main image and one with the bottom half of Copper.

> **→ TIP ←**
> *When you're creating a photo composite or simply selecting a reference photo, don't worry too much about the background. You can always change or eliminate it for your painting.*

On the main layer, I dial down the opacity to about 50 percent so I can clearly distinguish the layers from one another. Moving back to the second layer, I use the scale tool to adjust the size of Copper's bottom half to match the top. Then I align the two layers. You can erase any parts of the secondary layer that you won't need so that more detail shows through on the main layer. Once you increase the opacity on the original layer back to 100 percent, you can flatten the image and save it as a new file.

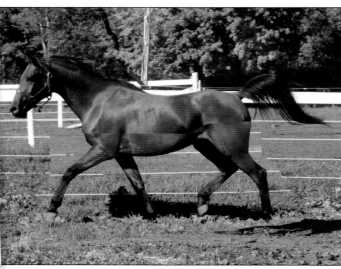

Itchy Foot

The natural, shiny coat of Sienna Noble Lady comes through beautifully in this painting. Sienna Noble Lady is also featured in the First Born project that begins on page 54. This zoomed-in portrait of Sienna Noble Lady at two years of age shows the detail of her anatomy. Here, she scratches her fetlock with a partially opened mouth. Horses scratch this way, as they do not have hands to reach for an itchy spot.

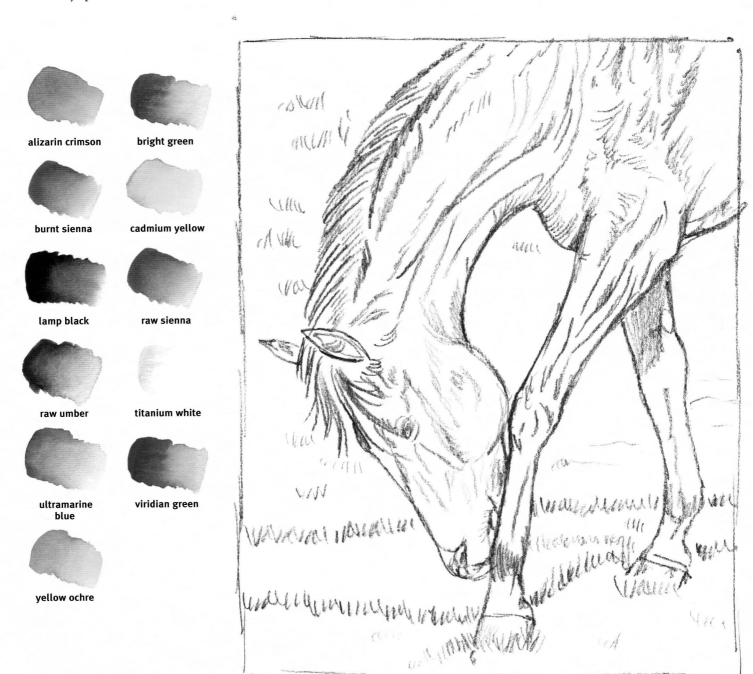

alizarin crimson

bright green

burnt sienna

cadmium yellow

lamp black

raw sienna

raw umber

titanium white

ultramarine blue

viridian green

yellow ochre

STEP ONE In this pencil sketch, develop very basic guidelines to show where the various muscles, tendons, and hair appear. The curves that form her neck are almost parallel but narrow at the base of her throat. Add guidelines for the bright highlights, so you know not to paint over these areas.

► **STEP TWO** Begin roughing in light layers of yellow ochre. Once this dries, lightly add burnt sienna on her jowl and areas of her face. To define the ridge of muscles in her neck and leg, use long strokes of raw sienna. Then add smaller strokes of burnt sienna that radiate outwards from the defining stroke. Paint in very light areas of her mane, one long hair at a time, with lamp black. As her mane gradually darkens, these first layers will add dimension. As a bay-colored horse, her legs gradually change from a reddish color to black. Carefully place black strokes extending above the knee and surround it with diluted burnt sienna.

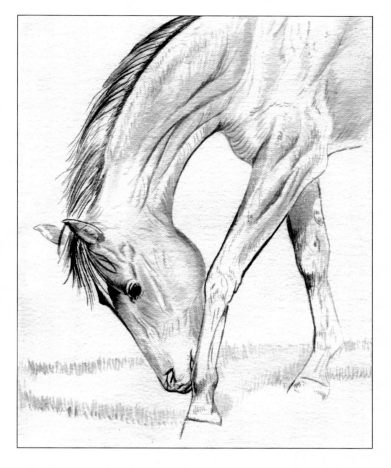

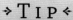

→ T I P ←

It is safer to leave the white highlight areas a bit larger than you might need them to be and gradually make them smaller. You can always darken them later with a diluted wash.

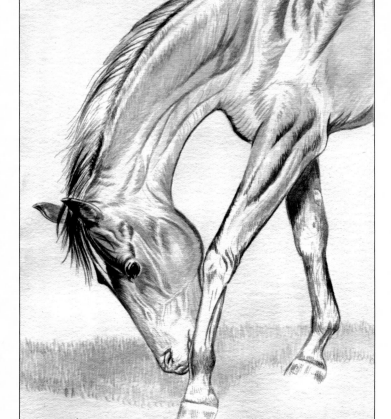

◄ **STEP THREE** Begin to darken every element except for the white areas by building layers. In areas of intense shadow on her face, use a mixture of alizarin crimson and ultramarine blue. To vary the bright highlights on the mane and legs, mix lamp black with more water for lighter values. Then build layers with less and less water to darken the color. The shadow on her leg in the background is almost pure black. In the foreground, the bright sun clearly defines her leg muscles, which you can now darken with raw umber. Make strokes of burnt sienna that radiate outward to create dark shadows. Then lightly outline her wrinkled muzzle and her partially opened mouth in diluted lamp black. Build the grass in layers of bright green gouache and add a touch of ultramarine blue to the shadow.

→ T I P ←

Instead of using bright green gouache for the grass, you can mix cadmium yellow and Hooker's green watercolor paints.

STEP FOUR Darken the shadow on her belly with a mix of lamp black and raw umber. Later add pure lamp black on top of that. Her hooves reflect the bright light, so give them definition with small vertical strokes in yellow ochre and lamp black. Darken the legs with extra layers of lamp black in strokes small enough to leave areas of paper showing for pristine highlights. Add her small eyelashes in thin white strokes. In the areas of her coat that are getting too red, add a wash of cadmium yellow. The chestnut, a small oval-shaped, callous-like area, on the leg in the background is visible above her knee, so add a bit of detail with a few small strokes of lamp black. Layer in more bright green for the grass and viridian green for the shadow. Build darker patches in the grass that will eventually show texture.

DETAIL ONE Patiently add small strokes to suggest various hair textures with gradually increasing amounts of burnt sienna and less and less water to make the paint more intense as the layers build. Vary the strokes in both length and direction as you follow the patterns of hair growth.

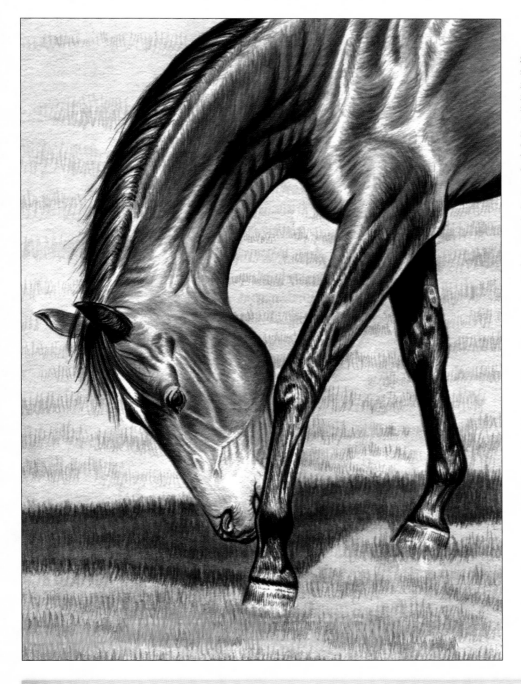

STEP FIVE Being careful not to muddy or over saturate the colors, add the final layers. Finish the grass by adding brushstrokes of diluted viridian green. Create strokes in an upward direction, similar to the way the grass grows, and do not make them all parallel. Create the shadow in the grass with light washes of viridian green, being careful to use light pressure so you don't disturb the multitude of layers below. Darken the shadow on the background leg with more layers of lamp black and repeat for the fetlock on the foreground leg. This intense black comprises six to 10 layers altogether. Use raw umber to define the darkest areas of her jowl while leaving her muzzle very light. Darken the inside of her ears with more layers of lamp black. Leave the light areas untouched at this end stage. The actual white of the paper shines though in contrast to the heavily layered areas.

DETAIL TWO Use diluted lamp black for the wrinkles and contours of the lips, mouth, and nostril. Add a small dab of diluted alizarin crimson in her mouth to suggest her tongue. Leave her main muzzle area fairly light as the highlight there is substantial. To finish, outline the main lines of her mouth and nostril with lamp black that's nearly dry.

DETAIL THREE On her neck, use strokes of alizarin crimson mixed with ultramarine blue for an intense purple. Radiate these strokes upwards from the dark neck strokes and stop just before the white highlight at the top of her neck.

First Born

This portrait of Cinnamon Lady and her foal, Sienna Noble Lady, allows you to see the differences between an adult horse and a young foal's features. Notice the mare's long, silky mane and forelock compared to her foal's short, sparser mane. In this project you will also contrast Sienna Noble Lady's fuzzy coat, sticking up in tufts around her neck, against her mother's smoother coat.

burnt sienna **burnt umber** **cadmium red** **cadmium yellow** **lamp black**

Payne's gray **raw umber** **titanium white** **ultramarine blue** **yellow ochre**

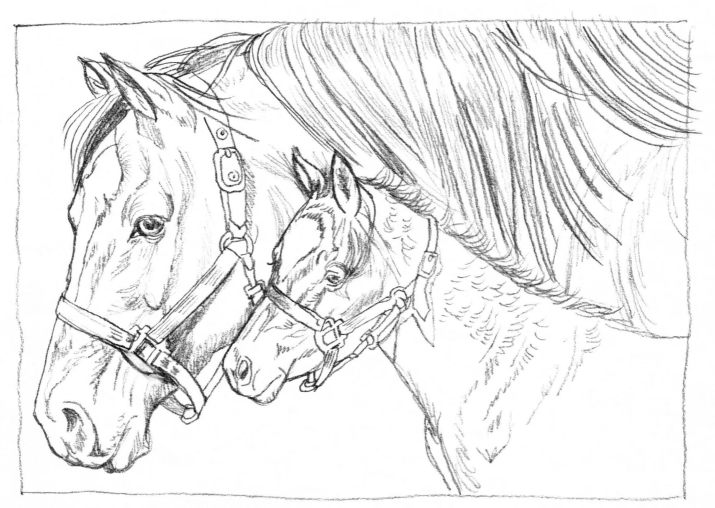

STEP ONE Outline the heads and halters of the mare and foal. Sketch in the main areas of the mare's mane and leave light areas for the highlight. The foal has a fuzzy coat, so add a few small strokes on her neck. Then transfer your initial sketch to a clean sheet of watercolor paper.

⇥ TIP ⇤

The light source is coming from the far left, which means the shadows develop on the lower sides of the halters and the underside of their jaws.

STEP TWO Their red bay coats are shining brightly with strong highlights, so leave the highlights unpainted. Lay down light washes of yellow ochre for the coats. Then add strokes of almost pure burnt sienna on top of the washes once they are dry. Gradually darken the facial bones with additional strokes of pure burnt sienna on top of the earlier strokes. Use crosshatching on some of the lines on the cheekbones. Lightly rough in the halters with ultramarine blue and suggest the nylon webbing with darkened lines of Payne's gray. Use diluted lamp black for the manes and leave a large white area in the long mane of the mare. Develop the eyes in this early stage because they are very important to their expressions.

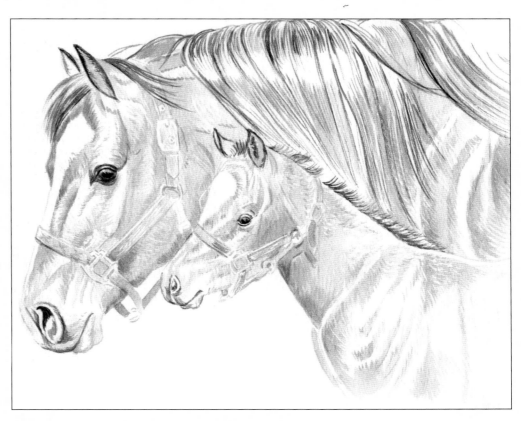

⇥ T I P ⇤
Always keep cotton swabs on hand to blot colors that go on too intensely.

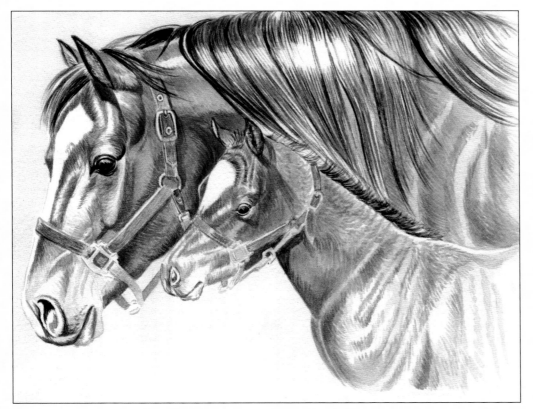

STEP THREE Using lamp black darken the mare's mane in long strokes. Let each layer dry before adding the next and leave white highlights throughout. The filly is not yet old enough for a thick mane and forelock, so use light, short strokes of lamp black. Follow the direction of hair growth on their necks and shoulders with burnt sienna mixed with yellow ochre. Create light strokes with an upward curve to suggest the filly's fuzzy coat. Build up the halters with ultramarine blue plus layers of cadmium yellow and yellow ochre for the brass hardware and fittings. Add washes of Payne's gray in the mare's mane to separate out the sections. Develop the muzzles with layers of Payne's gray and lamp black. Add yellow ochre higher up where the muzzles meet the coats. Suggest small details on the mare's muzzle by outlining the structures and placing a tiny shadow of raw umber on the underside.

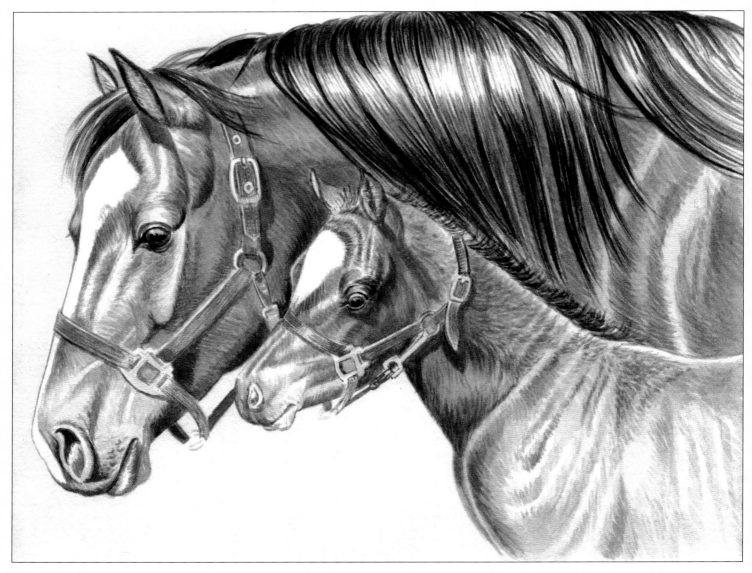

STEP FOUR Add the first wash of yellow ochre with lots of water to the background, but it will hardly show until two or three more layers are later added. Allow each wash to dry thoroughly before adding the next. Add shadows of burnt umber on the mare's jaw and under the halter, as well as on the filly's shoulder area. Continue with burnt sienna and burnt umber strokes on the necks and gradually darken the black strokes of the manes. The mare has a large white blaze that goes all the way down her face, so allow the pure white paper to show through. Put small strokes of diluted burnt sienna on the outer edge of this white marking so it doesn't blend into the background.

DETAIL ONE Add a bit of watered down cadmium red to the mare's nose to suggest the curves and shapes on her muzzle. Then add small lumps above her lip where the whiskers grow. Lightly paint the shadows of these lumps in Payne's gray and darken the nostril shadows until they are almost black.

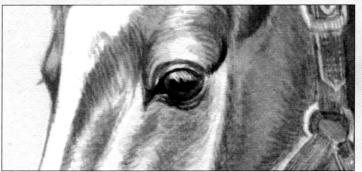

DETAIL TWO Darken the pupils of the eyes with lamp black and further fill in the eyelashes with white. Horses' eyelashes are actually black, but they reflect a lot of light. They sometimes appear very light in the bright sun, so you can put them in with white.

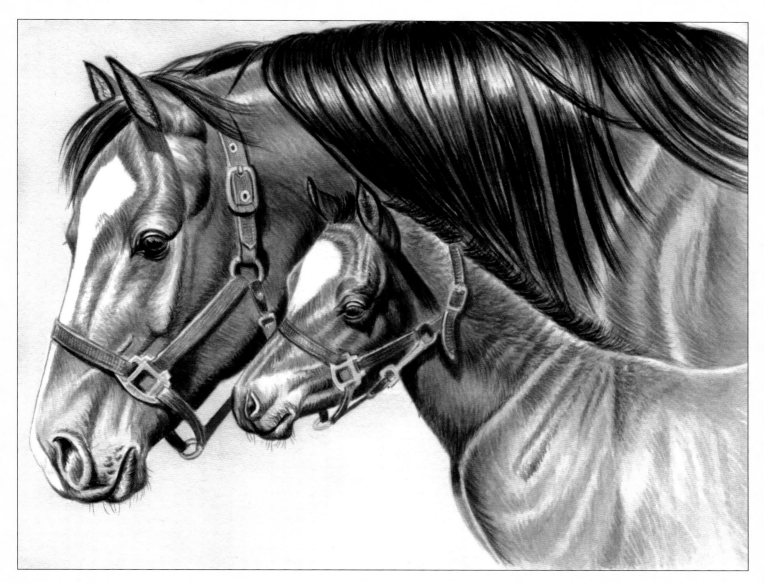

STEP FIVE It's time to darken the colors and add the finishing details. Add about four light washes of diluted yellow ochre and burnt sienna to the background. Let each layer dry thoroughly before adding the next. Add more layers of yellow ochre and cadmium yellow with Payne's gray to darken the details on the halter hardware and buckles. Add small white brushstrokes to the filly's fuzzy mane that curls out of her neck. On the mare's mane, stroke tiny black lines on top of the bright highlight. Add tiny whiskers, one hair at a time, in heavily diluted Payne's gray (almost 95 percent water) to both muzzles. Radiate the small strokes outward from the chin in a tapering motion. Then add light strokes of burnt sienna for the hair in their ears. Finish the mare's eye with a small white highlight and small strokes of lamp black on top of the white eyelashes. Finally, use heavy strokes of raw umber to finish the darkest shadows.

⤞ T I P ⤝

The key to getting flat washes is patience. Constantly move the paint around until it is uniform. If color pools even for half a minute, it stains the surface and cannot be removed.

GETTING TO KNOW THE HORSES

The horses in this painting are very special. The mare, Cinnamon Lady, was a wonderful show hunter in her early years. She is a Quarter Horse, and her father was a World Champion in 1995. She's been featured in a multitude of licensed products as well as in an episode of an Ontario children's television show. The filly, Sienna Noble Lady, is an appendix Quarter Horse. Her father was Noble Lord, a thoroughbred with racing bloodlines. Beyond their breeding, however, these horses are beloved for their kind, gentle temperaments.

Autumn Splendor

I t's time to paint Copper, an Arabian gelding. He was photographed in the fall as he frolicked in his paddock after coming home from a 25-mile competitive trail ride. He was 12 years old at the time. You can clearly see the beauty of the Arabian breed in this photo and painting. The arched neck, slightly dished face, high-set tail, and short back are typical of the breed.

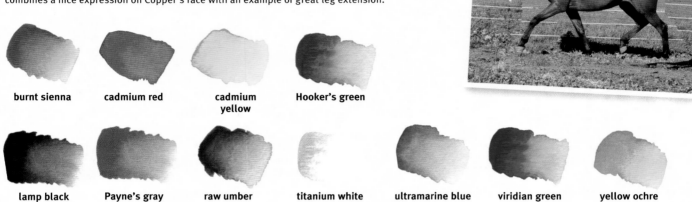

▶ **CREATING PHOTO COMPOSITES** This is a photo composite created in Photoshop® that combines a nice expression on Copper's face with an example of great leg extension.

burnt sienna **cadmium red** **cadmium yellow** **Hooker's green**

lamp black **Payne's gray** **raw umber** **titanium white** **ultramarine blue** **viridian green** **yellow ochre**

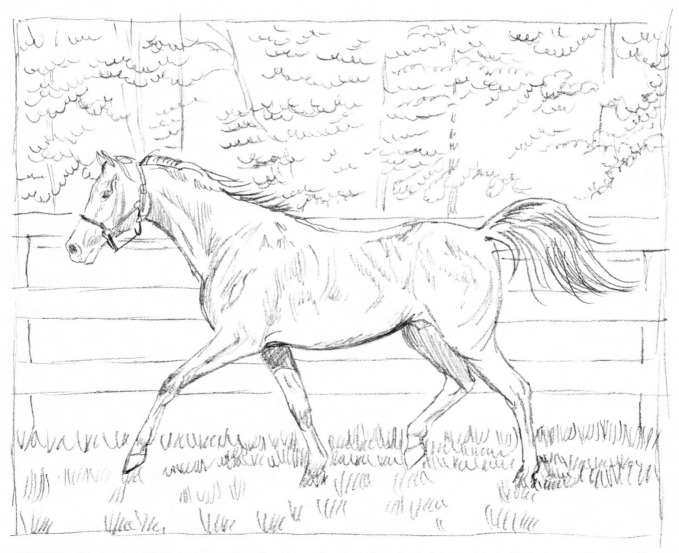

STEP ONE In this stage, modify the background from the photo to simplify the fence line and change the wire fencing into wood boards. Adding the background features to your sketches helps you understand how the horse is placed within the environment. Suggest the highlights in Copper's coat so you know where to let the paper show through in the painting. Also add the shadows on his background legs.

STEP TWO Begin with a 75-25 ratio of paint to water. Rough in the lightest values of his coat using cadmium yellow, burnt sienna, and raw umber. Leave highlights of blank paper amid the dark strokes of lamp black for his mane and tail. Continue with raw umber to define his muzzle and halter and lamp black for his nostril. Outline the tree trunks lightly in Payne's gray. Develop the colorful foliage with Hooker's green and a 50-50 mix of cadmium red and cadmium yellow. Then use more layers of these colors in the darker foliage. Lightly add the grass with Hooker's green, and mix Payne's gray with ultramarine blue for Copper's shadow. Outline the fence with Hooker's green, leaving the white of the paper to shape the boards.

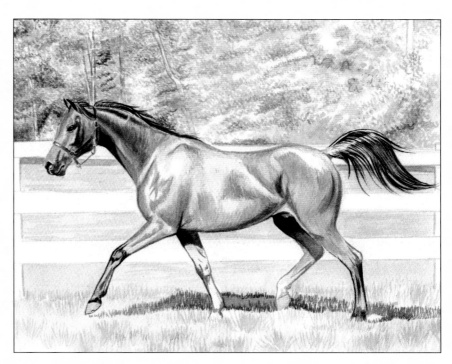

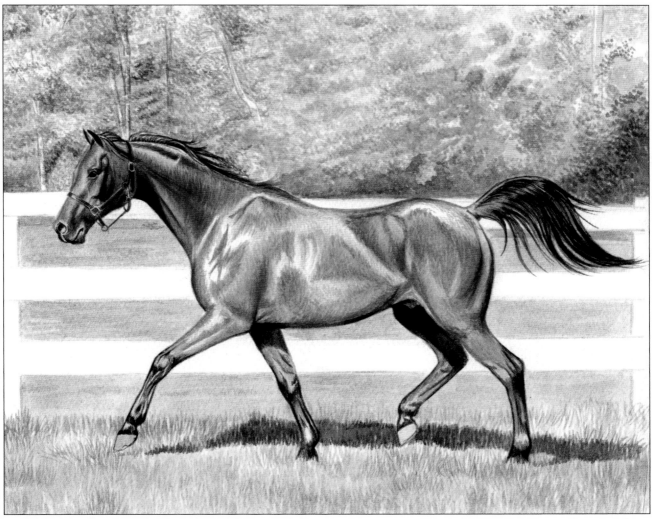

STEP THREE Continue darkening Copper's coat with burnt sienna. Use raw umber to develop his muscles, the shadows in his coat, and his halter. Then darken the lower half of his legs with lamp black and build additional layers in the darkest spots. For the shorter grass, use horizontal strokes of yellow ochre, Hooker's green, and ultramarine blue. Continue with Hooker's green to define the blades of grass in the foreground. Then build on previous layers of foliage with small dot-shaped strokes for the leaves.

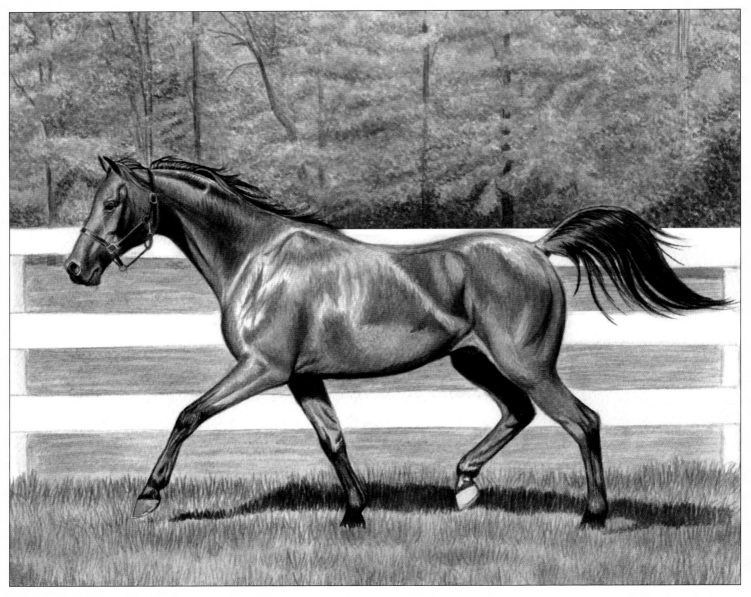

STEP FOUR Further define Copper's darkest areas with more and more layers of burnt sienna. Add individual mane and tail hairs in lamp black and carefully maintain the highlight areas. His two raised hooves show his toe clips and shoes, so add those with diluted Payne's gray. Use a touch of titanium white in a 50-50 ratio of paint and water to lighten the area over his knees and fetlocks, suggesting the round joints. Then continue adding tufts of grass in the foreground with single strokes of fairly diluted Hooker's green. Use upward brushstrokes to mimic the direction of growth.

DETAIL ONE Use small dots to fill in the layers of foliage and build up more intensity in the Hooker's green and the mix of cadmium yellow and cadmium red. Introduce a mix of Hooker's green and cadmium yellow to suggest the depth of the forest. Then darken the trunks of the trees and add smaller branches with heavily diluted lamp black.

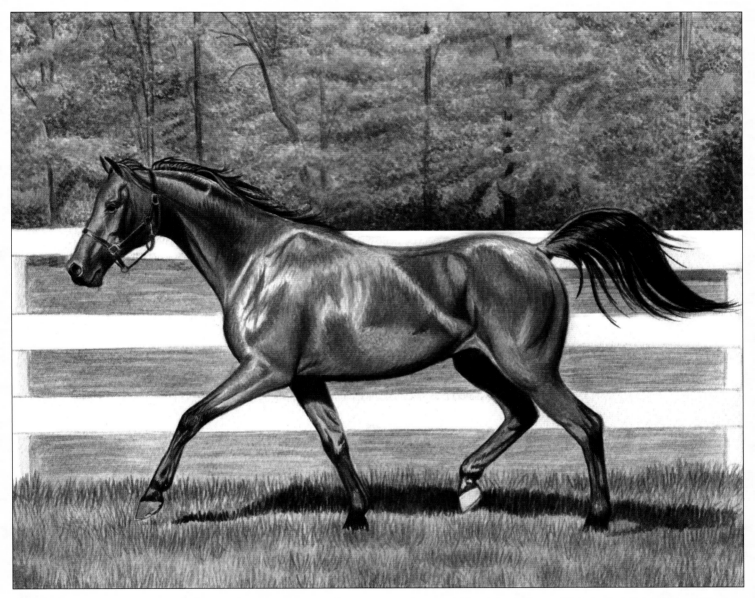

STEP FIVE Continue to darken Copper's body with additional strokes of burnt sienna. Using a wash of cadmium yellow and cadmium red, finish the coat. Then build more layers of lamp black as needed to darken his legs. Define his shadow with diluted ultramarine blue using upward brushstrokes to depict the grass where the shadow falls. With titanium white, add highlights to the tail, mane, and hardware on the halter. Add more clumps of grass in the foreground with Hooker's green and use long horizontal strokes of viridian green to add depth to the background grass. Darken some of the tree trunks with Payne's gray and leave some lighter to suggest overlap. Carrying through colors from the previous steps, intensify the fall foliage. Finally, add titanium white over the boards of the fence with slight shadows in diluted ultramarine blue where the boards meet the posts.

DETAIL TWO The legs of every bay-colored horse gradually transition from a reddish color on the upper legs to black on the lower legs. Always study your photo references to know when and how to transition between the two colors. On Copper's front, extended leg, notice how the black spreads above his knee. Use small strokes that feather toward each edge to gradually bring the lamp black into the red. The color transition appears gradual instead of abrupt. Surprisingly, sometimes in the winter, these black points fade to reddish brown due to normal, seasonal color changes.

Pasture Pals

These two Thoroughbred foals are socializing at the fence, so you have a chance to practice painting wood grains in addition to the contours and shapes of the foals' heads. It is rewarding to pay special attention to the surroundings and habitat of the horses that you paint.

❖ T I P ❖

The colors in this painting are very pure. Use each one right out of the tube or jar with very little mixing with other colors.

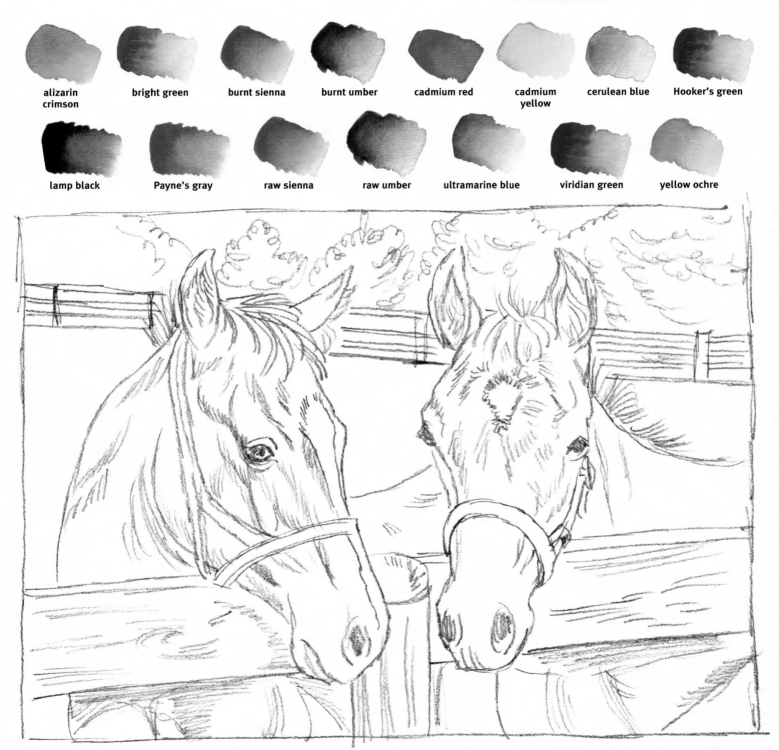

| alizarin crimson | bright green | burnt sienna | burnt umber | cadmium red | cadmium yellow | cerulean blue | Hooker's green |

| lamp black | Payne's gray | raw sienna | raw umber | ultramarine blue | viridian green | yellow ochre |

STEP ONE Creating a pencil drawing helps you identify the intention of your painting. In this case, it's the interaction between these two herd mates. The drawing also gives you a chance to figure out the shapes of the trees and how they relate to the horses.

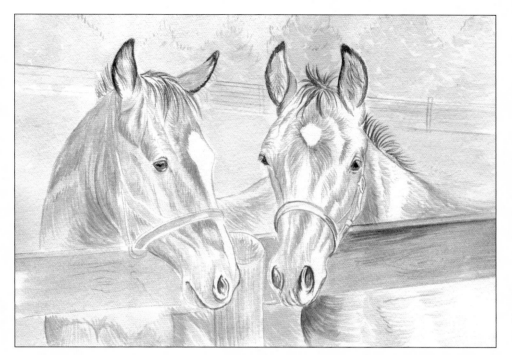

STEP TWO Start with washes of yellow ochre and then burnt sienna for the foals' coats. Use raw umber for the halters and leave the nosebands unpainted. Then add a heavy stroke of burnt sienna for the eyes with lashes in Payne's gray. Use diluted lamp black for the manes, forelocks, outer ears, and nostrils. Color the grass and sky with single washes of bright green and cerulean blue. Rough in the trees with Hooker's green and lightly paint the background fence in heavily diluted Payne's gray. The foreground fence shows knots, cut marks, and the top edge of the plank, so develop color and texture with less diluted Payne's gray.

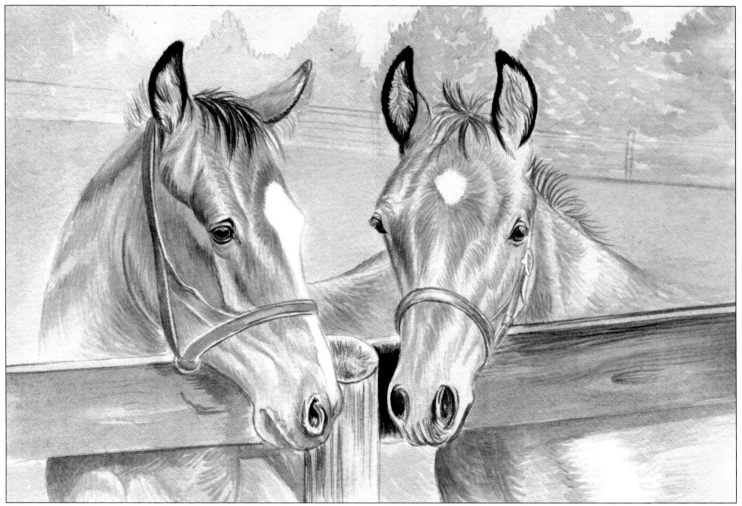

STEP THREE Further develop the horses' coats with layers of cadmium yellow, cadmium red, and burnt sienna. Suggest areas of shadow by building more layers of burnt sienna. Then darken the areas of lamp black and continue darkening the halters with raw umber while maintaining the highlight on the nosebands. Leave the background fence untouched in this step. Add a small amount of detail to the trees, again using Hooker's green topped with a single layer of viridian green to suggest individual branches. Add one additional wash of bright green for the grass and cerulean blue for the sky. In small, increasing strokes of diluted lamp black, depict the grain of the wood in the foreground fence with darker areas for the shadows.

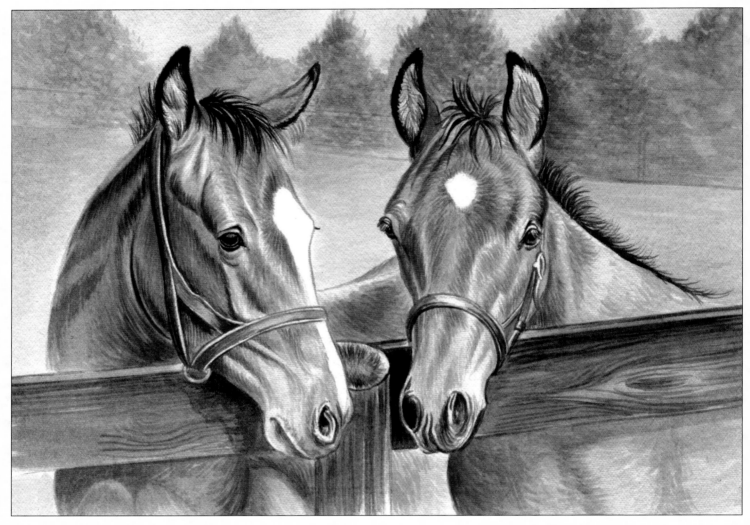

STEP FOUR Gradually darken each element with increasing layers of color. The background fence is the exception as it disappears into the trees for now. Introduce raw sienna to define the chest muscles, and use shadows of raw umber under the fence line to add depth. Use burnt umber to define the neck crease of the foal on the left and the bone structure and eye sockets in the face. Add alizarin crimson to their faces to bring out the redness of their coats. Develop the details of the halters with diluted layers of raw sienna, gradually moving toward the center highlight. The foal on the right looks too big and bulky. This is probably due to the camera angle in the photo. Make his mane heavier so that his neck appears thinner. Continue darkening the grass with horizontal strokes of Hooker's green. In the tree line, add viridian green and ultramarine blue separately for depth. Add more detail to the grain of the wood fence with individual strokes of lamp black. For the shadows on the fence, first add raw umber and then Payne's gray.

DETAIL ONE Being able to develop realistic looking wood grain is important when your subjects are horses. Everywhere horses are, there is wood: barns, stall doors, and, of course, fences. Use your photo reference as a guide and experiment with different shades. For white fences, leave lots of paper showing through and add the grain in light washes of diluted gray and black. You can soften and add warmth to grays and blacks by adding raw umber, or you can cool them down by adding ultramarine blue. In this project, the four-board oak fence is painted black, but you can still see the detail of the grain. It's important not to let the fence get too dark and flat looking. Start with the diluted Payne's gray from Step Two and gradually build up to lamp black using less and less water. There are a multitude of shades of gray and black on this fence. Patiently add one smooth stroke at a time to depict the texture of the grain, and you'll bring realism to your equine art.

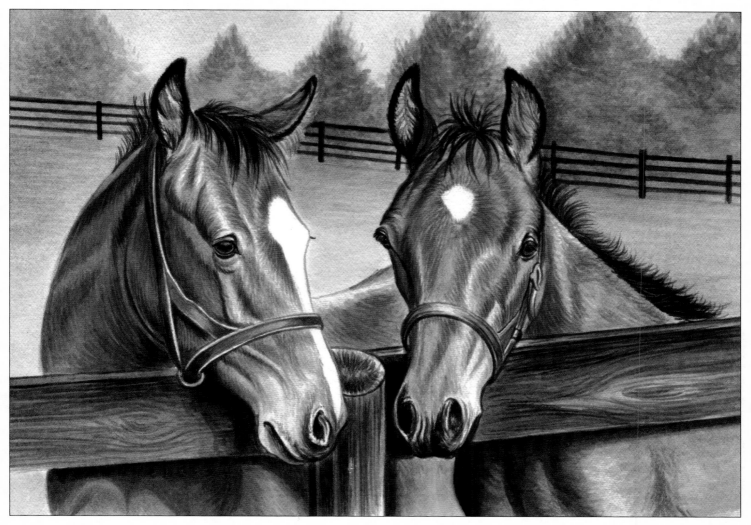

STEP FIVE Finish the painting by adding burnt sienna, burnt umber, and raw umber in separate layers to the neck and chest areas. This adds muscle and shape definition. Darken the manes with heavy strokes of lamp black and continue to thicken the mane of the foal on the right. Finish the halters with washes of burnt umber, using darker strokes at the edges to suggest stitching. Add several strokes of lamp black to the edges of the foreground fence and darken the shadow to the left of the post, also with lamp black. This is one case where pure black shadows fit the image. Add more layers and strokes of viridian green and ultramarine blue to the trees. Then wait for the trees to dry completely before adding the background fence back in with heavy strokes of lamp black that's mostly dry. Finally, complete the painting with washes in the sky and grass.

DETAIL TWO It's important to differentiate the foals' dark muzzle areas from the even darker tones of the fence. Outline both muzzles and nostrils with lamp black, which you should also use on the interiors of the nostrils. Apply long narrow strokes of Payne's gray finished with lamp black to the fence post. Make the shadow to the right of the post almost pure lamp black. Make sure the nostril of the foal on the right stands out from this dark shadow by leaving a lighter area down the outside edge of the nostril. It is also important to correctly portray the anatomy of the mouth and muzzle. For instance, the outline of the lips is never a straight line. Use small uneven strokes of diluted Payne's gray, and extend the color in small strokes to create a bit of texture on the upper lip. Noticing these details as you're studying the horse or your photographs is crucial to capturing a good likeness of the animal.

Future Promise

In this painting, Showdin is playfully enjoying his natural habitat. This is a scenic painting with a full background, and you have to be aware of the overwhelming presence of green in various hues, values, and intensities. Green is made up of a warm color (yellow) and a cool color (blue), so it is difficult to get it just right without being overpowering.

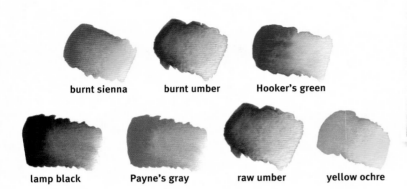

burnt sienna burnt umber Hooker's green

lamp black Payne's gray raw umber yellow ochre

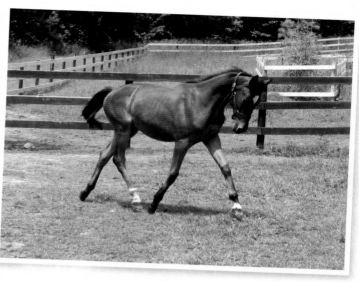

SIMPLIFYING A COMPOSITION Removing the white fence you see in this reference photo will create a simpler background for the painting.

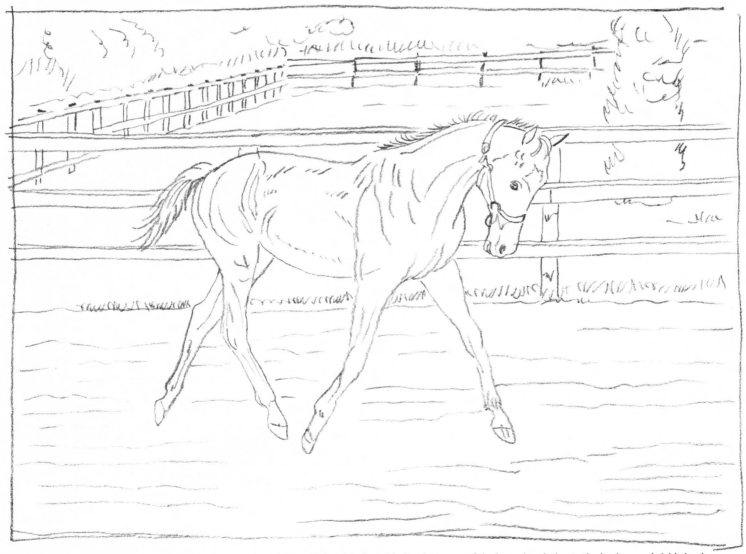

STEP ONE The fence line in this project is complicated, and a pencil sketch helps with the placement of the horse in relation to the background. Add simple lines to show the highlights on his shoulder, hip, and stifle area. The small lines on the ground show the transition between dirt and grass in the pasture.

STEP TWO Start by adding masking fluid in the background for the lighter areas of the tree line. You can also apply it on top of Showdin's facial marking if needed. Use burnt sienna for his coat and build up to about four layers for the darkest shadows in his musculature. Leave the white paper blank for areas of highlight in his coat. For the shadow on the inner thigh of his back leg, use raw umber. Color his mane, tail, and the black points on his legs with lamp black in a 50-50 ratio of paint to water. Add his halter with strokes of diluted burnt sienna. Then rough in the fence using Payne's gray and lamp black separately. Begin building layers of foliage and grass, and paint Showdin's shadow with Hooker's green. Use yellow ochre in varying intensities for a base color for the rest of the ground.

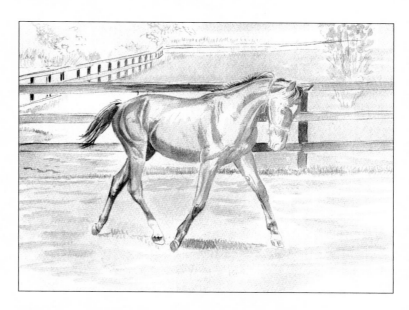

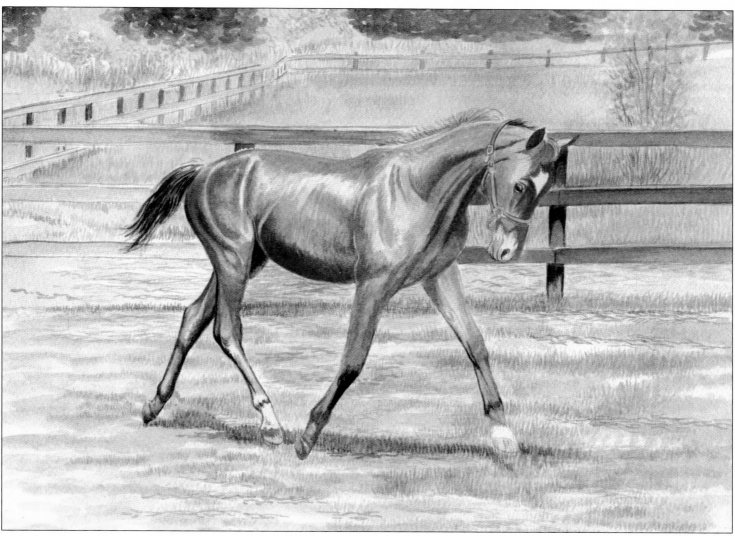

STEP THREE Add strokes of light yellow ochre to Showdin's body to unite the areas that are in dark shadow, but carefully leave the highlighted areas untouched. Use lamp black for the muscles and tendons in his legs as well as the definition on his hooves. His mane and forelock are getting too dark, so remove some of the black strokes using a damp cotton swab. Then paint his halter with very light strokes of raw umber. Darken his shadow in the grass with Hooker's green and use small strokes of raw umber and burnt sienna for the soil. Use dot-shaped strokes of heavy Hooker's green to quickly develop the darker areas of foliage in the background. Continue using this green to develop the grassy areas. Then mix Hooker's green with yellow ochre to add leaves one at a time to the background trees and the tree in the paddock. Outline the branches of this little tree with light strokes of raw umber. Finally, use light washes of lamp black to solidify the color of the fence.

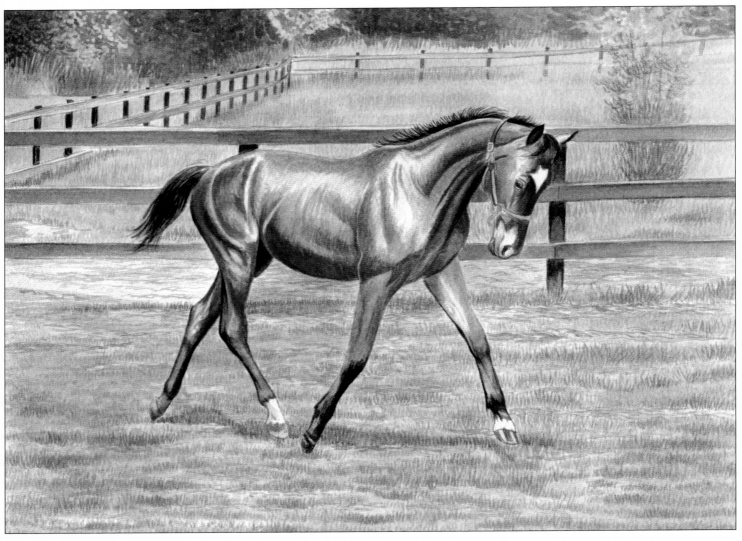

STEP FOUR Spend a lot of time in this step on the small vertical brushstrokes of Hooker's green that create the clumps of grass. It's a tedious process, so take frequent breaks to walk around and rest your eyes. Notice that the grass in the back paddock is longer. To keep things interesting, alternate between working on the horse and foliage. Develop more of Showdin's musculature by darkening the edges of his neck and rump with strokes of burnt umber. Continue darkening the trees in the background with dot-shaped strokes of Hooker's green. Use yellow ochre for the lighter foliage as well as a 50-50 mix of Hooker's green and yellow ochre. Then add dot-shaped strokes to the little tree in the paddock. The extra dots add definition and visually divide areas of branches. Tone down some of the background green with a 50-50 mix of Hooker's green and raw umber. Next develop the halter by adding raw umber to the edges, and put the dark mane back in with individual brushstrokes of lamp black. Add diluted Payne's gray to the muzzle and outline the nostril in lamp black. Darken the lines of the fence in diluted lamp black to make them easier to see amid all of the green.

DETAIL ONE Each of Showdin's hooves is different. On the legs with white markings, he has light-colored hooves. Build up layers of diluted yellow ochre for these, and add details and stripes in heavily diluted Payne's gray. The two legs without white markings have darker hooves. Paint these in layers of lamp black and use fewer layers to distinguish the coronet bands, which separate the legs and hooves. Notice the dark shadows on the right tips of the hooves. For these, build up layers of lamp black using less and less water for each layer until you're almost working with a dry brush. The green of the shadow below shouldn't overlap the hooves. This is easy to achieve by carefully taking the green right up to but not overlapping the hooves.

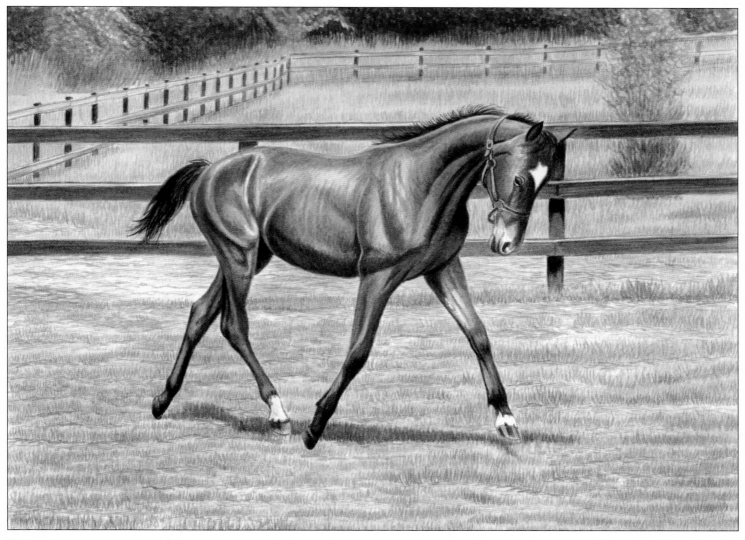

STEP FIVE Now it's time to remove the masking fluid with a cotton swab and kneaded eraser. You've painted over it, but it's easy to detect due to its raised surface. Once the masking fluid is gone and the white of the paper shows through, lay down light washes of Hooker's green to tone down the brightness. Add small strokes of diluted raw umber to the soil for depth. Add a few more strokes of Hooker's green with a nearly dry brush to balance the whole image and tie it together. Then add heavy strokes of lamp black to the fence. Continue building darker layers of burnt sienna in Showdin's coat, rib area, shoulder, and back hock joint. Soften his mane by slightly smudging the strokes with a damp cotton swab. To finish, darken the shadows on his neck and legs with raw umber and reduce the highlights on his hocks, knee, back, and rib area with light washes of burnt sienna.

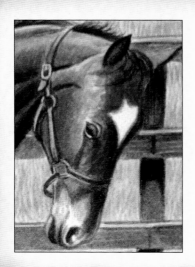

DETAIL TWO The finishing touches for Showdin's head and neck include strokes of raw umber for the halter and lower eyelid. Add one more layer of lamp black to define his nostril and a small stroke of Payne's gray to depict his lip. For his ears, carefully outline the edges in lamp black. Create the lighter area inside the ear with a few delicate strokes of heavily diluted burnt sienna. Then add intense shadows on the right edges of his face, neck, and chest. Use raw umber for these shadows with strokes radiating inward from the edge so they taper naturally and blend into the coat.

> ⟶ T I P ⟵
>
> *Raw umber is great for lowering
> the intensity of green. Care must
> be taken not to add too much or
> your color will get muddy and dull.*

Near the In Gate

This painting depicts hunter, an equine sport that comes from the tradition of fox hunting. The fashion and overall appearance of the horse and rider have not changed much in hundreds of years. This rider and her warmblood horse are shown at the Ottawa Capital Classic horse show at the Nepean National Equestrian Park, where the grounds are truly spectacular. The rider was waiting at the "in gate" to start her competition. Hunter is a disciplined sport with judging based on the appearance, form, and abilities of the horse and rider.

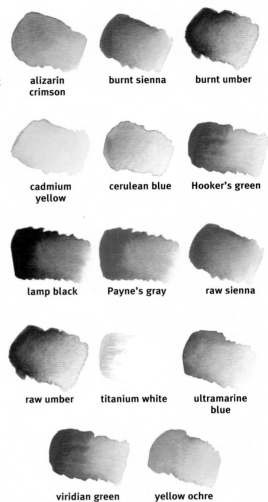

alizarin crimson	burnt sienna	burnt umber
cadmium yellow	cerulean blue	Hooker's green
lamp black	Payne's gray	raw sienna
raw umber	titanium white	ultramarine blue
viridian green	yellow ochre	

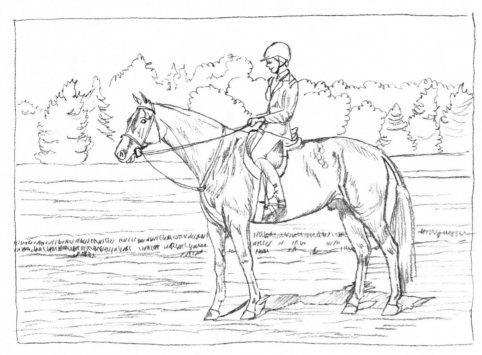

STEP ONE In this sketch, make each tree a different abstract shape, which will help you differentiate them in the painting. Outline the horse's shadow and add lines to separate the major areas of color, such as on the ground and the horse.

STEP TWO Develop light shades of yellow ochre and burnt sienna for the horse's coat with burnt sienna and burnt umber on the barrel. Next color the tack with light washes of raw sienna and then lightly add the horse's shadow in Payne's gray. Mix yellow ochre with Hooker's green for the grass and suggest individual blades using dots of Hooker's green. Lightly add varying intensities of burnt sienna for the dirt and cerulean blue for the sky. Use Hooker's green for the pine trees and viridian green and raw umber for the spruce. Create sharp strokes that radiate upwards or outwards from the center of the trees.

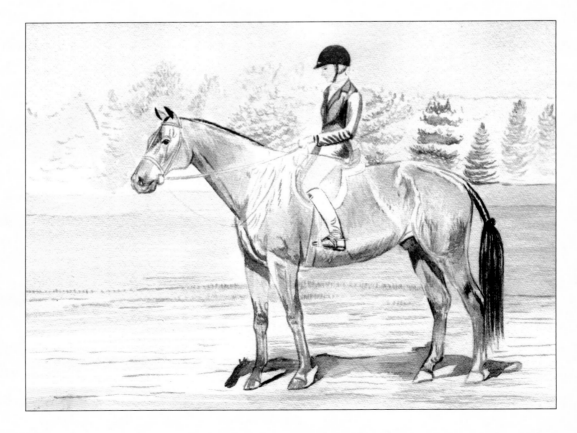

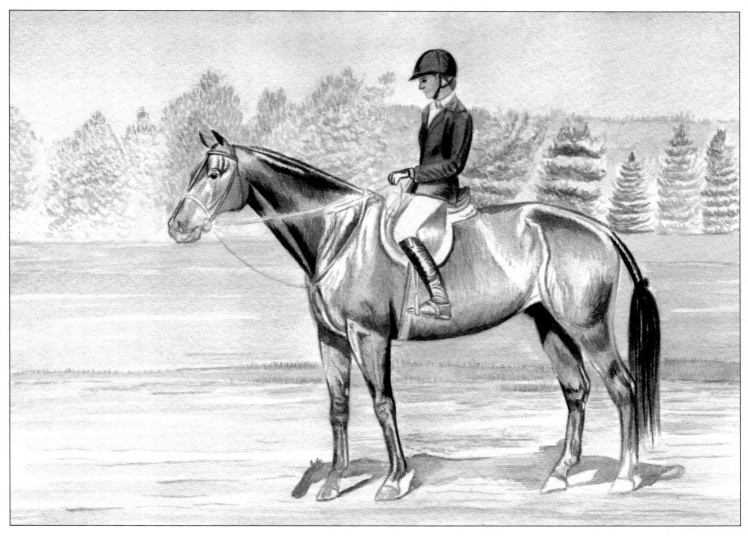

STEP THREE Darken the black points on the horse's legs and braided tail with three layers of lamp black. Layer over the horse's coat with raw sienna, careful to leave the highlights untouched to suggest shine. Develop the deciduous trees in the background with varying intensities of Hooker's green. Add raw umber and lamp black to the green of the pine and spruce, and lay down cadmium yellow washes in the two hardwood trees behind the rider. Then darken the grass with Hooker's green and cadmium yellow. Build more layers of the colors already established for the sky and dirt. Paint the muscles on the rump of the horse with small strokes radiating outward in burnt sienna and darken the shadows on the background legs with raw umber. For the rider's pants, use a very light wash of yellow ochre toned down with raw umber. Develop her boot with heavier layers of lamp black on the edges and lighter layers in the middle. Darken areas of the saddle with burnt umber and outline its flap with a single stroke of raw umber. Also use raw umber for the shadow at the edge of the white saddle pad.

DETAIL ONE First rough in the rider's tailored jacket with light washes of Payne's gray and ultramarine blue. Build darker, heavier strokes to show the creases in the sleeve. For her face, use a light wash of raw sienna, and a dot of Payne's gray to shape her eye. Use lamp black for her helmet and strap.

DETAIL TWO Further develop the rider's face with very light washes of alizarin crimson on top of the raw sienna from Detail One. Outline her helmet strap in lamp black and use raw umber for her hair. Remove some of the black from the helmet with a damp cotton swab where the light hits it to give it more form. Continue developing her jacket and glove in varying intensities of lamp black.

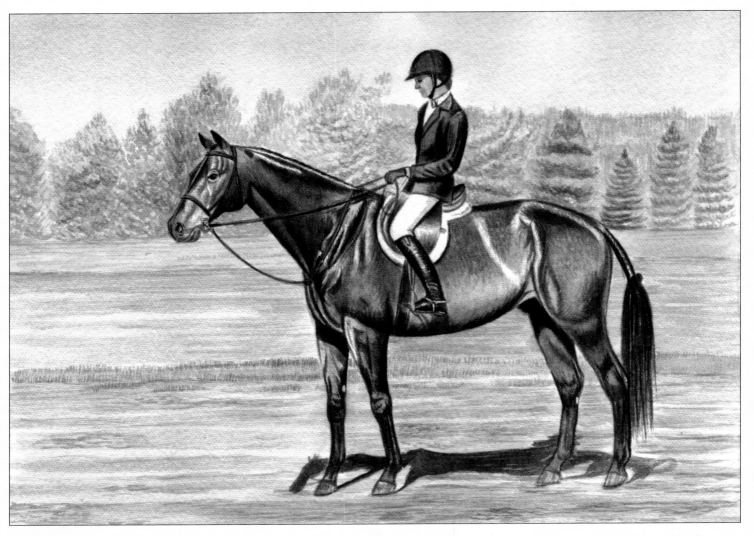

STEP FOUR Continue darkening the colors in ever-increasing layers. Develop the darker areas of the arena dirt with raw umber, and use slightly rectangular-shaped strokes to suggest bits of gravel. Define the horse's face by building layers of burnt umber and cadmium yellow while maintaining the white highlights. Next give the background trees individual attention by building on already established colors. To add realism to the trees, add titanium white to the mix of Hooker's green, ultramarine blue, and raw umber. Build the dark areas underneath branches in strokes of the corresponding color with heavier paint to water ratios. For the intense shadow on the horse's rump, mix alizarin crimson and ultramarine blue and add heavy strokes in two layers. Use alizarin crimson to darken the saddle as well. Heavily apply Payne's gray to the shadows in the rider's jacket and add more washes of lamp black to her glove and boot. Add heavier layers of raw umber to the shadows on the horse's body and create a deeper red in the shoulder area with heavy strokes of alizarin crimson.

DETAIL THREE Build the shadow on the ground in layers of diluted Payne's gray, being careful to let some of the brown show through. This ensures the shadow is not one dark blob. In the final step, use a touch of alizarin crimson to complete the shadow and give it a deep purple color. Create defining strokes of lamp black to distinguish the coronet band, where the hair begins growing above the hooves. Also darken the legs and tendons with more lamp black.

→ T I P ←

To soften the top layers of color without making a mess and disturbing the layers underneath, use a brush with clean water to drag the color out of the dried layers. You can also blend colors with a damp cotton swab.

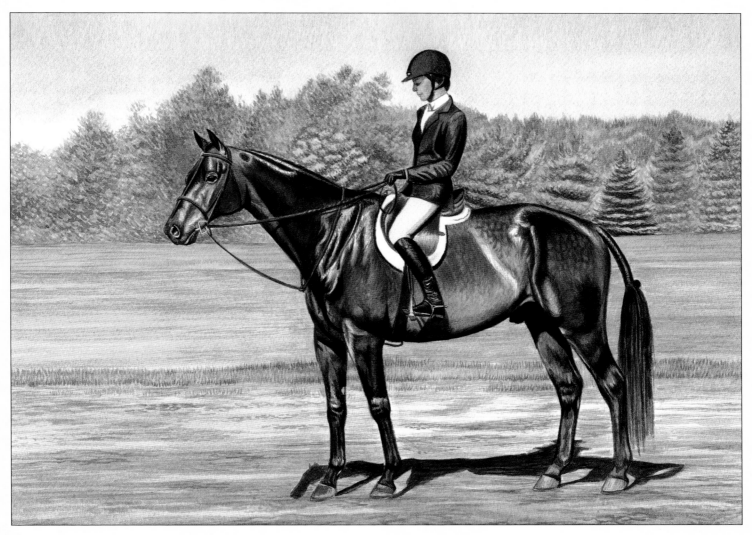

STEP FIVE Separately add many more layers of yellow ochre, burnt sienna, burnt umber, and then raw umber to the body of the horse. Let each layer dry in between. Leave the yellow ochre on the horse's barrel untouched to show the lighter hues. Darken the ground with more layers of burnt umber and raw umber, and add dots of individual pebbles. Add one final layer of cerulean blue mixed with titanium white to flatten the sky. Finish the tail with lamp black and the tack with alizarin crimson. Then add a dark stroke of raw umber to the bottom of each strap of the tack. Layer alizarin crimson over the saddle, as reddish tack was popular at the time of this show. Give more detail to the shoulder area of the horse by darkening the outlines of the muscles with raw umber and alizarin crimson. Leave the highlight areas pure white. For the grass, add more small brushstrokes and then a wash of cadmium yellow. Outline the rider's face one more time with Payne's gray. Paint an overall wash of ultramarine blue over the rider's jacket to prevent it from appearing too gray. Finish her glove and boot with lamp black on a nearly dry brush using strokes that radiate inward toward the highlights.

DETAIL FOUR Add dapples on the coat by carefully painting in small irregular circles in a checkerboard-like pattern in alizarin crimson mixed with ultramarine blue. Dapples are a nice finishing touch but are not seen on all horses, so careful observation is a must.

DETAIL FIVE Finish the trees with dot-shaped strokes of Hooker's green. For the trees farthest away, combine Hooker's green and ultramarine blue for a final wash. This flattens these distant trees and gives them a bit of depth.

Three Ponies

A painting with three equine subjects can be challenging. These three ponies need individual definition and separation as well as a sense of unity. Before they came together in this painting, they were each photographed separately. In this project, you will learn how to capture the combined humor and charm of these three distinct ponies.

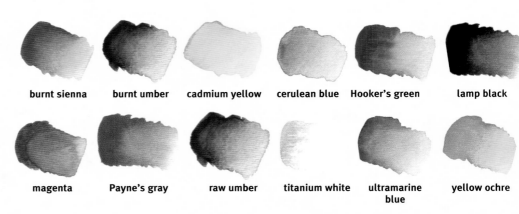

burnt sienna **burnt umber** **cadmium yellow** **cerulean blue** **Hooker's green** **lamp black**

magenta **Payne's gray** **raw umber** **titanium white** **ultramarine blue** **yellow ochre**

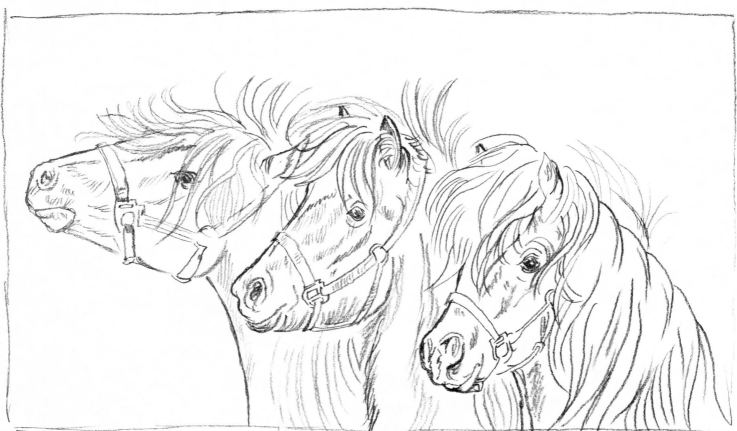

STEP ONE In this sketch, use slightly darker lines to outline the three pony heads so that the tangle of forelock and manes do not overwhelm the entire painting. You can easily see where the manes and forelocks overlap each other.

DETAIL ONE If you are right-handed, work on this project from left to right to avoid smudging the paper (as shown in these steps). (If you are left-handed, you may want to begin with the pony on the right and work your way left.) Here the pony on the left gets more attention in the beginning stages. Build more layers of burnt sienna and yellow ochre in his face than in the others. Continue building more layers of burnt sienna for the darker areas in a 50-50 ratio of paint to water. Use tiny strokes of burnt sienna on the far side of his white facial marking to distinguish it from the background. You want his ear to show up in the tangle of his mane, so outline the tip slightly with dry burnt umber. The cheekbone also gets a bit of dimension in this dark color. Mix titanium white and yellow ochre for his slightly blond mane and forelock. His halter is a mix of cadmium yellow and Hooker's green. Slowly add details to the halter fittings and buckles in yellow ochre with raw umber shadows underneath.

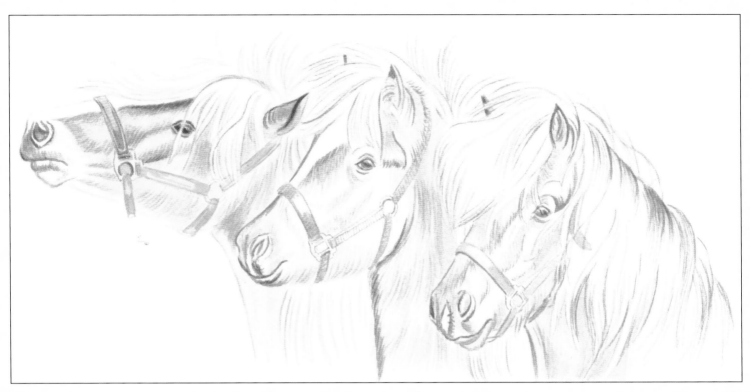

STEP TWO Block in areas of rough color using a mix of burnt sienna and yellow ochre. For the halters, mix magenta and ultramarine blue (middle) and ultramarine and cerulean blues (right). Leave areas of highlights white on each halter. Use longer brushstrokes to define the long hair of the manes and the neck of the middle pony. Focus on the eyes with heavy dots of burnt sienna and a dot of titanium white for the highlight. Then add detail in burnt sienna around the eye and eyebrow area. Develop the muzzles with preliminary strokes of heavily diluted lamp black. Carefully add small tight strokes to suggest nostrils and wrinkles around the lips, and leave the paper blank for their facial markings.

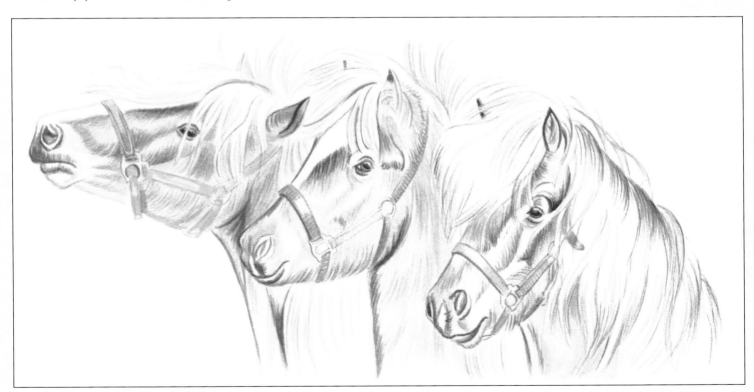

STEP THREE The three ponies are slightly different shades of red, so build up layers for each using burnt sienna, raw umber, yellow ochre, and cadmium yellow in different combinations. Use a #3 brush with hardly any bristles left for the long, thin brushstrokes of the manes and forelocks. Add reflections of burnt sienna to the middle pony's mane. The pony on the right has an almost white mane, so outline it in strokes of raw umber. Darken the individual halter colors, and be careful to leave the white highlights. Notice the hair on the bottoms of their chins. Add these in one at a time with dry brushstrokes in colors that match their coats. Use longer brushstrokes for the pony in the middle as the hair on his neck is longer than the others. Add strokes of Payne's gray to the eye areas and darken the pupils substantially with heavy dots of burnt sienna. Add one dark lamp black stroke to the center of each pupil and create a shadow of raw umber above the eye of the pony on the right.

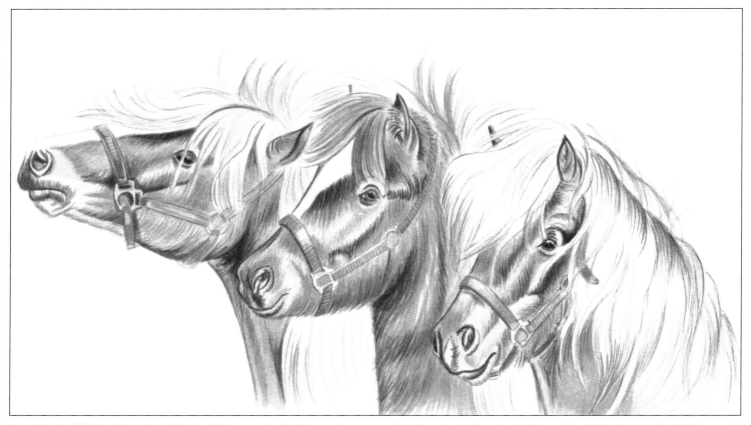

STEP FOUR Continue to build additional strokes of the established colors on the ponies slowly and in layers. Leave white areas on the nylon halters and add in vertical strokes to depict the webbing of the nylon. Pay particular attention to the ponies' eyes. Give them individual eyelashes using burnt sienna for the middle pony and very light strokes of titanium white for the other two. Then outline their eyelids in Payne's gray and lamp black. Their muzzles and nostrils add to their charming expressions. Darken the muzzle areas with shades of Payne's gray and diluted lamp black. The hair here is very soft, fine, and short. Continue developing their manes with a few hairs crossing over lower layers to add realism. Add shadows to the insides of the metal rings of the halters using raw umber to create depth.

DETAIL TWO Don't let the middle pony get lost between the other two. Separate him from his buddies by leaving his muzzle light. Use small strokes of Payne's gray to suggest the wrinkles, and overlap these strokes with the yellow ochre of the muzzle. Define the outside edge of his muzzle and nostril with small but fairly heavy strokes of titanium white. Create a dark raw umber shadow down the length of his face on the left to distinguish him from the far left pony. Add another deep shadow in raw umber under his chin and along his neck to give him even more distinction. Then add a few dark strokes of raw umber on top of the purple halter. Use tapering strokes in a downward motion from the jaw to define the hair on his chin. Then add a little burnt sienna in strokes angling down to further define this area.

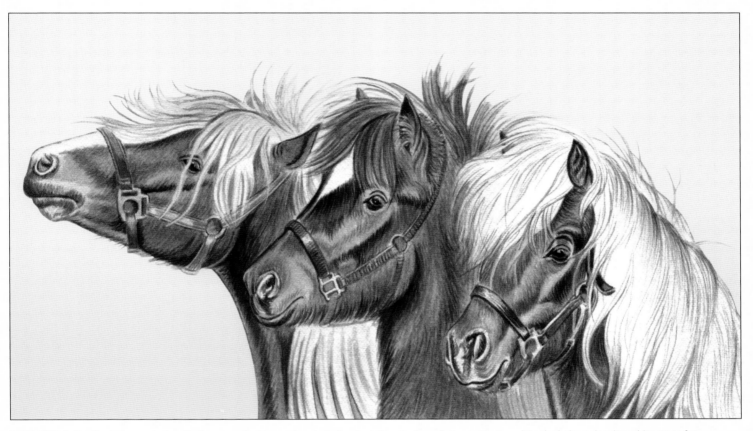

STEP FIVE In the final stages, darken the layers and add more brushstrokes to define the long, hairy coats. Complete the halters, leaving white areas for highlights and adding vertical strokes to depict the nylon webbing. Finish the muzzles by bringing the face colors in closer to the lips. Then, finish shaping the facial bones with darkening shades of burnt umber and then raw umber. The cheekbone strokes are small and thin. Use a #0 brush and carefully add one stroke at a time so the shadows don't get too overpowering. It is important during this final step to make sure the ponies are clearly differentiated. To accomplish this, add deep, dark shadows of raw umber to the edges of their necks. This also helps to unify the image. Finally, add a gradient of yellow ochre and burnt sienna in a very light wash for a simple background that doesn't compete with the detail in the ponies' faces.

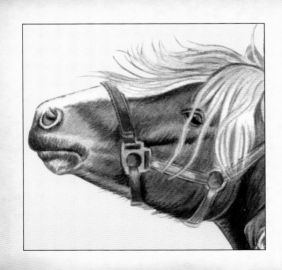

DETAIL THREE Creating a gradient requires practice. If you are unfamiliar with the technique, first practice on a separate piece of paper. Use a large round squirrel-hair brush and paint about six layers of the lightest shade. For this painting, use yellow ochre and burnt sienna (about a 75-25 mix) heavily diluted with water. Lay down flat washes and let each dry before adding the next. Then increase the amount of burnt sienna to about 75 percent of the color mix. Start applying this mixture about halfway down. Add lots of water to the top edge of the wash so it blends and flows into the established layer. When these three or four washes dry, apply one final wash. You may prefer to add the gradient before painting the ponies or in Photoshop®.

The Stragglers

This serene ranch setting takes this modern cowboy out of the rodeo and onto a working farm. He's using a typical western or stock saddle, and he carries one of the tools of the trade, a lariat for lassoing cattle. This style of riding evolved from working ranches and cattle drives, and weekend rodeos keep the tradition alive and well.

▶ **SETTING THE SCENE** This cowboy was photographed at a rodeo. There was a big cattle ranch and a highway in the background. This photo composite was created to remove the highway and add the cows, which are from a different photo, creating a ranch-like setting that you will capture in this painting.

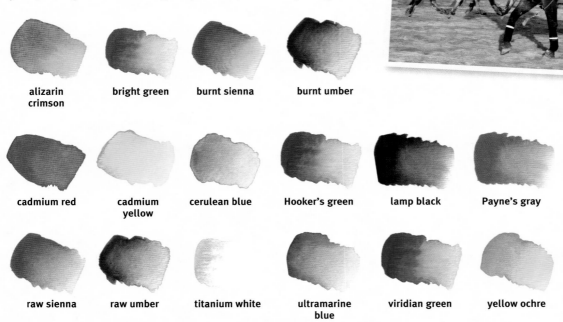

alizarin
crimson

bright green

burnt sienna

burnt umber

cadmium red

cadmium
yellow

cerulean blue

Hooker's green

lamp black

Payne's gray

raw sienna

raw umber

titanium white

ultramarine
blue

viridian green

yellow ochre

STEP ONE Sketch in the unfamiliar shapes of the cows and the structures in the background so you can work out any compositional problems. You can move the cows around to make a more pleasing arrangement.

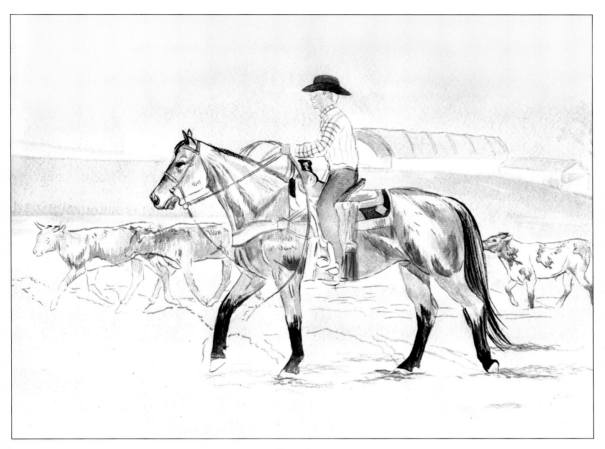

STEP TWO Begin this painting with washes of burnt sienna for both the horse and cows. Use diluted lamp black for the legs of the horse as well as the mane, tail, cowboy hat, saddle horn, and detail of the saddle blanket. Lay down light washes of cerulean blue in the sky and suggest the outline of the shadows on the ground in raw umber. Lightly outline the cowboy in raw umber as well, and add a wash of ultramarine blue for his jeans. Begin developing the lines of alizarin crimson strokes that will create his plaid shirt. Use burnt sienna for his saddle, bridle, and lariat. Then lightly outline the buildings in Payne's gray and lightly paint the tree using raw umber to outline the branches. Add a few leaves with very light dot-shaped strokes of Hooker's green and establish the grass with a light wash of bright green.

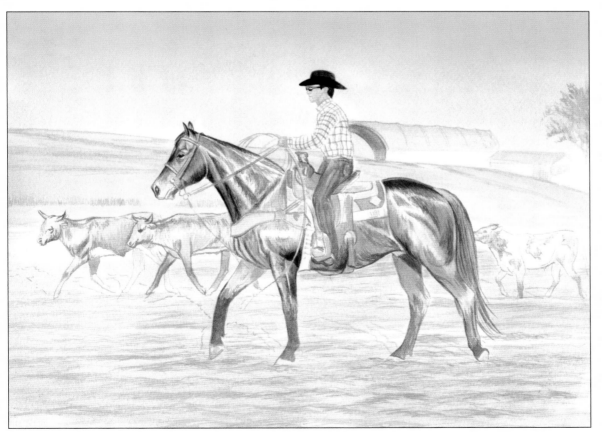

STEP THREE Darken the layers of burnt sienna and lamp black on the horse, whose bay color has prominent red tones. Then add raw sienna for the darker coat areas. Develop the cows in burnt sienna washes and the buildings in shades of Payne's gray with diluted lamp black shadows. Use long, horizontal strokes of Hooker's green to suggest the grass, define the slopes, and add depth to the hills. For the sand ring, layer in burnt sienna and burnt umber in light strokes to suggest the uneven dirt. Use flat layers of raw sienna for the saddle, bridle, and breastplate. Rough in the face of the cowboy with small strokes and layers of diluted cadmium red and yellow ochre. Use the colors separately with a #1 brush to work on the small details. For his sunglasses, use lamp black with a highlight left in the closest lens.

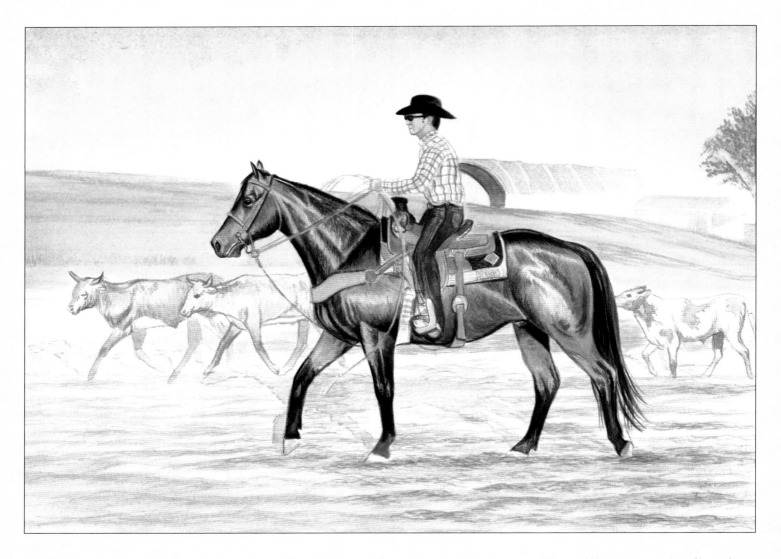

STEP FOUR Unify the horse's coat with dark shadows painted in three layers of burnt umber on the back, neck, and chest. Add long narrow strokes of heavy lamp black to all four legs. Then use the same heavy color for the black tape on the saddle horn, and darken the saddle with raw sienna. Complete the cowboy's face with light lines of Payne's gray and add almost dry strokes of ultramarine blue mixed with Payne's gray to his jeans. Darken the top of the far leg. Suggest morning sun with light shadows of heavily diluted ultramarine blue on the ground behind the horse and cows and under the cowboy's arm. Gradually add layers of burnt sienna to depict the raised sand. For the grass, combine Hooker's green and cadmium yellow. Add small vertical strokes of viridian green to suggest the longer grass. Darken the lone tree with Hooker's green for the leaves and raw umber for the trunk. Then use a bit of cadmium yellow to lighten the tree's value.

DETAIL ONE Slowly build details in layers to define the horse's face and tack. Use a heavy mix of raw umber and lamp black (50-50 ratio) on his jaw line and the top edge of his face. Darken his muzzle with Payne's gray and outline his nostril in almost dry strokes of lamp black. Add detail to the eye area with small strokes of Payne's gray under the eye, heavier strokes of raw umber above, and dots of almost pure lamp black in the pupil. For the bridle, outline one small dark stroke of raw sienna on the crownpiece (over the forehead), the throatlatch (under the jowl), and the tie down that goes from the noseband down to the cinch. Then add one dark stroke of raw umber on the bottom edge of the headstall, the piece that stretches from the bit to behind the ears, to act as a shadow.

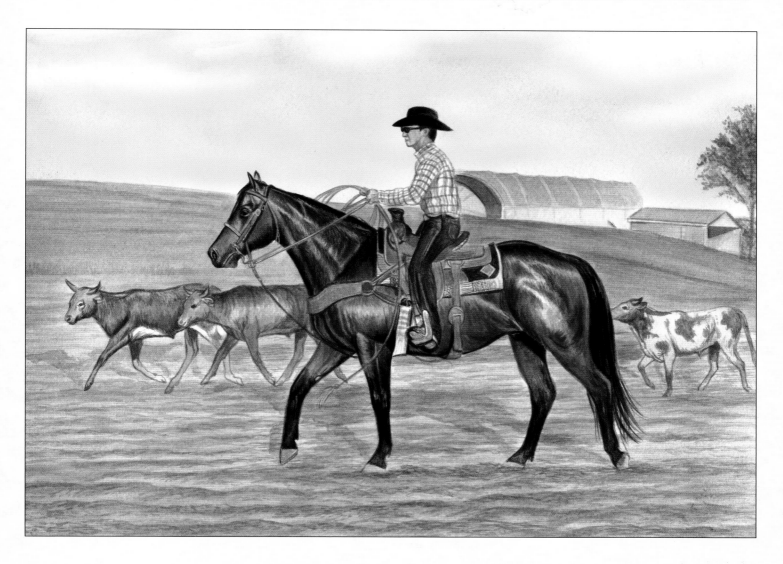

STEP FIVE Darken and outline the buildings with Payne's gray and then raw umber, keeping both colors well diluted. Use horizontal strokes of Hooker's green to add variation in the grass. Add marks and color to the cows with a burnt sienna and yellow ochre combination. Lightly go over the existing lines of the bridle and rope with raw sienna. Finish the cowboy's clothing by adding Payne's gray for the contours of his jeans and cadmium red and ultramarine blue for the plaid shirt. Press hard with your brush for three more flat washes of cerulean blue in the sky. Darken the shadows on the ground with Payne's gray. Use washes of raw sienna to intensify the red of the horse. For the tree, apply about six more layers of Hooker's green plus a cadmium yellow wash. Develop the hedge behind the tree in dot-shaped strokes of Hooker's green. Add a lamp black shadow to finish the small shed, and apply a yellow ochre wash to both buildings.

DETAIL TWO Layer burnt sienna and raw sienna to depict the double-skirted saddle. Outline the edges with very light raw umber and develop a deeper red for the darker areas with burnt umber. For the off-white sheepskin of the saddle pad, use light strokes of raw umber. Add a shadow of raw umber along the bottom and sides of the saddle pad as the finishing detail.

DETAIL THREE You can still add clouds at this stage, even though you've already laid down several blue washes in the sky. As you can't cover these washes with white watercolor, use an airbrush and compressor with thick titanium white gouache paint. This easily allows you to cover the cerulean blue in the sky. You can also add them in acrylic or use masking fluid in the beginning to preserve the white of the paper for the clouds.

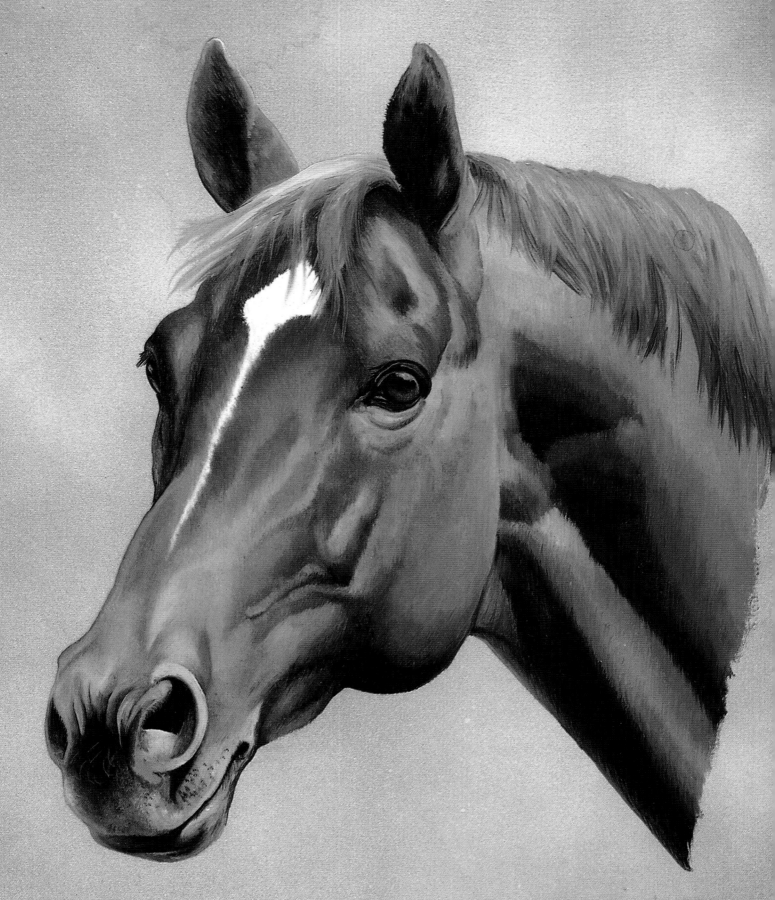

SECRETARIAT
1970-1989
© LARIMORE

Horses in Oil

with Cindy Larimore

The rich, versatile art of oil painting has captivated artists for centuries and continues to be a favorite artistic medium. Oil is a very adaptable medium that lends itself to the art of painting horses. As oil dries more slowly than watercolor or acrylic, you have the opportunity to refine your paintings, building up different breed coats in rich, textured strokes. In the following pages, you will be guided step by step through the art of painting horses in oil. You'll learn methods for depicting various horse colors, such as chestnut, paint bay, gray, black, and palomino. You will also explore techniques for painting specific equine features and capturing horses in action.

Oil Tools & Materials

There are so many items to choose from in art supply stores, it's easy to get carried away and want to bring home one of everything! However you only need a few materials to get started. A good rule of thumb is to always buy the best products you can afford. And think of your purchase as an investment—if you take good care of your brushes, paints, and palette, they can last a long time, and your paintings will stay vibrant for generations. The basic items you'll need are described here, but as with all new media, it is best to experiment with different tools to see which work best for you.

BUYING OIL PAINTS

There are several different grades of paint available, including students' grade and artists' grade. Even though artists' grade paints are a little more expensive, they contain better-quality pigment and fewer additives. The colors are more intense and will stay true longer.

BASIC PALETTE

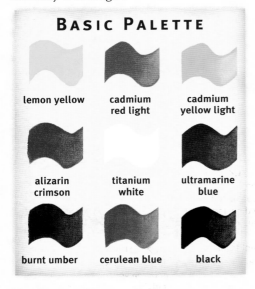

lemon yellow	cadmium red light	cadmium yellow light
alizarin crimson	titanium white	ultramarine blue
burnt umber	cerulean blue	black

CHOOSING A PALETTE OF COLORS

The nine colors shown above are a good basic palette. As you become more comfortable painting in oils, you will find that you gravitate to certain colors more than others, and eventually you will develop your own personal palette. Here are the colors you will need for the projects in this chapter: brown madder alizarin, burnt sienna, burnt umber, cadmium yellow, flesh, ice blue, ivory black, jaune brilliant, mars orange, Naples yellow light, Payne's gray, raw sienna, raw umber, terra rosa, titanium white, ultramarine blue, Van Dyke brown, and yellow ochre.

SELECTING SUPPORTS

The surface on which you paint is called the "support"—generally canvas or wood. You can stretch canvas yourself, but it's simpler to purchase prestretched, preprimed canvas (stapled to a frame) or canvas board (canvas glued to cardboard). If you choose to work with wood or any other porous material, you must apply a primer first to seal the surface so the oil paints will adhere to the support (instead of soaking through).

PURCHASING AND CARING FOR BRUSHES

Oil painting brushes vary in size, shape, and texture. There is no universal standard for brush sizes, so they vary slightly among manufacturers. Some brushes are sized by number, and others are sized by inches or fractions of inches. Just get the brushes that are appropriate for the size of your paintings and comfortable for you. The six brushes pictured below are a good starting set; you can always add to your collection later. Brushes are also categorized by the material of their bristles; keep in mind that natural-hair brushes are best for oil painting. Cleaning and caring for your brushes is essential—always rinse them out with turpentine and store them bristle side up or flat (never bristle side down).

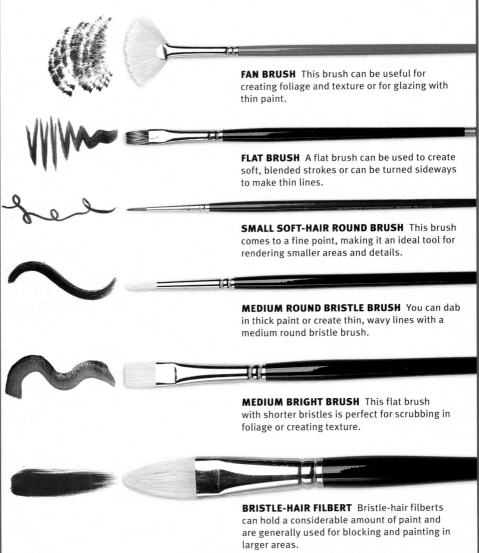

FAN BRUSH This brush can be useful for creating foliage and texture or for glazing with thin paint.

FLAT BRUSH A flat brush can be used to create soft, blended strokes or can be turned sideways to make thin lines.

SMALL SOFT-HAIR ROUND BRUSH This brush comes to a fine point, making it an ideal tool for rendering smaller areas and details.

MEDIUM ROUND BRISTLE BRUSH You can dab in thick paint or create thin, wavy lines with a medium round bristle brush.

MEDIUM BRIGHT BRUSH This flat brush with shorter bristles is perfect for scrubbing in foliage or creating texture.

BRISTLE-HAIR FILBERT Bristle-hair filberts can hold a considerable amount of paint and are generally used for blocking and painting in larger areas.

Utilizing Additives

Mediums and thinners are used to modify the consistency of your paint. Many different types of oil painting mediums are available—some thin out the paint (linseed oil) and others speed drying time (copal). Still others alter the finish or texture of the paint. Some artists mix a small quantity of turpentine with their medium to thin the paint. You'll want to purchase some type of oil medium, since you'll need something to moisten the paint when it gets dry and stiff and to thin it for underpaintings and glazing. Turpentine or mineral spirits can be used to clean your brushes and for initial washes or underpaintings, but you won't want to use them as mediums. They break down the paint, whereas the oil mediums you add actually help preserve the paint.

Picking a Palette

Whatever type of mixing palette you choose—glass, wood, plastic, or paper— make sure it's easy to clean and large enough for mixing your colors. Glass is a great surface for mixing oil paints and is very durable. Palette paper is disposable, so cleanup is simple, and you can always purchase an airtight plastic box (or paint seal) to keep your leftover paint fresh between painting sessions.

Including the Extras

Paper towels or lint-free rags are invaluable; you will use them to clean your tools and brushes, and they can also be used as painting tools to scrub in washes or soften edges. You may want charcoal or a pencil for sketching and a paint box is also useful to hold all your materials. In addition to the basic tools, you may also want to acquire a silk sea sponge and an old toothbrush to render special effects. Even though you may not use these additional items for every oil painting you work on, it's a good idea to keep them on hand in case you need them.

SETTING UP A WORK STATION How you set up your workspace will depend on whether you are right- or left-handed. It's a good idea to keep your supplies in the same place so that each time you sit down to paint, you don't have to waste time searching for anything. If natural light is unavailable, make sure you have sufficient artificial lighting. Above all else, make sure you're comfortable!

SELECTING AN EASEL The easel you choose will depend on where you plan to paint. You can purchase a studio or tabletop easel for painting indoors, or you can buy a portable easel if you are going to paint outdoors.

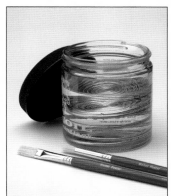

CLEANING BRUSHES Purchasing a jar that contains a screen or coil can save some time and mess. As you rub the brush against the coil, it loosens the paint from the bristles and separates the sediment from the solvent. Once the paint has been removed, you can use brush soap and warm (never hot) water to remove any residual paint. Then reshape the bristles of the brush with your fingers and lay it out to dry.

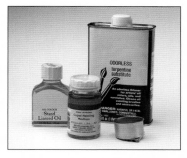

ADDING MEDIUMS In addition to the medium or thinner you choose, be sure to purchase a glass or metal cup to hold the additive. Some containers have a clip built into the bottom that attaches easily to your mixing palette.

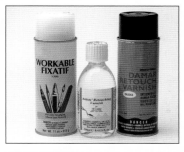

FINISHING UP Varnishes are used to protect your painting—spray-on varnish temporarily sets the paint, and brush-on varnish will permanently protect your work. See the manufacturer's instructions for application guidelines.

USING PAINTING AND PALETTE KNIVES Palette knives can be used to mix paint on your palette or as a tool for applying paint to your support. Painting knives usually have a smaller, diamond-shaped head, while palette (mixing) knives usually have a longer, more rectangular blade. Some knives have raised handles, which help you avoid getting wet paint on your hand as you work.

Checklist of Basics

At right is a list of the materials you'll need to purchase to get started painting in oils. (For specifics, refer to the suggested brushes and colors on pages 86–87.)

- Basic oil colors
- Brushes and palette knife
- Medium (copal or linseed oil)
- Thinner (mineral spirits or turpentine)
- Containers for thinner and medium
- Palette and palette paper
- Easel
- Supports
- Paper towels

Manes & Tails

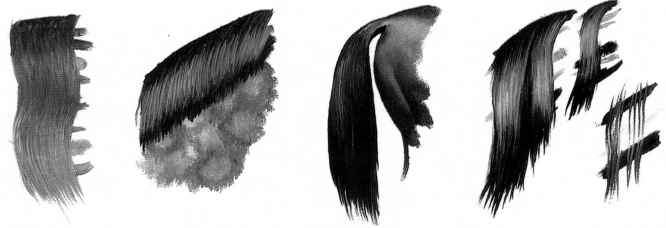

PAINTING HORSE HAIR Lay out colors horizontally, with darks and highlights in separate bands, then pull the colors through each other using swift vertical brush strokes (far left). Use short strokes for clipped manes (near left) and longer strokes for tails (near right). Add long vertical highlight colors last (far right).

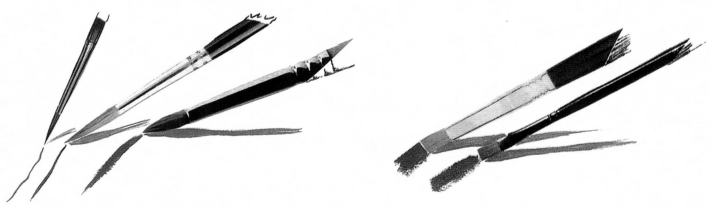

USING LINERS AND ROUND BRUSHES For smaller paintings and for creating individual hairs, use a 000 or 0 liner. For the body, use a round 0 or 1.

USING FLAT BRUSHES Use a 0 or 1 flat brush to paint horse bodies on larger paintings.

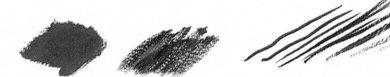

WORKING WITH TURPENTINE Add turpentine to body work for smoothness (left). If the paint is too dry, it will be difficult to create this effect (right).

CREATING SHARP LINES Use a wet liner brush to create clean, sharp lines. Make sure to keep your brush wet to ensure solid lines.

PRACTICING STROKES Practice making brush strokes on scrap canvas to discover the proper paint consistencies and what to expect out of each of your brushes.

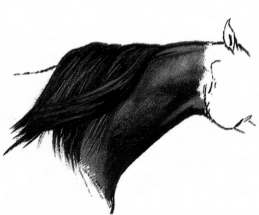

PAINTING LONG MANES Practice painting long, thick manes using the techniques in "Painting Horse Hair" above, with long, flowing brush strokes. Be sure to create a shadow beneath the mane and add highlights to suggest the hair's shine.

PAINTING SHORT MANES Use the techniques in "Painting Horse Hair" above to create this short mane. Start and stop your vertical strokes at precise intervals and stroke gently through a dark line at the bottom of the mane to create a shadow.

PAINTING TAILS For windblown tails, paint from the bottom up. Work up the colors from dark to light, making sure color bands do not extend outside the perimeters of the tail. Add overlapping, curved strokes last to show the wind blowing up the ends.

Coats & Palettes

BUCKSKIN burnt umber, raw sienna, flesh, and titanium white

DUN brown madder alizarin, raw sienna, jaune brilliant, and flesh

CLAYBANK ivory black, burnt umber, raw sienna, and Naples yellow light

GRULLA ivory black, burnt umber, flesh, and titanium white

DARK CHESTNUT ultramarine blue, brown madder alizarin, mars orange, jaune brilliant, and Naples yellow light

LIVER CHESTNUT ultramarine blue, burnt umber, raw sienna, terra rosa, and flesh

SORREL brown madder alizarin, burnt sienna, and Naples yellow light

BRIGHT CHESTNUT ultramarine blue, brown madder alizarin, terra rosa, jaune brilliant, and Naples yellow light

DARK BROWN ivory black, burnt umber, flesh, titanium white, and ultramarine blue

TRUE BLACK ivory black, Payne's gray, titanium white, and ultramarine blue

BLACK POINTS ON BAY ivory black, ultramarine blue, and titanium white

WHITE/GRAY Payne's gray, titanium white, and various reflecting colors

DAPPLE BAY/BROWN ivory black, burnt umber, flesh, and Payne's gray

RED ROAN titanium white, flesh, burnt sienna, and brown madder alizarin

BLUE ROAN Payne's gray, titanium white, ultramarine blue, and ivory black

FLEA-BITTEN GRAY titanium white and Payne's gray

ROSE GRAY titanium white, terra rosa, flesh, and brown madder alizarin

DARK BAY ivory black, Van Dyke brown, burnt sienna, jaune brilliant, and Naples yellow light

BLOOD BAY ivory black, Van Dyke brown, burnt sienna, and mars orange

MAHOGANY BAY Payne's gray, brown madder alizarin, ultramarine blue, and titanium white

PALOMINO flesh, Naples yellow light, jaune brilliant, mars orange, and brown madder alizarin

PALOMINO EXAMPLE Paint this palomino with the colors indicated in the palette list above. Use titanium white for the tail and apply Payne's gray with some of the body color in the shading.

BRIGHT CHESTNUT EXAMPLE Use many of the same colors for this horse as you did for the palomino (see palette list above). Add ultramarine blue for the shadows.

SORREL EXAMPLE Refer to the "Sorrel" palette list for the body colors. Then add the tail with titanium white, working in reflected body colors for more depth.

Beautiful Eyes

They say that eyes are windows to the soul, and this is especially true with horses. To capture the likeness of a horse and express it's unique personality, it is essential to accurately depict the horse's eyes. Notice that horses have a horizontally placed and oval-shaped pupil, compared to the vertical slits of a cat's pupil or the perfectly round, centrally placed pupil in the human eye.

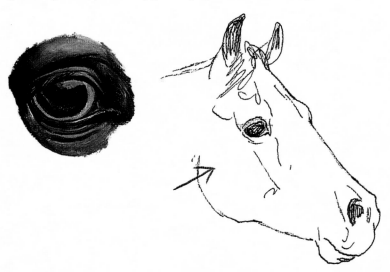

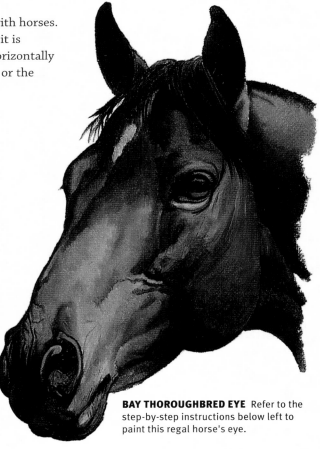

APPALOOSA EYE The sclera is the area of the eye that encircles the iris (colored or pigmented part of the eye). The Appaloosa's sclera is white and more visible than in other breeds. When painting an Appaloosa's eye, be sure to include its distinctive white sclera.

BAY THOROUGHBRED EYE Refer to the step-by-step instructions below left to paint this regal horse's eye.

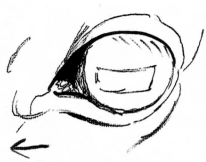

STEP ONE Begin with a sketch of the eye, lid, and surrounding folds, drawing a rectangle for the pupil.

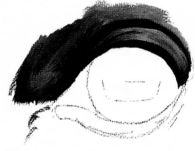

STEP TWO Outline the area without hair in black, then work in a tint of white, black, and brown for the eyelid.

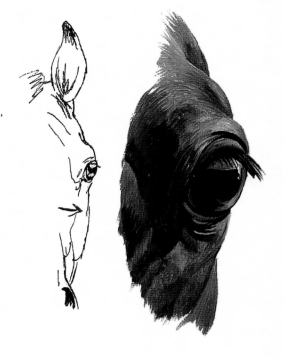

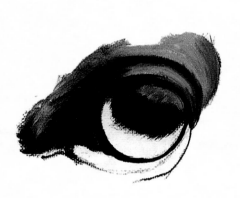

STEP THREE Now lay in the rectangular pupil and add a highlight above it, always thinking in terms of light shining on and through a glass sphere.

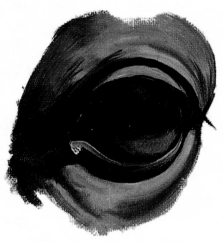

STEP FOUR Work in the rest of the eye's color and fill in the surrounding areas, adding shadows and highlights to create the illusion of depth.

ARABIAN EYE An Arabian horse's eyes are large and lustrous, with no visible sclera. They are set widely apart and are very expressive. The clipped eyelashes and shaved and oiled skin on this Arabian indicate that it is a show-groomed horse.

Faces

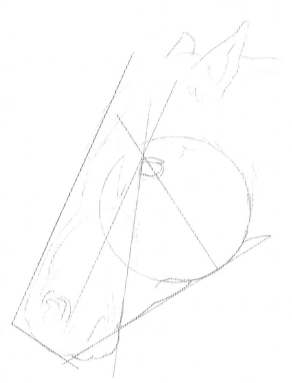

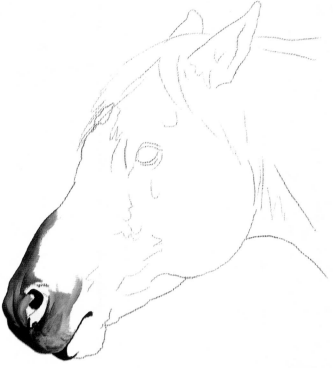

STEP ONE It is helpful to begin a painting with a sketch of your subject, blocking in basic shapes and proportions. You can draw directly on the canvas with charcoal, as it rubs off easily, or create a pencil sketch and transfer it onto your canvas using the grid method.

STEP TWO Begin defining the muzzle, using ivory black to fill in the nostril, outline the lips, and apply the darkest shadows. Work in burnt sienna and flesh around the nostril, and add Payne's gray to the upper lip and nostril.

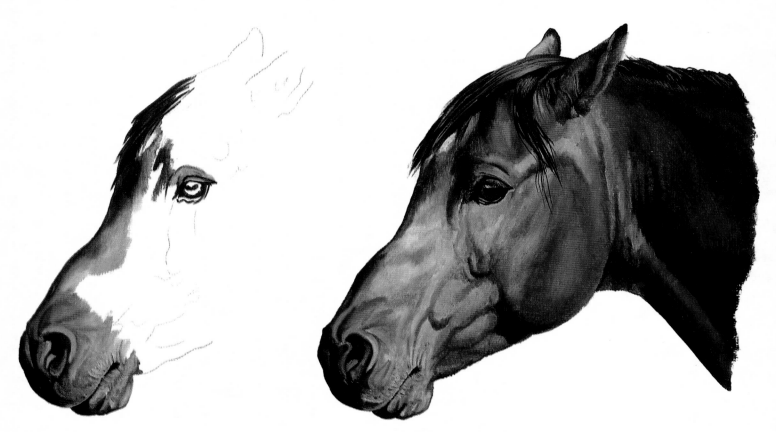

STEP THREE Further define the lips with short strokes of Payne's gray mixed with titanium white and begin outlining the eye with ivory black. Create the forelock with long strokes of ivory black and fill in more of the muzzle with burnt sienna and Naples yellow light. Develop the eyelid, then create shadows with ivory black and burnt umber, and add highlights with titanium white.

STEP FOUR Complete the eye, using the techniques on page 88, then fill in the rest of the face, following the forms of the horse's musculature and bone structure. Paint the neck with brown madder alizarin, burnt umber, and ivory black, with the flesh, Naples yellow light, and burnt sienna colors of the face carrying over. Finish the forelock and mane with ivory black and Payne's gray highlights.

Legs

In these action drawings, lines represent the bones and dots represent the joints. Notice that the leg bones go all the way to the spine, although movement is more restricted up into the body. Be aware of where the legs bend, how far they will stretch, and which muscles are bunched or stretched in movement.

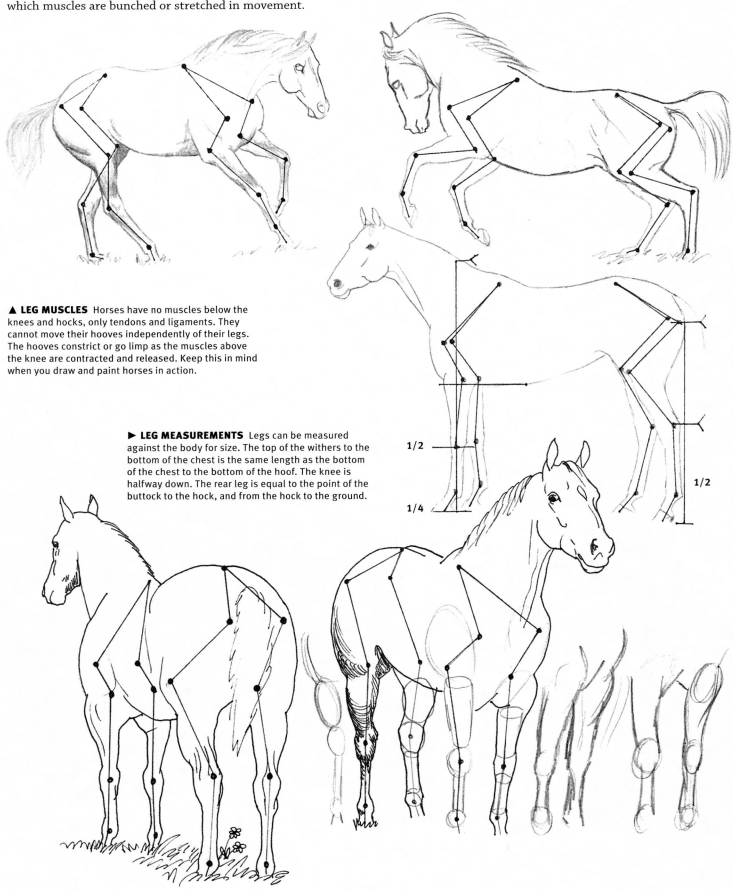

▲ **LEG MUSCLES** Horses have no muscles below the knees and hocks, only tendons and ligaments. They cannot move their hooves independently of their legs. The hooves constrict or go limp as the muscles above the knee are contracted and released. Keep this in mind when you draw and paint horses in action.

▶ **LEG MEASUREMENTS** Legs can be measured against the body for size. The top of the withers to the bottom of the chest is the same length as the bottom of the chest to the bottom of the hoof. The knee is halfway down. The rear leg is equal to the point of the buttock to the hock, and from the hock to the ground.

1/2

1/4

1/2

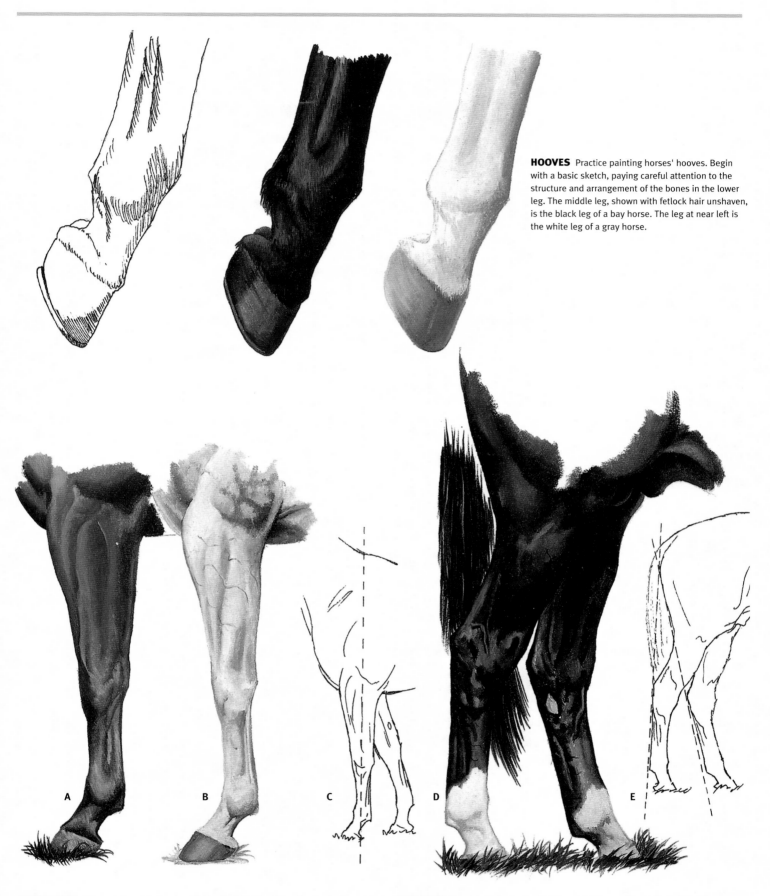

HOOVES Practice painting horses' hooves. Begin with a basic sketch, paying careful attention to the structure and arrangement of the bones in the lower leg. The middle leg, shown with fetlock hair unshaven, is the black leg of a bay horse. The leg at near left is the white leg of a gray horse.

A

B

C

D

E

FRONT LEGS Although they are structurally identical, the front leg of a quarter horse (A) has more muscle mass in the forearm, greater diameter in the cannon, and a slightly smaller hoof than that of an Arabian (B), which has lighter bone and slimmer muscle. In example C, a vertical line drawn from the front of the withers runs down the center of the foreleg. The farther forward the withers, the more sloping and desirable the shoulder.

HIND LEGS Example D shows the hind legs of a Thoroughbred. Notice that the rear hoof fetlocks tend to have more of a point than the front hooves, as seen in examples B and C. Hind legs should pivot from the hip joint. Example E is a side view drawing of the Thoroughbred's hind legs with a vertical line drawn from the back of the cannon bone through the point of the buttock, representing an ideal hind leg alignment.

Different Breeds

TRUE BLACK FREISIAN

This beautiful, graceful creature is one of the oldest breeds of warmbloods. Its solid black body (no white markings) gives witness to its purity. Warmbloods, like draught horses, have totally different conformation than the light breeds and you must be aware of the relative proportions of each individual when you draw them. Others in this group include the Holstein, Hanoverian, Cleveland Bay, Swedish, Trakehner, Furioso, and Oldenburg.

CHESTNUT BELGIANS

Belgians are one of the most popular draught horses for small farms and harnessing in America. They come in every shade of chestnut and sorrel possible, and almost always have beautiful dapples. These two were painted with the same acolors, only mixed in different proportions for each horse. This is simply a matter of color mixing and success comes with experience. These were painted from photos taken in bright sunlight on a light, sandy ground. Notice the reflected light on their bellies and that the only intense shadows are high up on their necks.

Dark Bay or Brown Thoroughbred Stallion

This is "Windy Sands" at age 10. He is a retired race horse whom spent his working days well cared for and fit. He has now put on weight, his belly sags a bit, his muscle tone is off, and he has developed the crest of a stallion on his neck. When painting horses you must be aware of age and sex because they affect the horse's appearance. Sex even has an effect on a head and neck study because you can tell the sex of a mature horse by observing its face.

Seal Brown Paint Stallion

This beautifully balanced horse is a quarter-type paint. Paints and Pintos are color bred and can be Arab-type, saddlebred-type or quarter-type conformation.

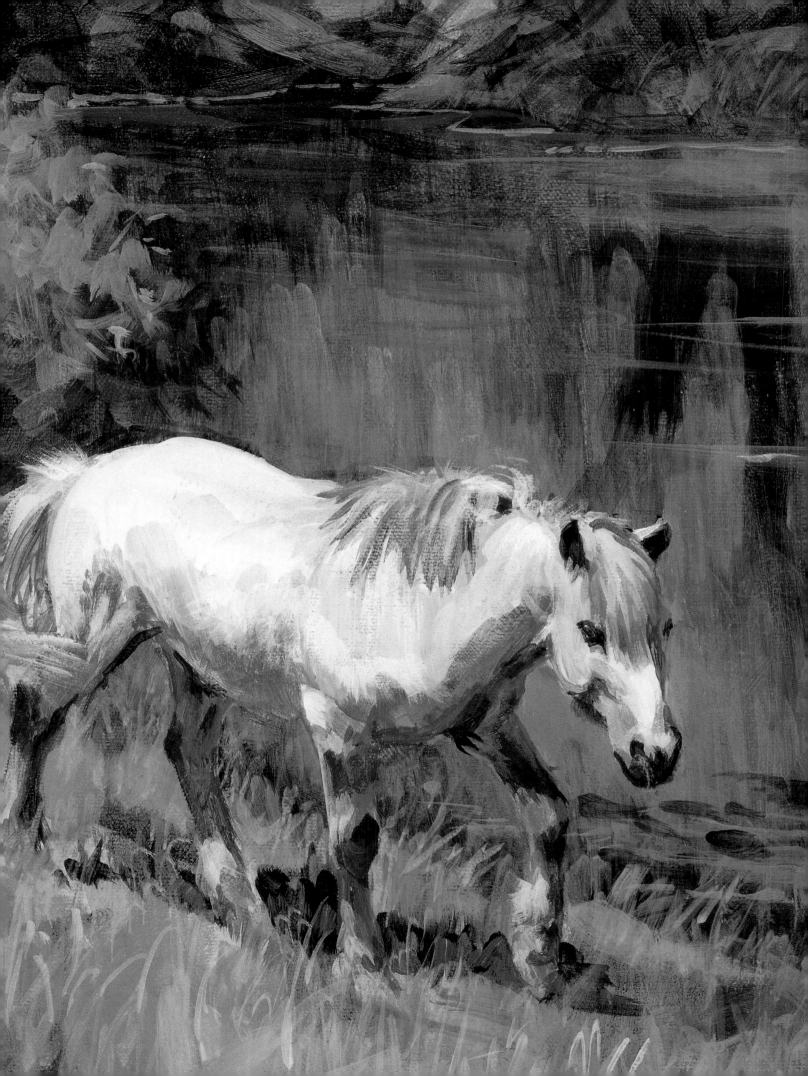

Horses in Acrylic

with Elin Pendleton

Acrylic is a very distinctive painting medium. In addition to having a unique look and feel of its own, it can mimic other media, such as watercolor, oil, and even pastel. Because of its great versatility, acrylic paint is a wonderful medium for painting horses in every setting. Not only can it be worked as either a transparent or opaque medium, it also dries quickly—allowing you to swiftly build up layers and easily paint over mistakes. In the following lessons, you will learn how to use acrylic to the best advantage for painting beautiful equines. You will also discover a range of techniques that you can use with any medium, from depicting depth and distance to painting on site and conveying quick motion. Then, once you've learned the basics, you can begin your own acrylic painting journey!

Acrylic Tools & Materials

One of the nicest qualities of acrylic is that you need only a minimal number of supplies. Once you purchase some basic paint colors, a few different-sized paintbrushes, and a painting surface, you have everything you need to begin. And these materials are all readily available at any local art store. You also don't need any solvents or harsh chemicals to work in acrylic—the wet paint can be cleaned with plain water, and the brushes can be cleaned with any soapy solution. While wet, acrylic can be mixed with many different painting mediums. When dry, it is permanent. Here you will find an overview of the basic supplies for painting in acrylic, but you should experiment with different items to discover the tools that create the effects you prefer.

▶ **SETTING UP YOUR STUDIO** The space you work in will greatly influence your creative process, so it is important that you have an effective studio setup. It is good to have plenty of natural light. However, you can paint around the clock using artificial lighting with "daylight simulation" bulbs that prevent the light from casting too much yellow (as incandescent bulbs do) or too much blue (as fluorescent bulbs do). To support your canvas, use a sturdy easel that easily tilts and adjusts. You should also have a comfortable chair for long painting sessions.

BASIC PALETTE

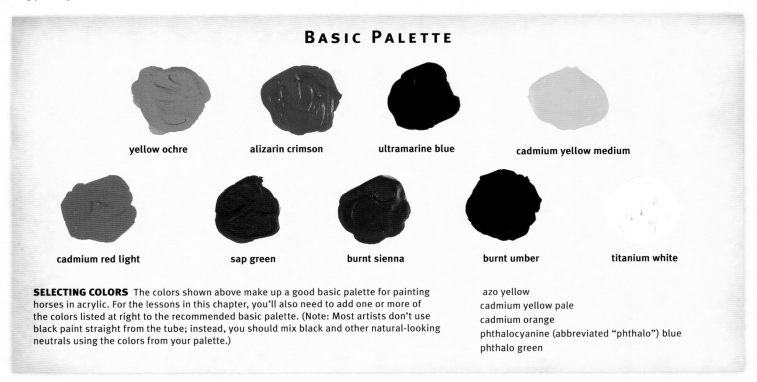

yellow ochre alizarin crimson ultramarine blue cadmium yellow medium

cadmium red light sap green burnt sienna burnt umber titanium white

SELECTING COLORS The colors shown above make up a good basic palette for painting horses in acrylic. For the lessons in this chapter, you'll also need to add one or more of the colors listed at right to the recommended basic palette. (Note: Most artists don't use black paint straight from the tube; instead, you should mix black and other natural-looking neutrals using the colors from your palette.)

azo yellow
cadmium yellow pale
cadmium orange
phthalocyanine (abbreviated "phthalo") blue
phthalo green

CHOOSING YOUR BRUSHES

It's a good idea to start your brush collection with a variety of brush types and sizes. Begin with a small, medium, and large size of each of the following paintbrush styles: flat, round, and filbert. Flat brushes are good for producing straight, sharp edges, and the medium and large flats are good for quickly filling in large areas of color. The small round and filbert brushes have pointed tips that are well suited for detail, and the larger rounds and filberts are perfect for sketching rough outlines and general painting. Synthetic hair brushes are easier to clean, as the paint tends to cling to natural hairs (and dry paint will ruin your brush). Also be sure to handle several different brands of brushes, and choose ones that are comfortable in your hand.

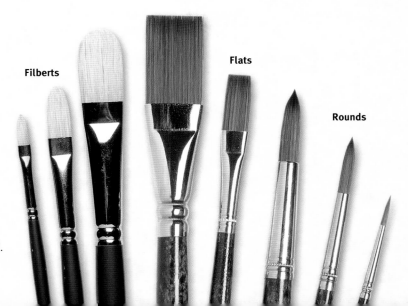

Filberts

Flats

Rounds

SELECTING SUPPORTS

When you visit an art store, you'll see that there are a variety of *supports* (or painting surfaces) to choose from. Many artists choose to paint on primed canvas or canvas board, which has a clothlike grain. Primed pressed-wood panels generally have one very smooth side and another rough side. Illustration board is good-quality, sturdy cardboard with a simulated canvas surface, which makes it a lightweight, easily portable support.

Canvas

Illustration board

Primed hardwood panel (smooth side)

Primed hardwood panel (rough side)

SURFACES FOR ACRYLIC PAINT Each type of support has a different surface texture that affects the way it accepts paint, whether it's silky and smooth or rough and grainy. Above you can see how each of the four surfaces accepts thick applications (left) and thin applications (right).

CHOOSING YOUR PAINTS

A variety of acrylic paint colors are available in jars, tubes, squeeze bottles, or cans. Acrylic tube paints are a popular choice; they offer a wide range of colors, and the tubes make it easy to control the amount of paint you place on your palette. No matter which form you choose, you'll want to purchase the best quality paints that you can afford. The highest-quality acrylic paints (labeled "artist quality") contain more pigment and less filler than do less expensive "student grade" paints, providing richer, truer colors that are worth the extra cost. If possible, stick with one brand of acrylic paints; because each manufacturer has its own formula, the handling qualities may differ from one manufacturer to another.

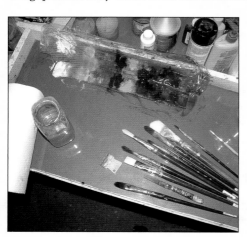

PREPARING YOUR PALETTE You can use a side table, or "taboret," to hold your mixing palette and supplies. You can also create your own palette by placing a 1/4"-thick sheet of glass over a piece of wood that has been painted gray. This neutral surface will allow you to see the correct values and hues of the paints, and you can easily wipe the glass clean or scrape off dried paint with a razor blade.

OTHER SUPPLIES Aside from the essentials, you'll find it helpful to gather a few additional items before you begin painting. Although you may not use every item pictured here for every painting, it's a good idea to have all of these tools in your studio setup.

GATHERING EXTRAS

As with watercolor and oil painting, you'll also want to have a few extra supplies on hand as you paint. Palette knives and painting knives are great for mixing colors and applying thick paint to the canvas. A roll of paper towels will help keep your brushes and your painting area clean. Jars of fresh water are also important to have nearby; designate one for rinsing your brushes and one for adding pure water to paint mixes. It's also helpful to have a sponge for soaking up large spills or even for creating texture on your canvas with paint. To make sure your paints stay moist, keep a spray bottle full of water near your palette. You can also seal your palette with plastic wrap between painting sessions to trap in moisture and extend the drying time of your paints. This is especially useful for preserving mixes that may be difficult to match.

MEDIUMS

Water is not the only substance that you can add to your acrylic paint to alter its consistency. There are a variety of acrylic mediums you can use to achieve various effects—from thin, glossy layers to thick, impasto strokes. In the projects in this chapter, you will use only a few mediums, but it's a good idea to get to know all the possibilities.

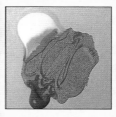
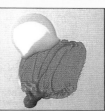
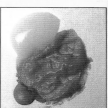

Gloss medium

Matte medium

Gel medium

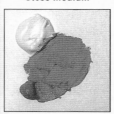

Texture medium

Retarding medium

Flow improver

Gloss medium is a runny fluid that is useful for thinning the paint while maintaining its luster. In contrast, *matte* medium causes the paint to dry to a soft satin sheen. (*Satin* medium—not pictured—produces a similar effect.) *Gel* medium has more body than gloss or matte mediums, giving the paint a heavier consistency for thick strokes. *Texture* mediums are even thicker, and they turn the paint into a paste; they come in different types, such as sand and fiber. *Retarding* medium helps slow the drying time of the paints. And *flow improver* increases the fluidity of paint and eliminates brush marks within strokes. Although these mediums may at first appear milky or opaque, most dry clear or almost clear.

Planning a Composition

A successful painting has more than just an appealing subject; it also has an attractive composition. *Composition* refers to the way objects are placed in a painting and how they relate to one another. The elements in a good composition are grouped into a balanced unit, and there is a distinct center of interest, or *focal point*. A strong composition also comprises interesting colors, shapes, and lines that lead the viewer's eye through the painting and toward the focal point. As you plan your composition, determine ways to steer the eye around the painting. In this scene, the objects are arranged to create a visual path toward the jockey and racehorse, which are placed slightly off-center to guide the eye into the painting. You will also place the highest contrasts of values and the most unique colors in the center of interest to lead the viewer's eye toward the focal point. The darker values and more muted colors of the crowd and landscape make them less important, directing the viewer's interest toward the lighter and brighter colors of the jockey's silks.

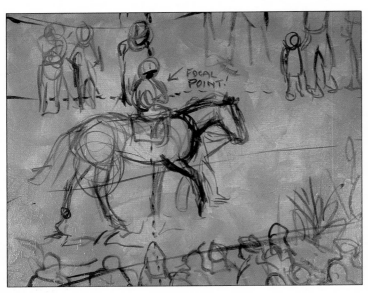

STEP ONE Start with an underpainting, toning the canvas with a thick, textured mix of gel medium and pale yellow. The color of the underpainting will provide a sense of warmth wherever the background shows through in the finished painting, and the texture will provide a slight sense of movement. Then use a mix of phthalo green and alizarin crimson to block in the composition.

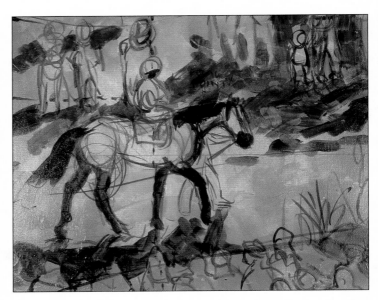

STEP TWO Now, with a 50-50 mix of gel medium and phthalo green, block in the dark shadows above the horse and rider, which will provide contrast and bring attention to the rider's light clothing. Next mix phthalo green and alizarin crimson to paint the horse's mane, tail, and legs, adding ultramarine blue to the mix to create the shadows underneath the horse.

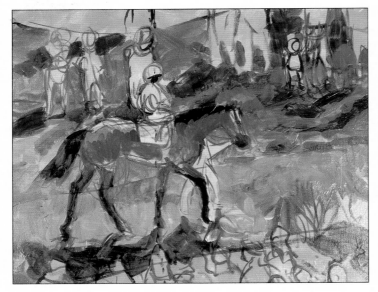

STEP THREE Next, using gel medium mixed with alizarin crimson, ultramarine blue, and touches of yellow ochre and white, paint the shadow side of the gray horse. Add white to a mix of cadmium yellow and sap green to paint the sunlit grass. Then mix gel medium with white, burnt sienna, cadmium orange, and burnt umber to add color to the walkway.

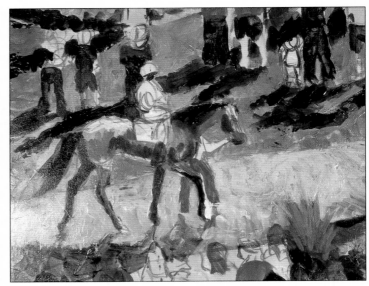

STEP FOUR To block in the crowd, use mixes of burnt umber and ultramarine blue, adding white for medium blues. For a second layer of greens, use a palette knife to apply light and dark mixes of phthalo green and gel medium. Then add a second layer to the path with a mix of white, burnt sienna, cadmium orange, and burnt umber, using more white for lighter values.

HORSE COLOR VARIATIONS: SHADOWS AND REFLECTED LIGHT

phthalo green + alizarin crimson + yellow ochre

yellow ochre

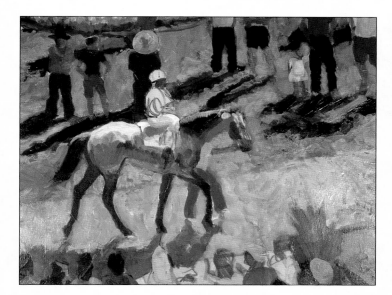

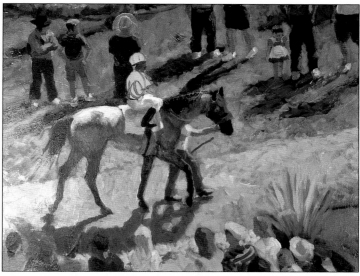

STEP FIVE Next apply lighter colors, but reserve the most intense color for the jockey's clothes. For the flesh tones, use a mix of cadmium red light and white with a little burnt umber. The white clothing is a mix of ultramarine blue and white with a touch of cadmium yellow medium for highlights. Next touch up the edges on and around the horse with previously used mixes.

STEP SIX Now pick up variations of the colors used before to add details to the crowd, adding darker mixes in the background and more variation in the foreground. For the dark hair and hats, use burnt sienna mixed with white. Then add foreground plants with a mix of sap green and cadmium yellow medium; the flowers are cadmium yellow medium mixed with white.

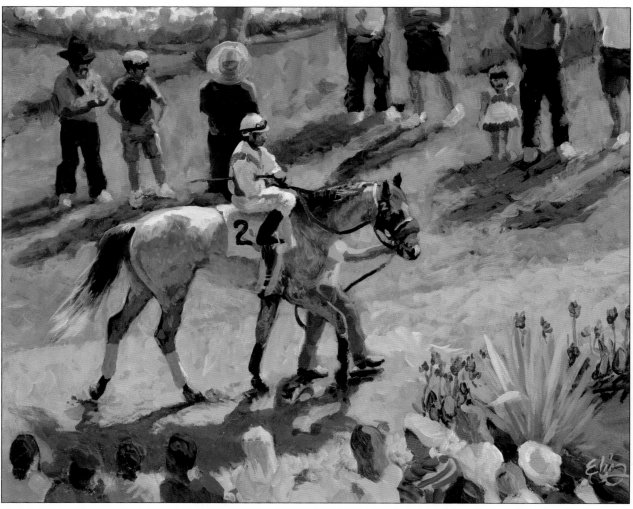

STEP SEVEN Now add the brightest colors. For the light areas of the jockey's clothing and helmet, apply cadmium yellow medium mixed with a little white. To refine the shape and form of the silks, add shadows using cadmium yellow pale mixed with phthalo green. Refine the shape of the helmet by touching up the darker colors surrounding it. Next, using alizarin crimson mixed with cadmium red light, add red details to the silks and finish the crop and reins. Then make a few minor modifications to the horse, adding details to the leg wraps and reins and touching in some ultramarine blue on the shadow side of the horse to reflect the sky. Finally balance out the composition with red flowers in the foreground.

white + alizarin crimson + ultramarine blue

white + cadmium orange

ultramarine blue + white

phthalo blue + white

Expressing Mood

Color has a tremendous effect on people. Subtle or strong, colors have the ability to affect our feelings and arouse our emotions. Warm colors—such as reds, yellow, and oranges—convey energy and excitement, whereas cool colors—like greens, blues, and purples—tend to be more relaxing and calming. Muted, grayed tones also have a soothing effect. Knowing how colors relate to and interact with one another will help you express an array of emotions—as well as create interest and unity—in your paintings. For example, this scene includes a palette that consists of cool tones and very muted warm colors. These colors convey the sense that the pond and forest offer a peaceful, secluded spot of respite for the horse on a warm autumn afternoon.

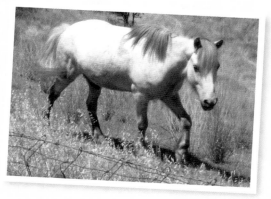

PORTRAYING TIME OF DAY This photo captures an early morning light, with its soft colors and the long shadows thrown by the low sun. To create an afternoon scene, change the colors and the shape of the shadows.

STEP ONE First establish the base colors with an underpainting. Use a large filbert brush to cover the entire canvas with loose strokes and washes of cadmium red light, azo yellow, and ultramarine blue. To make the horse stand out, paint the distant areas with dark blue-green and use mid-value tones where the white horse will be.

Horse Warm Midtones
cadmium yellow medium + white

Horse Cool Midtones
white + alizarin crimson + ultramarine blue

Horse Shadows
white + ultramarine blue + alizarin crimson + burnt umber

STEP TWO Next sketch the scene with a small round brush and mix of alizarin crimson and phthalo green. Place the horse on a diagonal, counterbalanced by the more horizontal water and trees. Make corrections by painting over unwanted lines with an opaque pigment. (White, cadmium yellow, and cadmium red all work well.)

STEP THREE Now block in large, dark shapes to establish the basic value structure and mood of the scene. First take a large filbert brush loaded with thin phthalo green, alizarin crimson, and ultramarine blue. Wash this color over the distant shore and groups of tree trunks, and use it to lay in the darks of the water with vertical strokes.

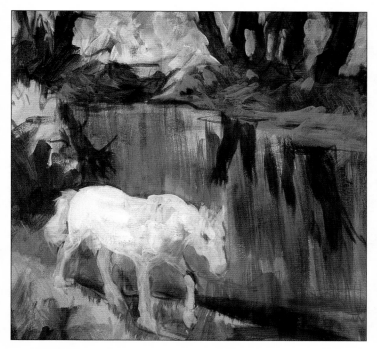

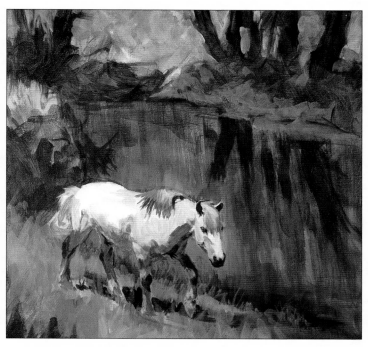

STEP FOUR Next block in the horse using white tinted with cadmium yellow medium. The distant foliage is azo yellow mixed with white; its reflections are mixes of cadmium orange and cadmium yellow medium. For tree trunk reflections, mix phthalo green, alizarin crimson, and ultramarine blue.

STEP FIVE Apply an ultramarine blue glaze—a thin, semitransparent coat of color—over most of the canvas, including spots on the horse. Then apply burnt umber over the shore and trees, white mixed with cadmium orange over the foreground, and cadmium orange and yellow in the grasses. Add a gray mix of alizarin crimson, phthalo green, and white to the horse.

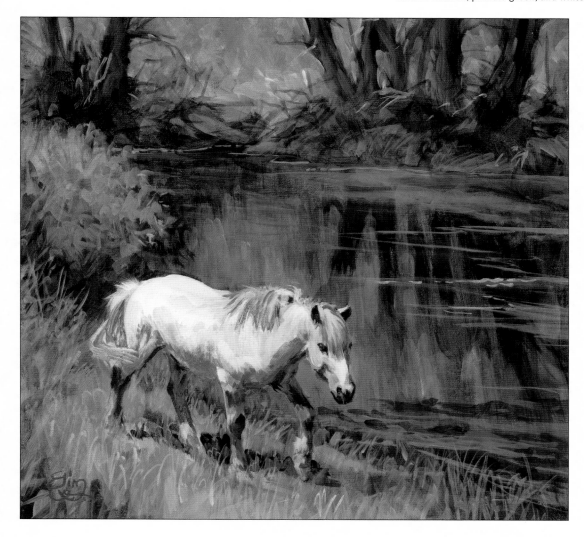

STEP SIX Next glaze green over the water for the algae and for the reflections on the water's surface. Then brush glazes of azo yellow and burnt umber across the tree trunks and leafy parts of the forest, taking care to keep the muted colors that set the mood of this piece. On the water, apply horizontal strokes of ultramarine blue and white, adding burnt umber in the darker areas. Next paint the light upper edge of the shrubbery on the left with sap green and azo yellow, flicking your brush to indicate leaves. Then use a small round brush for the final grass details.

Depicting Depth and Distance

To create the illusion of depth and distance, artists use a variety of visual cues. One of the most important of these is *atmospheric perspective,* which refers to the fact that particles in the air—such as moisture and dust—block out some of the wavelengths of light, making distant objects appear less distinct than near objects. Following the rules of atmospheric perspective, artists paint objects closest to the viewer with more texture, detail, and intense color, using increasingly less detail and more muted color for farther objects. Another way to enhance the sense of depth is to adjust the scale and overlap of objects. The rules of *linear perspective* dictate that, as objects recede, they appear smaller in scale (such as the way a road appears to taper off to a point in the distance). Overlapping emphasizes distance because objects blocking other objects are perceived as being in front and therefore closer to the viewer. To create depth in this scene, you will paint the stallion in the foreground with more detail, greater size, and warmer colors. Objects farther afield will have blurred edges, smoothed forms, and cooler colors, "pushing" them into the distance.

▶ **EMPHASIZING DEPTH** Use a sketch to work out the scale before you begin a painting. For example, in this scene, you should make sure the sizes of the animals in the distance are in proportion to the larger stallion's. Then roughly indicate the detail and texture the nearer horse will feature.

HORSE COLORS

Palomino Warm Midtones
cadmium orange + cadmium yellow medium + burnt sienna + white

Palomino Shadows
yellow ochre + burnt umber

Bay Base Color
cadmium red light + burnt umber

Chestnut Base Color
burnt sienna + cadmium orange + burnt umber

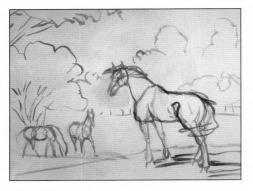

STEP ONE To create a warm backdrop for this scene, cover your canvas first with a mix of gesso and cadmium yellow medium. When this layer dries, add a thin application of cadmium yellow medium mixed with white and a touch of cadmium orange—giving the canvas a more textured appearance. Then mix phthalo green with alizarin crimson to roughly sketch the scene, first marking the horizon line along the base of the distant trees.

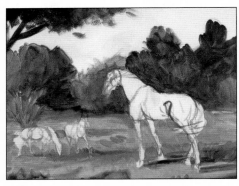

STEP TWO Begin by applying a dark green mix of phthalo green, ultramarine blue, and a touch of burnt umber to the distant trees and shadows on the hill, adding more burnt umber to paint the overhanging branch (which has a darker value because it is nearer). For the pasture, begin with a mix of ultramarine blue, white, and sap green in the distance, gradually adding cadmium yellow medium as you move toward the foreground.

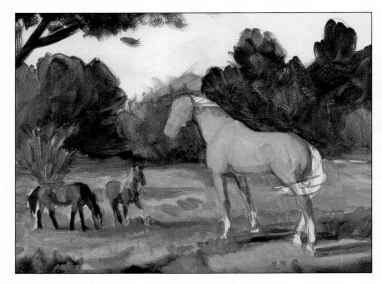

STEP THREE Next apply base colors to the horses. The nearest horse is a palomino, so use cadmium orange for the sunlit areas and yellow ochre mixed with burnt umber for the shadows. For the other two horses—a bay and a chestnut—use darker values of the umber mix, with the addition of cadmium red light for the sunlit portions.

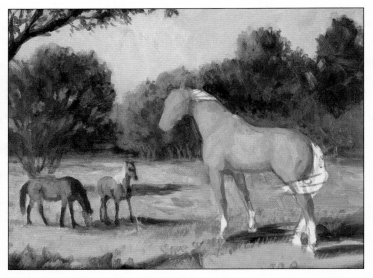

STEP FOUR Mix white, ultramarine blue, alizarin crimson, and yellow ochre for the sky, adding more blue as you move right, away from the light source. For the trees, stroke a warm sap green and yellow ochre glaze over sunlit areas and a cool phthalo green and ultramarine blue glaze over shadows. Then, using mixes already on your palette, develop the trees, grass, and horses.

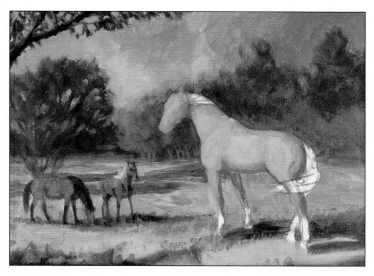

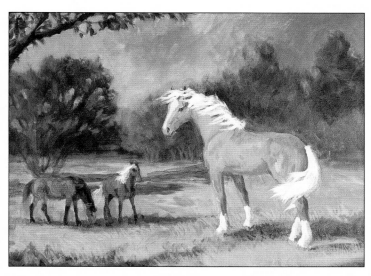

STEP FIVE If the color of the distant horses appears a little too bright and pure, tone it down by glazing burnt umber over the sunlit hides. The resulting grayed dark orange visually pushes the horses into the distance. Then use glazes of phthalo green mixed with burnt umber to add shadows to the middle-ground tree and under the two horses.

STEP SIX Add lighter glazes to the sky to complete the background. Now concentrate on the horses. Build up the palomino's form using layers of cadmium orange mixed with cadmium yellow medium, adding white for highlights. Then paint the horse's stockings, tail, and mane using white mixed with ultramarine blue and a little yellow ochre.

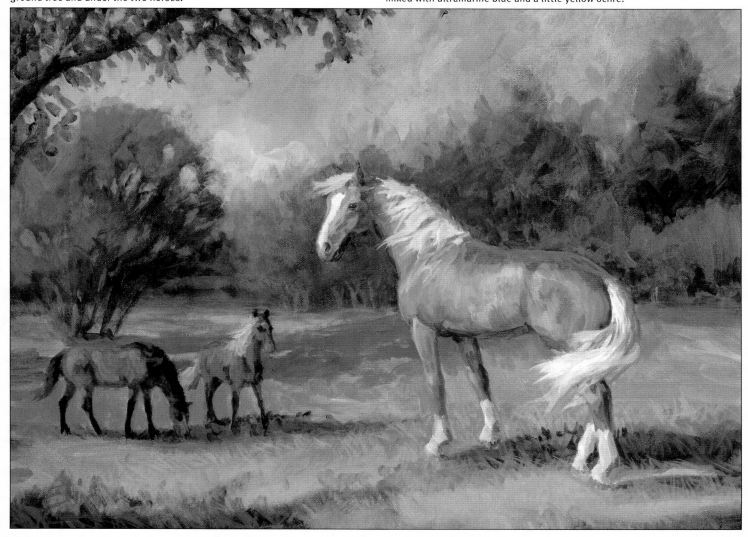

STEP SEVEN In this final stage, look at the painting in a mirror for a fresh perspective. This new viewpoint may reveal areas that could use some adjustment. Mix gel medium with azo yellow and glaze it over the sky, creating more visual interest with interweaving colors. Then, using the background greens, paint over the edge of the palomino's front leg to move it back into a more natural position. Next clean up the legs of the two distant horses, and tame the palomino's mane. Then paint a few more leafy, overhead branches. Finally touch up the palomino, using white mixed with cadmium yellow medium for highlights and burnt umber mixed with gel for more darks.

Understanding Foreshortening

An understanding of proportion along with some knowledge of *perspective* (the representation of objects in three-dimensional space to give the illusion of depth and distance) can help you produce a realistic scene on a two-dimensional surface. The farther away things are, the smaller they look; this is also true of parts of objects. Foreshortening causes the closest part of a subject to appear larger than parts that are farther away. Technically speaking, foreshortening is a technique for rendering objects that aren't parallel to the picture plane. Because of your viewing angle, you must shorten the lines on the sides of the nearest object to show that it recedes into the distance. For example, when viewing a horse in strict profile, the size of the head appears in correct proportion to the body. However, when viewing a horse from the front and at an angle, the head appears disproportionately large compared to the body; the sides are foreshortened. In this scene, foreshortening causes the horses in front to appear larger than the horses behind them, lending the lead team a powerful presence.

▶ **CREATING DRAMA** The angled viewpoint in this scene creates a dramatic impact. An extreme viewpoint such as this one—where the viewer is looking sharply up—further accentuates the size of the lead team, making them seem more powerful. For even more drama, you can use artistic license to change a scene; in this case, a rural setting and cold, winter weather will add to the painting's appeal.

STEP ONE Begin by covering the canvas with a thick mix of white gesso tinted with yellow ochre and alizarin crimson; this backdrop will add warmth to subsequent layers that you will add to the snowy scene. Next loosely sketch the placement of the teams of horses. To emphasize the size and strength of the lead team, place them above eye level. Draw lines above and below the horses to show the steep angle of the perspective, increasing the sense of the horses' power and presence.

STEP TWO Next use a small filbert brush and mix of ultramarine blue, phthalo green, and alizarin crimson to block in the first group of dark values. Use this first application of darks as a way to map and plan the basic value structure and balance of the total composition. Although you will use these blocks of values to guide the placement of colors and values for the rest of the scene, you can always modify this "map" as you develop the painting.

STEP THREE Next cover a good portion of the canvas, painting the sky, distant field, and snow shadows with a mix of white, ultramarine blue, and a touch of yellow ochre. Apply additional snow shadows using ultramarine blue mixed with white and grayed with touches of alizarin crimson and yellow ochre. Then mix alizarin crimson with burnt umber to paint the horses; for the lead pair, apply a dark mix of alizarin crimson and phthalo green.

STEP FOUR Now use a large filbert to add a unifying glaze over the sky, snow, and shadows under the horses using 50% matte medium with a mix of white, ultramarine blue, alizarin crimson, and yellow ochre. Then use the edge of a medium filbert and the black mix of phthalo green and alizarin crimson to add darks to the harnesses, manes, and shadows. Next add two small patches of vegetation using glazes of sap green mixed with phthalo green.

**Snow Shadows
and Sky**
*ultramarine blue +
yellow ochre + white*

Lighter Snow Shadows
*ultramarine blue +
white + alizarin
crimson + yellow ochre*

Horse Base
*burnt umber +
alizarin crimson*

Horse Darks
*phthalo green +
alizarin crimson*

Horse Highlights
*cadmium red light +
burnt sienna*

**Horse Highlights
and Harness Sheen**
phthalo blue + white

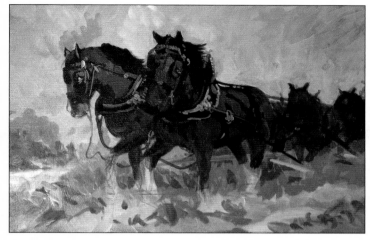

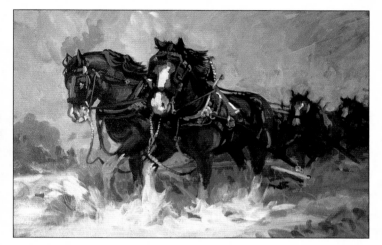

STEP FIVE Add interest to the sky and snow using lively brushstrokes to touch in mixes already on your palette. Next develop the harnesses and tack, starting with burnt umber for darks and phthalo blue mixed with white for sheen. Add the brass accents last, using a mix of yellow ochre, cadmium yellow medium, and cadmium orange. Then, with a red-toned mix of cadmium red light and burnt sienna, add large areas of midtones on the horses' hides.

STEP SIX Now paint the red ribbons with pure cadmium red light, adding alizarin crimson in the shadows. For the white areas of the horses, use white mixed with cadmium yellow medium for highlights and ultramarine blue mixed with white for shadows. Next apply white tinted with ultramarine blue in some places and phthalo blue in others to create highlights on the snow underfoot. Then apply highlights to the horses and tack.

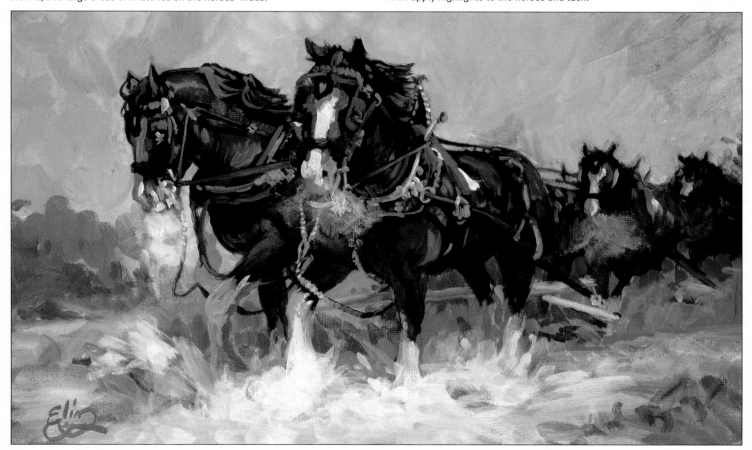

STEP SEVEN To create harmony in the composition, repeat the red hues of the horses in the background by mixing a reddish glaze of burnt sienna and ultramarine blue to accent the snow shadows. Then apply the final touch—the horses' steamy breath. It's important that you add this detail last because you want the other colors on the canvas to show through. Use a very small filbert and white with a touch of cadmium orange for the steam, mixing one part color to about nine parts medium for a very thin mix.

Developing Texture

One way to add interest and realism to your work is to include texture. Artists sometimes paint the illusion of texture; other times they create physical texture on the canvas. Because acrylic dries quickly, it lends itself to a variety of physical texturizing techniques. For example, you can apply thick applications of paint to build up layers of visible brushstrokes. You can also mix in additives, such as painting mediums, sand, or eggshells. And you can use tools and materials, like painting knives, sponges, or even plastic wrap! This portrait has a lot of textured elements—including shiny leather, smooth metal, and rough hides—so it offers the perfect opportunity to try your hand at creating true-to-life textures.

▶ **STUDYING STRONG CONTRASTS** The contrasting textures—smooth and polished versus rough and weathered—will help bring this portrait to life. But to add interest to the piece, you will develop other contrasts as well. In this composition the two horses are facing opposite directions. You will paint them with contrasting coat colors, as indicated by the shading in this sketch.

STEP ONE Start by covering the white surface with a thin wash of phthalo blue, ultramarine blue, alizarin crimson, and burnt umber, using visible brushwork for texture. While this is wet, spritz on rubbing alcohol with a spray bottle; the paint resists the alcohol to create a textured, mottled pattern, which will create interest anywhere it shows through in the finished painting.

STEP TWO Next mix a dark black with phthalo green and alizarin crimson, and—referring to the sketch above as a guide—draw the basic positions and shapes of the horses' heads. Loosely indicate where the details will be, concentrating primarily on getting the proportions right before you block in the color.

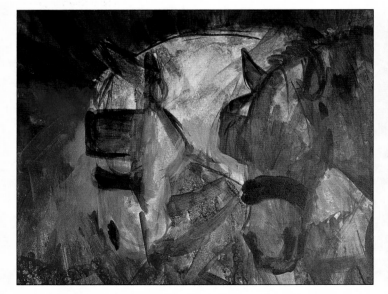

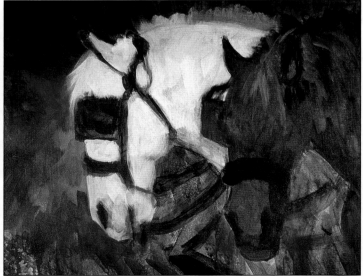

STEP THREE With a large filbert, glaze over the dark horse with burnt umber, using loose brushstrokes to produce more texture. Apply ultramarine blue to the dark areas behind the white horse. Then block in the harnesses using phthalo green mixed with alizarin crimson.

STEP FOUR Add phthalo green, ultramarine blue, and alizarin crimson separately to the background. Apply white mixed with cadmium yellow medium to the light horse and white, burnt sienna, and cadmium red light to the dark one. For the tack, mix burnt umber with ultramarine blue.

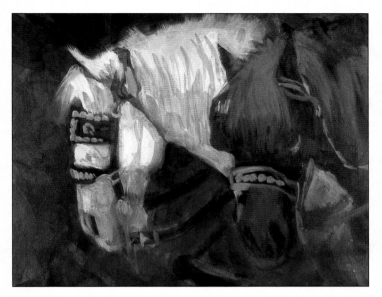

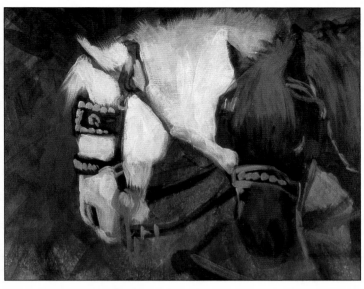

STEP FIVE Paint both harnesses with smooth strokes of phthalo green mixed with alizarin crimson. On the white horse's harness, add white highlights; then create the soft, textured hair of the mane using long strokes of white mixed with cadmium yellow medium and yellow ochre. For highlights on the dark horse's harness, use red with white and yellow with white.

STEP SIX Now apply thick strokes of phthalo green mixed with azo yellow, warming up the background as you build up a rough texture that contrasts with the silky hair of the white horse. Then glaze yellow ochre over the shadow side of the white horse's mane. Finally add a lot of matte medium to a little phthalo green to paint wispy shadows on the white horse.

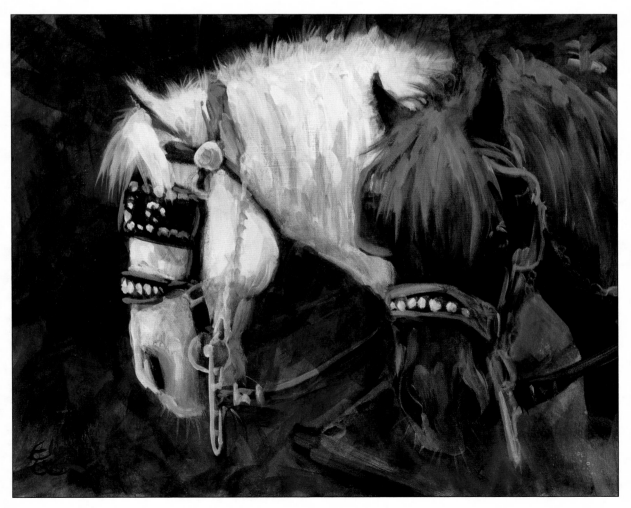

STEP SEVEN To add depth to the darker colors, glaze over everything but the white horse using ultramarine blue mixed with phthalo blue. Then turn to the white horse, adding highlights with the white and yellow mix. Next add smooth texture to the manes, softly stroking highlights over the shadows. For bridle accents, use smooth applications of grayed orange, using grays and pale ultramarine blue for the bits. Then brush on more background color to further develop the rough texture, and add stiff white whiskers to the muzzles.

Capturing a Likeness

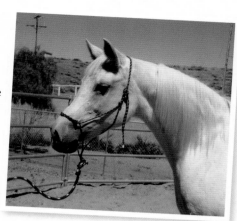

If you were to paint a portrait of your friends, you'd certainly want to accurately portray their physical characteristics, as well as capture their personality on the canvas. This, of course, is the artist's goal when creating any portrait—whether that of a person or an animal. When painting an equine portrait, it's helpful to know a bit about general horse structure and anatomy, but for an accurate likeness the most important thing is to capture the subject's unique qualities. First look for the basic shapes and contours of the subject; then concentrate on depicting the individual elements specific to your subject, such as the animal's wide-set eyes, smooth hair texture, or delicate muzzle. To create a true-to-life portrayal of this beautiful white Arabian, pay careful attention to its unique features, including its dished profile, large eye, and small ears.

▶ **WORKING FROM A PHOTO** It's rare for an animal to stay still for a portrait, so use a photo reference to study the sizes and relationships of the features. Measure from the top of the eye to the top of the head, using this as a basis for the size and placement of everything else.

STEP ONE Set the cool tone for this portrait with an underpainting of phthalo green and burnt umber. Cover the canvas quickly, mixing the colors loosely in some places and keeping them pure in others. Then randomly press a ball of plastic wrap into the wet paint; the mottled texture will create interest wherever it shows in the finished painting.

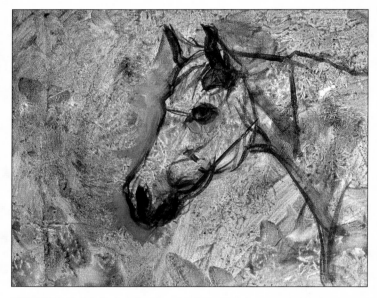

STEP TWO Sketch the head with a mix of alizarin crimson and phthalo green, paying careful attention to the placement of the eye, the width of the ears, and the length of the muzzle. Then add water to the black mixture to establish the darks, washing over the nostril, muzzle, eyes, and ears. Finally adjust the sketch using the background colors mixed with white.

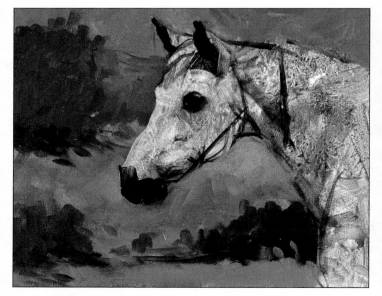

STEP THREE Next block in a background, using ultramarine blue mixed with white for the sky, phthalo green mixed with sap green for the foliage, burnt sienna mixed with white for the ground, and ultramarine blue mixed with alizarin crimson and white for the mountains.

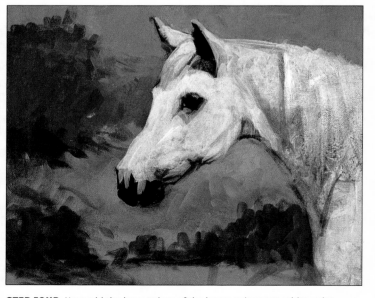

STEP FOUR Now add the base colors of the horse using pure white paint. For light values, mix in cadmium orange and cadmium yellow medium. For shadows, use a grayed purple mix of alizarin crimson, ultramarine blue, and yellow ochre with pure yellow ochre accents.

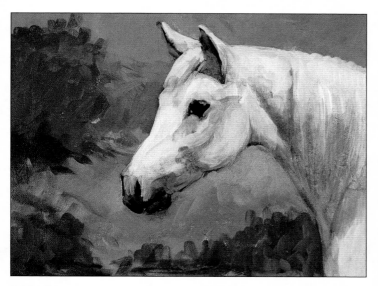

DETAIL ONE After establishing the shape of the eye, paint a flattened oval pupil using alizarin crimson mixed with phthalo green. Then paint the iris under the pupil with a brown mix of burnt umber and ultramarine blue. Add lashes and a bluish glaze around the perimeter to suggest moisture.

DETAIL TWO Now add warmth to the reflected light on the iris using a mix of yellow ochre, cadmium red light, and burnt sienna. Then lighten the cast shadow of the eyelashes with ultramarine blue mixed with white. To finish, highlight the cornea opposite the lightest area of the iris, and add a few lower lashes.

STEP FIVE Next apply thicker coats of white, mixing in cadmium yellow medium for highlights. Then glaze a 50-50 mix of matte medium and the grayed purple to add detail to the shadows. To create form, glaze white mixed with cadmium orange over the highlights.

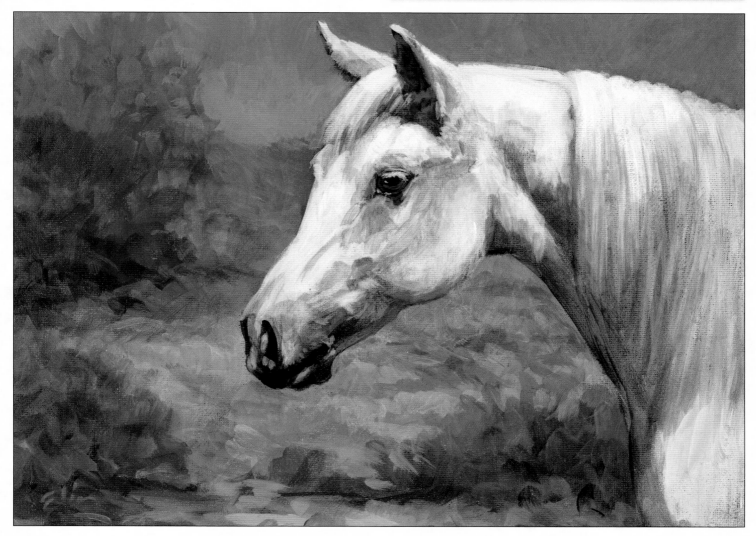

STEP SIX Now add white to the original background colors to produce lighter values, and work them into the sky and distant mountains. Then add a little cadmium orange to warm the bushes and bring them forward. Next finish the horse, starting with the eye. (See the details above.) Using a medium filbert, deepen the shadows and refine the horse's form with another glaze of grayed purple. Use the same glaze over the background to push it back in the distance. Next pull out details on the hide using lighter glazes. Then solidify the shape of the head and neck with another, lighter glaze of white mixed with a touch of cadmium orange. To finish, lighten the sky further with ultramarine blue and white.

Focusing on Foals

Foals are not just miniature horses—they have a number of unique physical attributes, including an almost entirely different set of proportions that make them distinct from their adult counterparts. For example, in adults, the measurement from the withers to the belly is almost equal to the distance from the belly to the ground; but in foals, the distance is nearly 1-⅓ times longer than the depth of the body. Foals' legs are almost as long as adults', but they have more upright hooves, created by a combination of the small size of the hooves and the proportionately long pasterns. And it's not only their bodies that are different. Foals' heads have less definition than adult horses' heads do—foals' jowls are less pronounced and their muzzles are much smaller in proportion to their heads. Even their hair is different! Most foals have short tufts for tails and brushlike, upright manes. In this painting, the subject is a young one-month-old, who exudes the awkward-yet-adorable character of youth.

▶ **CONSIDERING THE COAT** This foal is a lovely buckskin pinto, but its color won't stand out against the yellow-and-gold background you will paint. For contrast and interest, you will paint a bay coat instead of the buckskin color shown in the photograph.

FOAL PATCH COLORS

Brown Shadows
*burnt umber +
ultramarine blue*

Brown Highlights
*cadmium red light +
cadmium yellow medium +
white + yellow ochre*

White Shadows
ultramarine blue + white

White Highlights
white + cadmium yellow medium

STEP ONE Use a very large filbert brush and loose brushstrokes to cover the white of the canvas with both alizarin crimson and phthalo green. Make sure to leave visible brushstrokes; some of these textural marks will show through on the final painting, creating visual interest beyond the foal itself. Let the paint dry before moving on to the next step.

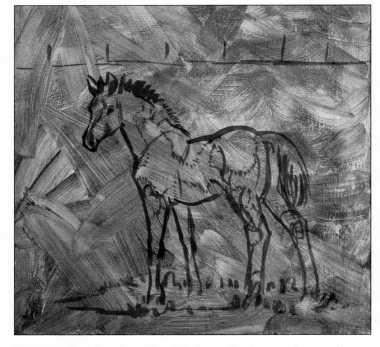

STEP TWO Next draw the outline of the foal on the canvas, using a small brush and a dark mix of alizarin crimson and phthalo green. Loosely block in the largest shapes, making corrections to your sketch where needed with the background color mixed with white.

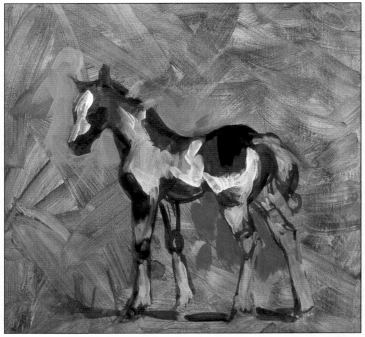

STEP THREE Now block in the pinto's coat, starting with grays for the white areas. For the darkest browns, use alizarin crimson mixed with phthalo green, which you should also apply underneath the foal to establish a cast shadow. For the medium browns, use burnt sienna.

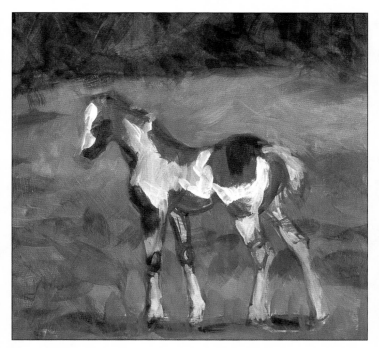

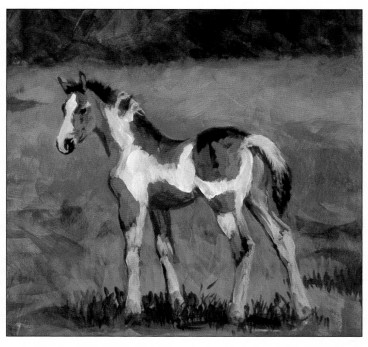

STEP FOUR Paint trees using phthalo green mixed with burnt umber. Then mix phthalo green with cadmium yellow medium to add the pasture and reshape the foal's head. Paint the light grass with sap green and cadmium yellow medium. Then add the shadows using phthalo green mixed with ultramarine blue.

STEP FIVE Using lighter background values, paint around and into the foal to refine its shape. For the sunlit brown patches, use cadmium orange and burnt sienna. Paint the grass at its feet with dark sap green and yellow, and the cast shadows with ultramarine blue and phthalo green.

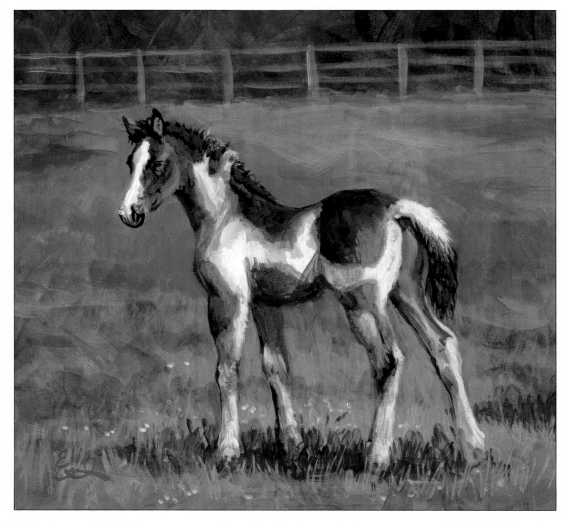

STEP SIX Next use a very small filbert to add white highlights to the light patches of the foal's coat, switching to cadmium orange for the brown highlights. Then add details to the nearby grass and finish the mane, tail, and face, all using a small round brush. Switch to a 50-50 mix of white and burnt sienna for the edges of the brown patches on the foal's coat, where they blend into the white hairs. Then, using white mixed with matte medium, add a distant fence, glazing over it with ultramarine blue. Finally touch in some orange and white flowers to better link the colors of the foal to the background.

Using Photo References

It's always a pleasure to paint from life, but there are times when painting on location is too impractical. When you're inspired by fleeting images—such as a horse racing across a track or cantering along a sun-dappled trail—quickly capturing the scene on canvas can present a challenge. One way artists meet this challenge is by using photo references. In essence, recording a moment on film stops the clock, giving you, the artist, the luxury of time. This makes it possible to experiment with the scene's composition and elements. Posing a mare and foal for a portrait—and getting them to stay in position—would be nearly impossible; so to depict a quiet moment with a mare and her foal, photo references are the best way to ensure success.

COMBINING REFERENCES

There will be times when you can't find the exact reference you're looking for and you'll need to use a little imagination—and your artistic license—to improve a background or adjust a pose. Another option is to combine references. When combining references, you can choose pictures from the same place and time, or you can use images that aren't related at all. Many artists collect photographs and other images for future use, organizing and storing their references in a file system called a "clip file" or an "artist's morgue." A good clip file is a great place for artists to look for inspiration.

THE FOAL This photograph captures a foal in a good pose with a sweet expression on its face as it looks over its shoulder. But using a photo of the foal by itself will mean finding an additional reference for the foal's mother.

THE MARE Though this is a poor photograph, the pose is perfect. Since the photo was taken at a different time and location, pay careful attention to scale when composing the scene—downsizing the foal in proportion to the mare. To add unity to the painting, you will paint them with matching coats.

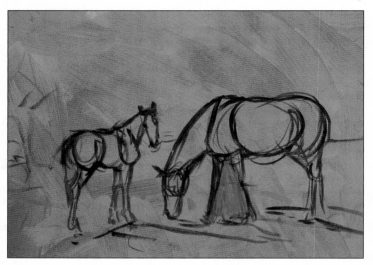

STEP ONE First cover the white canvas using cadmium red light thinned with water. When you prime a canvas with cadmium red, it produces a warmth that radiates through subsequent layers, unifying and enhancing a scene. After the undercolor dries, sketch the mare and foal on the canvas with a dark mix of phthalo green and alizarin crimson.

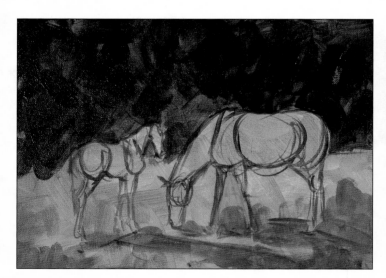

STEP TWO You may be using photo references for this scene, but that doesn't mean you have to follow them exactly. Begin with a background that suggests foliage, laying in the deepest colors first. Mix phthalo green with alizarin crimson to create a rich black, thinned slightly with gel medium. Then switch to yellow ochre mixed with ultramarine blue and a touch of cadmium red light to lay in the greenish base color of the pasture under the horses.

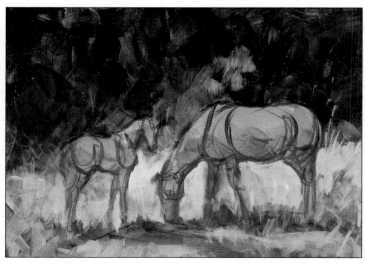

STEP THREE Now use a mixture of ultramarine blue, alizarin crimson, and yellow ochre to block in shadow shapes on the horses, which will serve as guides for the layers of lighter colors that will follow. Now use this mix to create an underlayer of color for the distant grass. Then apply a lighter color—a mix of white and yellow ochre—over the more distant dry grasses. For the highlights in the trees, use sap green mixed with yellow ochre.

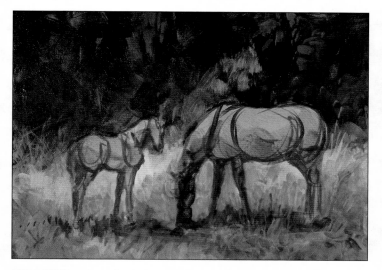

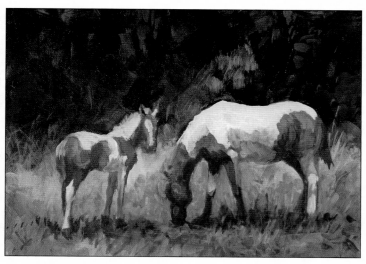

STEP FOUR Next use the dark mix of phthalo green and alizarin crimson to adjust the length of the mare's head. Then continue to work on the background, applying a mix of yellow ochre, alizarin crimson, and phthalo green to the grasses. Add ultramarine blue mixed with white into the trees to represent the sky peeking through the trees. Next add darker shadows to the mare and foal using burnt umber mixed with ultramarine blue.

STEP FIVE Now turn your focus to the mare and foal. First paint the sunlit white patches with a warm mix of white tinted with cadmium orange; then, for the shadows, switch to ultramarine blue mixed with white. For the sunlit brown patches, apply a mix of cadmium orange, cadmium yellow medium, and burnt sienna; use burnt umber mixed with yellow ochre for the shadows.

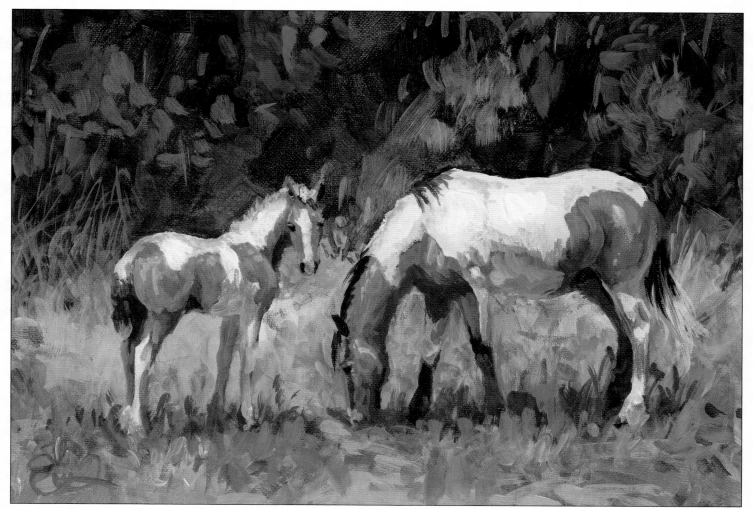

STEP SIX To finish, touch up details on the horses and the grasses. Check the photo references as you make a few refinements, working on and around the horses with the color mixes already on your palette. Further develop the distant trees using various combinations of burnt sienna, cadmium red light, and sap green. Then add a few more touches of the ultramarine blue and white sky mix in the trees to unify the background and horses. Deliberately include ultramarine blue in the background and in many of the shadows; this cool color leads the eye around the composition and toward the horses, with their complementary warm orange tones. You can take a number of artistic liberties in creating a setting for a scene; but by carefully copying the horses' poses in your photo references, you can create an accurate and realistic painting that would be difficult to achieve if you were painting from memory alone.

Conveying Quick Motion

To depict action realistically in a painting, it's not enough to simply pose a subject "frozen" in mid-move. Artists create the illusion of movement in a scene by incorporating a combination of techniques. For objects with some fluidity—such as a flowing mane or tail—curving lines can produce a sense of movement. Some artists use drybrush to create blurred brushstrokes that impart a sense of movement or speed; others simply soften some of the edges and details of the moving subject to make it look just a little out of focus, the way it would in life. Including diagonals increases the feeling of movement by drawing the eye in and along the angle. And asymmetry is another important action element: When you place a subject off-center, it implies that there is an entrance or an exit in the scene. For this racetrack painting, you will impart a sense of rapid movement by making most of the background slightly out of focus, keeping the details minimal and the edges soft. You will also create an asymmetrical composition; by placing the most dense objects on the left of the canvas, the galloping horse appears to be leaving the grandstand behind and running into a wide open space.

Racehorse Darks
alizarin crimson + phthalo green + a touch of burnt umber

Racehorse Midtones
burnt sienna + ultramarine blue + cadmium red light

Racetrack
burnt umber + cadmium orange + yellow ochre + white

Bushes Behind Track
cadmium yellow medium + phthalo green + white

STARTING WITH A SKETCH Create a sketch detailing elements that will show action, such as having all four hooves lifted off the ground and a trail of dust behind. You can also make a few adjustments on your canvas to accentuate the sense of movement, such as creating a larger open space in front of the horse—one twice as big as the space behind (as shown in this painting).

STEP ONE For the underpainting, thin a mix of phthalo green and alizarin crimson with water to create a light, gray-green wash. Then apply it over the entire canvas using a large filbert brush. When the underpainting is dry, use a small filbert brush and a dark mix of alizarin crimson and phthalo green to loosely sketch the shapes of the horse and rider.

STEP TWO After blocking in the darks of the horse and the bushes behind it (see color samples), add trees with a mix of phthalo green, yellow ochre, and white. Mix burnt umber with white for the clubhouse. Then fill in the sky with a mix of ultramarine blue, white, alizarin crimson, and yellow ochre, adding burnt umber for the grandstand and clubhouse detail.

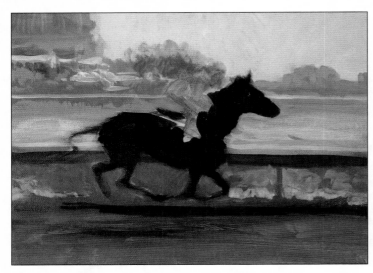

STEP THREE Next block in the racetrack and railing, adding shrubs between the rails. (See color samples.) Add a cast shadow under the horse using alizarin crimson mixed with phthalo green and a touch of burnt umber. For details in the background shrubs, use a small filbert and gray mixes of cadmium yellow medium and ultramarine blue, sometimes adding burnt umber. Then add details to the clubhouse with ultramarine blue, white, alizarin crimson, yellow ochre, and burnt umber, using more burnt umber in the shadows.

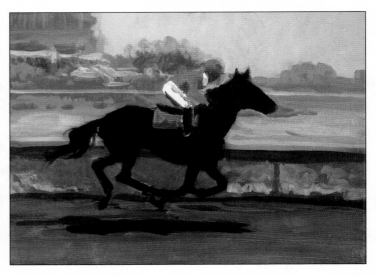

STEP FOUR Now start to refine the form of the racehorse by applying a darker variation of the base color. (See color samples.) After you create an accurate silhouette, paint the jockey's black boots. Then switch to cadmium red light to block in the jockey's silks and helmet; for shadows, mix alizarin crimson with cadmium red light. Next paint the white pants and collar, using white with a touch of cadmium yellow medium for the base and white with a touch of ultramarine blue for shadows.

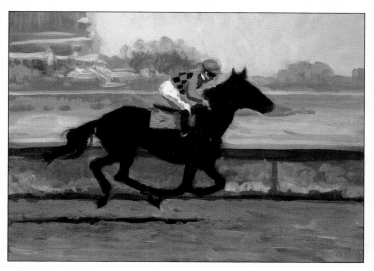

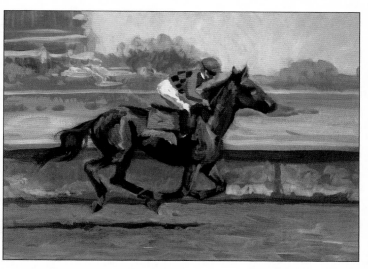

STEP FIVE Now add another, lighter layer to the racetrack, using the track mix of burnt umber, cadmium orange, yellow ochre, and white but with more white added. With a very small round brush, apply white mixed with cadmium red light to the jockey's face and hands, using burnt umber instead of red in the shadows. Then add details to the jockey's uniform, adding checks and goggles using a black mix of phthalo blue and alizarin crimson.

STEP SIX For the midtones of the horse, first apply mixes of burnt sienna, ultramarine blue, and cadmium red light with a small filbert, adding white for highlights; then use burnt sienna mixed with cadmium orange. For black areas with sheen, apply ultramarine blue mixed with white and phthalo blue mixed with white. Switching to a small round, add a second, lighter layer to the hooves—a mix of ultramarine blue and white grayed with burnt umber.

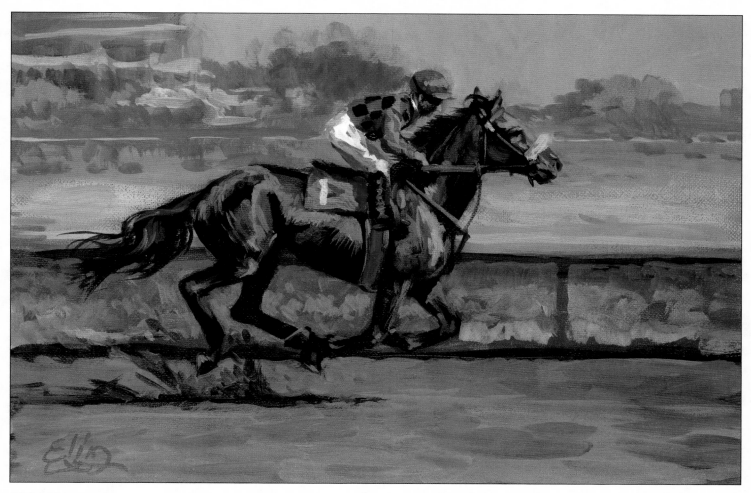

STEP SEVEN Now move on to the final details. First add the horse's tack. With a black mix of phthalo blue and alizarin crimson, place the bridle; for highlights, add white to the mix, sometimes tinting the highlights with ultramarine blue as well. Paint the saddle girth using ultramarine blue with a touch of white and use yellow ochre to indicate reflected light from the track on the girth. To finish the track, add more white to the original color, and then lightly glaze over the surface to give the ground a smooth appearance. As you move down the canvas, add more cadmium orange. Finally paint the noseband and add a dirt cloud behind the horse to complete the scene. In the finished painting, notice that the only hard edges that exist are those on the faces of the horse and jockey. Keeping the number of hard edges to a minimum—and softening the few remaining edges where there are color and shape transitions—helps to convey the illusion of motion and sense of speed that are integral to this scene.

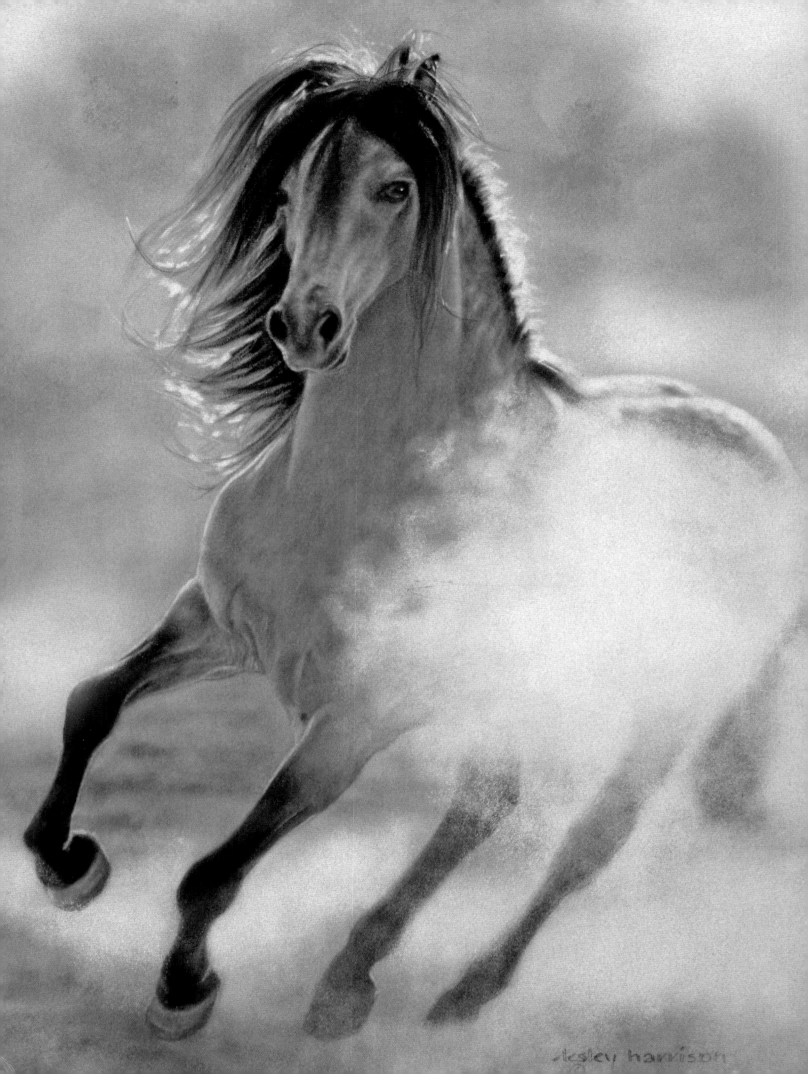

lesley harrison

Horses in Pastel

with Lesley Harrison

It's funny how life sometimes comes full circle. In the 1970s a Walter Foster book inspired Lesley Harrison to start working in pastels on velour paper. That book was about horses—and here she is, more than 30 years later, teaching you how to draw and paint horses with pastels. She invites you into her artistic world and shows you how to paint a variety of beautiful horses in pastel. This chapter explains the tools and materials needed to begin a journey in pastel, and then Lesley's own techniques for achieving breathtakingly realistic paintings are explained in detail. From a prancing buckskin pony to a kind and docile Arabian, you'll learn to paint horses of all shapes and colors.

Pastel Tools & Materials

PASTELS

You will need a set of soft pastels and hard pastels. You have many choices and may find that something different works best for you, but here are a few notes to get you started.

Soft pastels: Soft pastels can be used for the undercoats of color, whether for the sky in the background or the horse's coat.

Too soft: A pastel may be too soft if it fills up too much of the *tooth* (grooves or dips) of the paper early on and prohibits additional colors from going down on top.

Hard pastels: Sharpen hard pastels and use them to create detail, such as hair, whiskers, hooves, and blades of grass.

Too hard: A pastel may be too hard if it is very difficult to even tint the paper with the color.

PASTEL TIPS

• Only keep the pastels you are currently working with on the side of your drafting board. This will allow you to easily find the correct color and not pick up the wrong pastel.

• Rembrandt has a wonderful large range of grays in just the right consistency for velour paper—not too hard, and not too soft.

• Breaking a soft pastel into smaller pieces is often helpful for smaller areas. This is a little painful to do with a beautiful new pastel, but you'll soon realize how much more manageable it is to lay in color in smaller areas.

VELOUR PAPER

There are many wonderful papers to use with pastel these days. Try as many of them as you like. Then compare them to velour paper and see which you enjoy and feel the most comfortable using.

Velour paper comes in many colors. You can buy it by the individual sheet and find the colors that best suit your style and personality. Light gray, light blue, and beige tend to work for equine drawings.

You can find velour paper at most big art supply stores and also through mail order. You might consider having it mounted so that it is more stable to work on and doesn't buckle later after it is framed.

These scraps of velour paper are leftovers trimmed off a larger painting. Keep them for experimenting or for a smaller painting or study.

VELOUR PAPER TIPS

• Using a very light touch with a soft pastel on velour paper will allow you to rework an area later because the paper will only pick up a tint of the color. A heavy hand on velour fills up the tooth—or nap—of the paper quickly, and then you are out of options.

• Any time there is a substantial amount of white in a painting, use a light gray velour paper to achieve a clean, clear white. As you add other colors, the white will always bleed through a bit.

• Until you become comfortable with how much pressure it takes to transfer your lines from a sketch to the paper, practice on a scrap piece of velour. You will get a feel for it more quickly and won't have to worry about damaging the piece on which you want to paint.

CARBON PAPER

Use carbon paper, available at any office supply store, to transfer a sketch onto the velour paper. It can be almost impossible to get rid of lines drawn directly on velour.

BLACK CONSTRUCTION PAPER

While pastel doesn't smear as easily on velour paper as it does on other types, the oils and perspiration from your hand can change the nap of the paper. This will make the surface harsher and difficult to rework. To prevent this, cover the areas that are already finished with black construction paper so your hand doesn't damage the artwork.

You can also create a window around a difficult area, such as an eye, with strips of black construction paper. This will focus your concentration on the area so you don't get distracted by what you see in your peripheral vision.

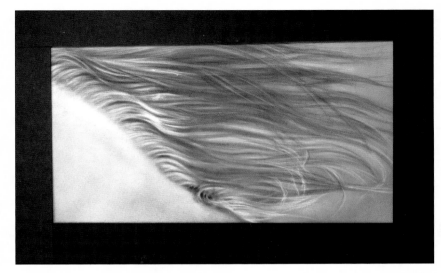

Black construction paper has several uses, such as protecting finished areas of the painting or creating a frame of focus for an area of detail as shown above.

ADDITIONAL TOOLS

A) Pastel pencils. You may choose to use pencils instead of hard pastels in your painting, especially if you find the color you need in a pencil but don't have it in a hard pastel.

B) Pastel holders. You'll need two different sizes, larger ones for soft pastels and smaller ones for hard pastels.

C) Masking tape. Keep black construction paper (see above for uses) in place with masking tape as you move it around on your painting. Don't place the tape directly on the velour paper but instead tape the construction paper to other sheets of paper or to your drafting board.

D) Blower brushes. These brushes help remove any unwanted pastel from a painting without damaging the paper. They can be purchased at camera or drug stores.

E) 9B graphite pencils. Use a 9B graphite pencil to create your sketch on a separate sheet of paper and then transfer it to the velour with carbon paper.

F) Razor blades. You can carefully sharpen your pastel pencils with a razor blade. This will expose the pigment, and you can then sharpen them to a fine point on some sandpaper.

G) Sandpaper. Use small sandpaper blocks or a large sheet of sandpaper stapled to a block of wood to sharpen hard pastels or pastel pencils.

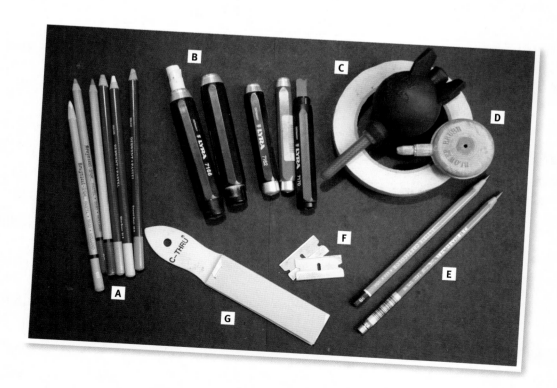

Pastel Techniques

If you have ever knitted, there are only two stitches you need to learn. Any pattern is just a variation of those two stitches. The same is true with pastels: There are really only two different strokes you need to learn and practice. One has a smooth look, using very little pastel, so that the strokes can be laid down one layer on top of another. The other stroke style creates fine lines that can become fur, hair, whiskers, or blades of grass.

SMOOTH SHADING VS FINE LINES IN PENCIL

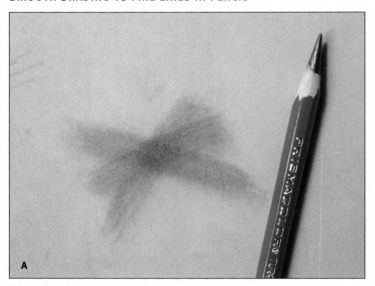

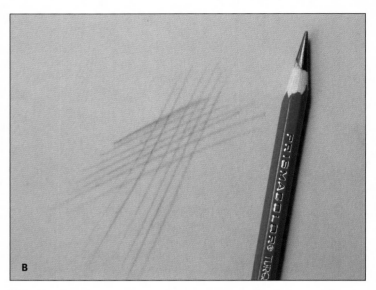

The same two strokes used with pastels also apply to working with a 9B graphite pencil to create your initial sketch for a painting. Create (A) smooth color using the side of the lead in a crosshatching motion or (B) fine lines with the sharpened tip of the lead.

FINE LINES IN PASTEL

To create fine lines, sharpen a hard pastel with sandpaper until you have four sharp edges. Then use these edges to stroke fine lines onto the paper. This creates the look of hair, fur, grass, or anything with a fine edge. When your hard pastel no longer delivers a fine line, simply sharpen and repeat. This technique allows you to create fine, delicate work, for which pastels are not necessarily known. The secret in achieving this look is sharpening and re-sharpening. In addition, the corner where two edges of a sharpened pastel meet is perfect for making small dots of color.

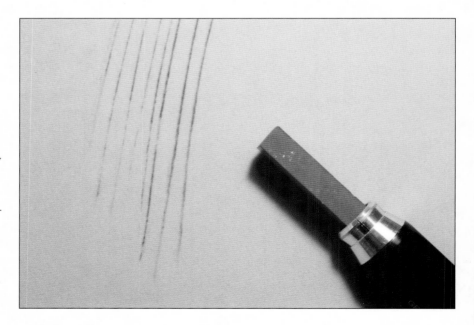

▶ This hard pastel was sharpened into four blunt edges on a sandpaper block to make these fine lines.

> ✣ TIP ✣
> *Use the sharpened edge or tip of a hard pastel for fine lines.*

✤ T I P ✤

Use the side of a soft pastel for smooth shading.

SMOOTH SHADING IN PASTEL

You can obtain a smooth look, such as shading for large areas of color, in your paintings by using the long side of a pastel. As you stroke the pastel onto velour paper, you want just a little color coming off the stick. That way the nap of the paper won't completely fill with pigment, and you will be able to add more colors and layers on top. To do this, lightly crosshatch the color back and forth across itself until you build up a smooth layer. As you add the next color, your pastel will press the layer underneath into the paper to help add depth.

SHADING WITH HARD PASTELS

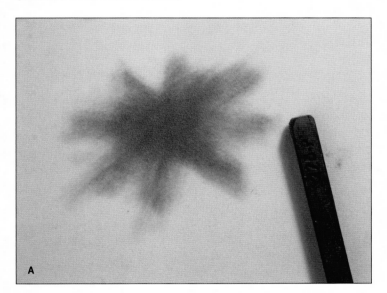
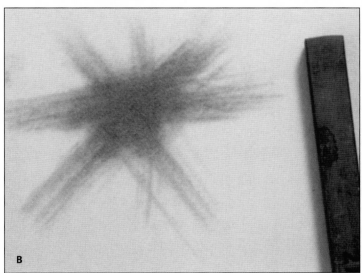

Shading with an unsharpened hard pastel (A), you can achieve broader, softer strokes of color than with a sharpened hard pastel (B). Crosshatch the color in four different directions. The area in the very center should be even and smooth with no edges or ridges of color showing as individual marks. It's a good idea to practice on scrap paper until you feel you are getting a very smooth look with your color.

SHADING WITH SOFT PASTELS

Use a light touch when you work with soft pastels. Because they are softer, they naturally leave a lot more pigment on the paper. This demonstration shows you how to practice layering three different colors using smooth, crosshatching strokes with the side of your pastels. After you place the layer of yellow (A), you'll likely notice that the ripples of the paper show through the color. As you add the next layers of color, they will help push the yellow down into the nap of the paper for a smoother look. Next, cover the yellow with pink (B) and see how smooth the paper and layers now look. Then, add light purple on top (C) and, again, notice how this third layer covers the other colors and continues to smooth the surface.

121

Dust Cloud

Buckskin ponies are so pretty because their coats are always a shade of gold and their legs, manes, and tails are black—a striking contrast. In this painting, the same pony you'll paint in the Childhood Magic project (page 134) is on his feet and moving right toward you.

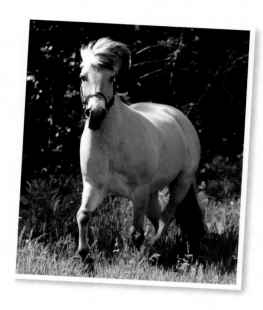

COLOR PALETTE

black, blue, dark blue, dark gray, gold, golden brown, light blue, light gold, light gray, medium gray, reddish gold, warm brown, and white

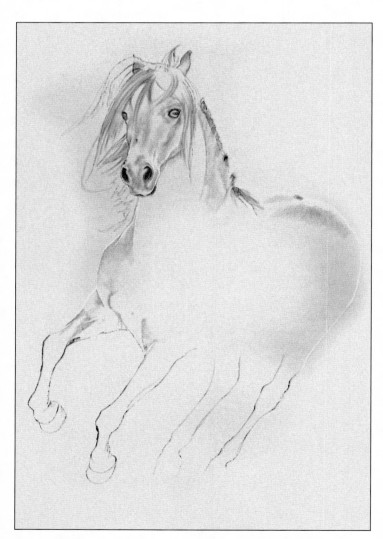

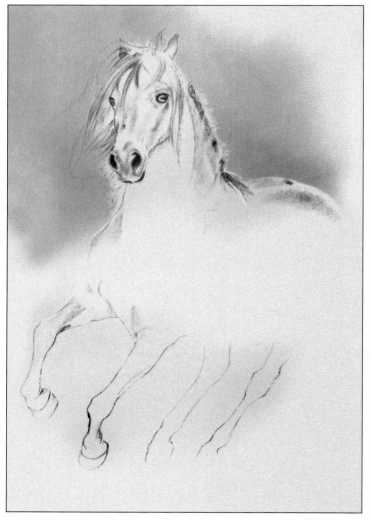

STEP ONE Use a light gray sheet of velour paper for this painting because you'll be able to apply light colors on top without the gray of the paper bleeding through. Transfer your sketch onto the velour with carbon paper and a 9B graphite pencil. Add more detail in pencil directly onto the velour in his face, mane, and back. With a white hard pastel, add thin highlights along several outside edges for a backlighting effect as well as in his face.

STEP TWO Use the side of a light blue soft pastel to crosshatch some color in behind him. Crosshatch smaller strokes as you get closer to the edge of the pony so you don't smudge blue across his body.

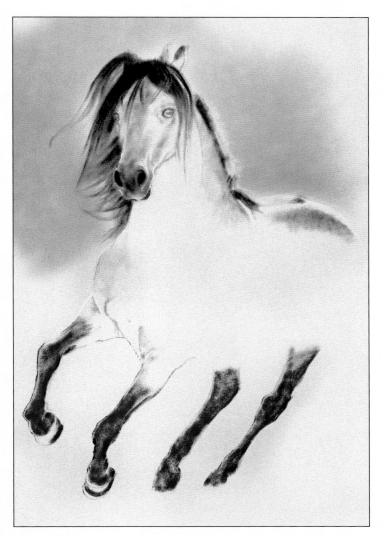

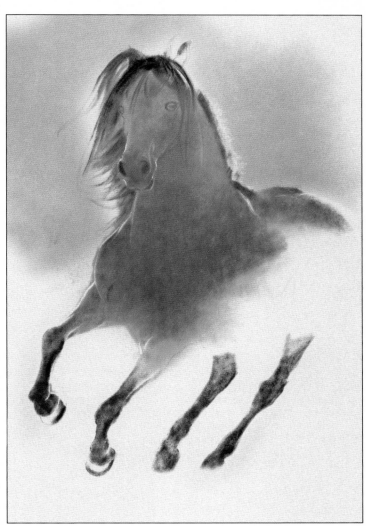

STEP THREE With a dark blue hard pastel, create an undercoat for the black that will later color his legs and mane. Add blue in the shadow areas on his face and muzzle, the tip of his ear, and his rear end. Use an unsharpened golden brown hard pastel in the mane to help give it the glow of the light shining through it.

STEP FOUR Find a nice gold soft pastel and use the side of it to cover most of his body, except for the blue in his mane and legs and the back area where the dust cloud will later be. On top of that, add a golden brown soft pastel. Use the side of the pastel and crosshatch in smooth strokes of color.

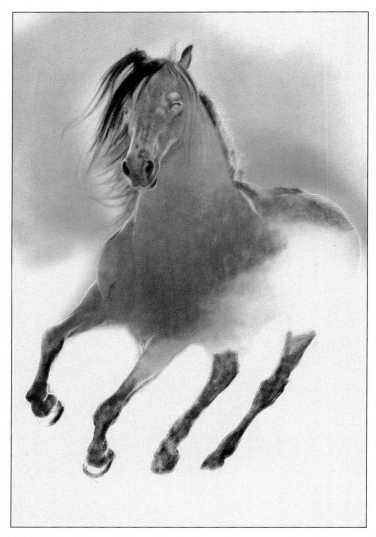

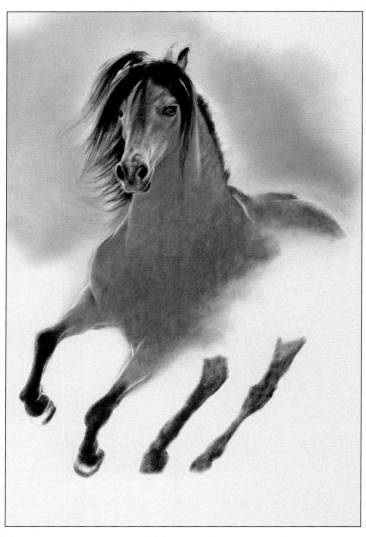

STEP FIVE Use a sharpened dark gray hard pastel to go over his forelock and mane. Your strokes should follow the direction the hair is flowing. With the sharp side of the pastel, darken both of his nostrils and lower lip. Then crosshatch the same dark gray in little straight strokes on his forehead and down the front of his face.

STEP SIX Repeat everything from the previous step, but this time use a sharpened black hard pastel on top of the dark gray. It takes patience, but, in the end, the layers will add depth and substance to the painting. The mane, tip of the ear, inside of the nostrils, and bottom lip all require fine lines of black.

> ⟩ T I P ⟨
>
> *The lighter the horse's coat, the lighter the eye color. Buckskins and Palominos (gold body with white mane and tail) tend to have more of a golden brown eye color instead of a deep chocolate brown.*

The eye on the right has more light in it, so give it more color and detail. With the sharpened edge of a black hard pastel, draw in the top and bottom eyelid and add a dark rectangle in the middle. Use a reddish gold hard pastel to fill in the rest of the eyeball. With a sharpened light gray hard pastel, add a dot of color in the corner of his eye and the black pupil to show the reflection of light. Finally, with a very sharp light gold hard pastel, add a halo of color near the bottom eyelid.

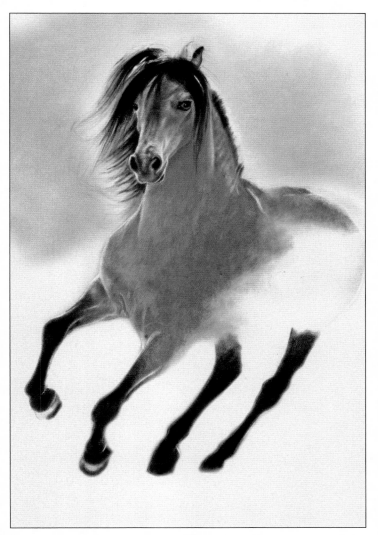

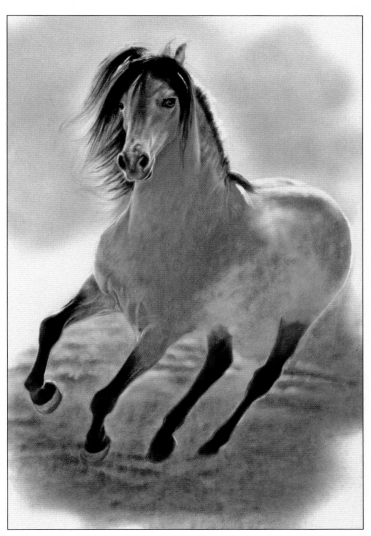

STEP SEVEN With a dark gray hard pastel, stroke in a light layer of color on the top side of his neck, along the mane. Then use a sharpened light gray hard pastel to start showing the contours in his chest and shoulder. The top or side of the muscle contours will always be lighter, depending on which direction the light is coming from.

STEP EIGHT Add a layer of gold soft pastel and then a layer of golden brown soft pastel where the dust cloud will be, just as you did with the rest of the coat. He needs some ground to stand on, so lay in a warm brown soft pastel with shadow areas in a dark gray soft pastel. Lay the colors in lightly and then quit. Don't overwork it.

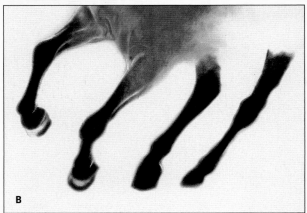

Darken the legs first with (A) a layer of dark gray hard pastel on top of the blue. Then add a final layer with an unsharpened black hard pastel (B).

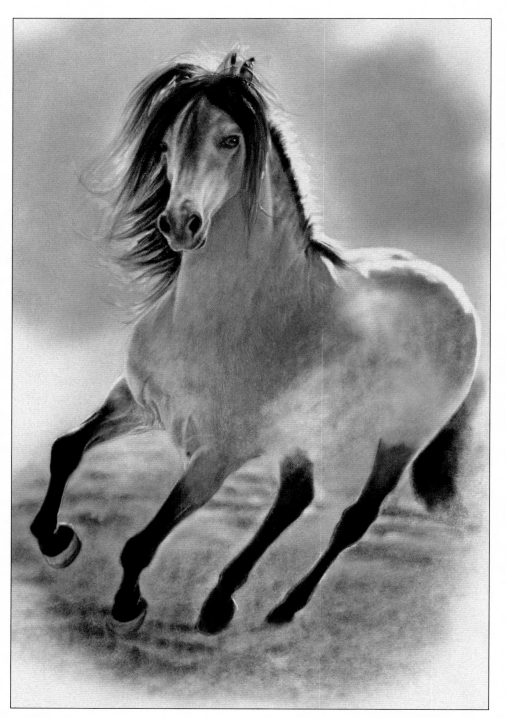

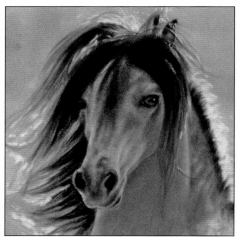

STEP TEN For the finishing touches on his head and mane, use a white soft pastel and black hard pastel. Add some bright white in his mane. Then sharpen the black pastel and drag some more strands of his mane out away from his body. Add a few more fine lines of black on top of his head and around the ear. Then, to make the eye on my right just a bit smaller, move the bottom lid up a little higher by drawing a fine line of black. Punch up the sky in the background with a blue soft pastel that's deeper than the first layer of blue. Use the side of the pastel to drag off a lot of pigment rather than try to blend it with crosshatching. Do the same, in just a few spots, with a gold soft pastel. Gold and blue always look great together. Plus, you'll emphasize the pony's color by adding a little of it in the background.

STEP NINE Use the end of a dark gray soft pastel and gently add some color in the basic shape of a tail so it will show through the dust a bit at the end. Using a soft pastel, lay down large areas of white on the top sides of his rear end, where the light is hitting him. Add more detail to the forelegs with a sharpened medium gray hard pastel. Gently crosshatch color to define his knees and fetlocks. Color his front hooves with some of the gray and gold used in his coat.

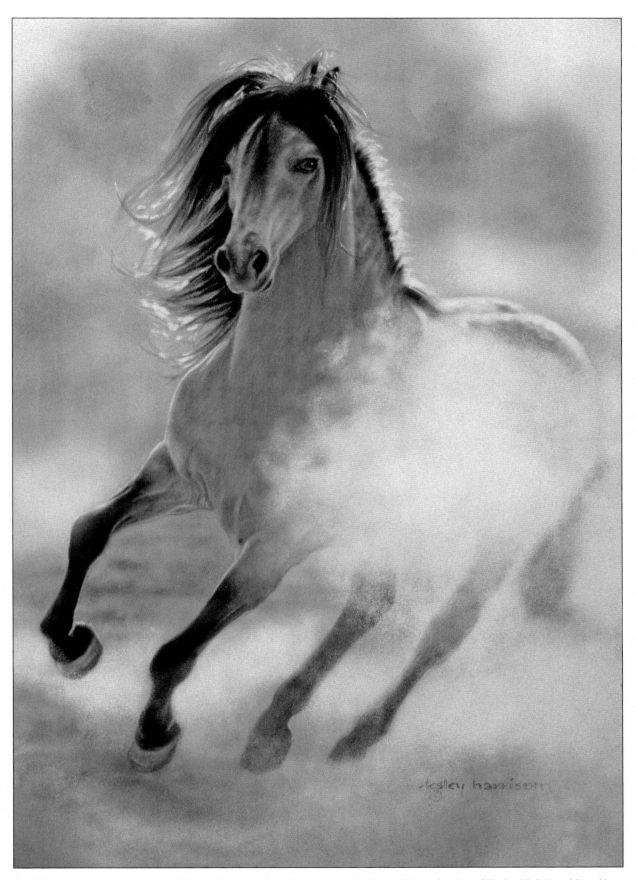

STEP ELEVEN Add a few final lines of black with a hard pastel on his shoulder. Then enhance the glow of the backlighting with a white soft pastel to rim his shoulders, legs, and rear end. Use a gold soft pastel on the corners just above his knees and rear end. For the dust cloud, use the broad side of a light gray soft pastel. First run it across a sandpaper block to loosen up the pigment. This allows the color to come off very easily. Lightly run the pastel over his back legs and tail so the dust cloud is semi-transparent. Then loosen up the pigment again on the sandpaper and leave a heavier dust cloud over his body and at his feet.

Free Spirit

A lot of artists say they are intimidated by painting anything black. And, yes, the color can be difficult to photograph or paint because it tends to absorb all the detail that gives an animal or object its contour and shape. Just follow along with this project, and you'll pick up several tips and tricks for portraying black horses. The most important of these tips is: Do not touch a black pastel until later in your painting.

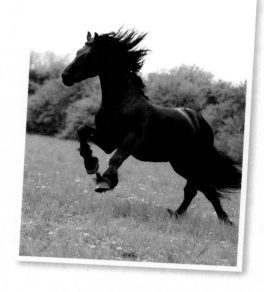

COLOR PALETTE

black, dark blue, dark gray, dark greenish blue, light blue, light gray, light greenish blue, purple, reddish brown, warm brown, and white

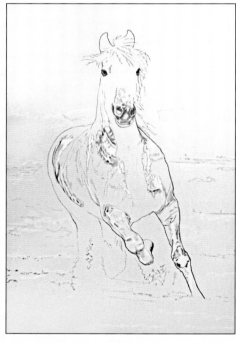

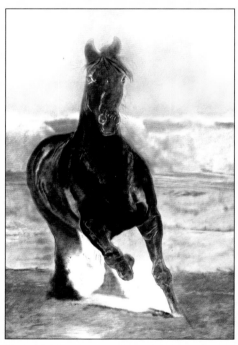

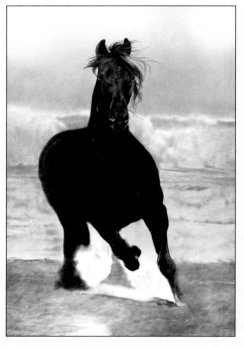

STEP ONE On a piece of light blue velour paper, transfer your sketch of a Friesian mare running on the beach using carbon paper and a 9B pencil. Then use a hard white pastel to map out where the whitecaps in the ocean and highlights on the horse will be. Starting with blue paper offers a distinct advantage for the background of sky and ocean in this particular painting.

STEP TWO As an undercoat for black, use dark blue or purple (or both) in a soft pastel. Build on top of that with a very dark gray layered over all of the dark blue. With a soft pastel in a light greenish blue, start to build color in the ocean and sky. Stay away from the white areas as much as possible but if you accidentally go over some of the white with blue, it will still be workable later. For the sand, use the side of a warmish brown soft pastel as a base coat.

STEP THREE Start to define the darkest areas of the horse's coat with a NuPastel black. Use the same color to fill in the eye sockets. This is a very gentle, soft black that feels more like a dark gray. Once you've built up a dark tone, start adding detail to her head and face with a light gray NuPastel that's sharpened to four keen edges. Carefully bring out the highlights in her face using a very light rubbing stroke. With a light gray soft pastel, fill in the sky from the top of the paper down to the blue you've already added above the whitecaps. Then use a darker light blue to fill in the sky near the whitecaps just a bit.

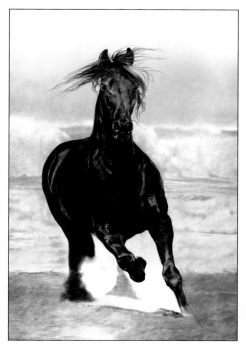

STEP FOUR Using the same technique and light gray from the previous step, add highlights throughout the rest of her body. These highlights define her form, and the large area of dark color now begins to look like something recognizable. Sharpen your NuPastel black and start stroking some of her forelock out away from her forehead. Balancing the lights and darks is what gives her face definition. Identify the needed highlights and crosshatch them in using a sharpened light gray or even white hard pastel. Add a semicircle of a reddish brown hard pastel in the bottom of both eyes and a dot of white highlight in the corner of and above the left eye.

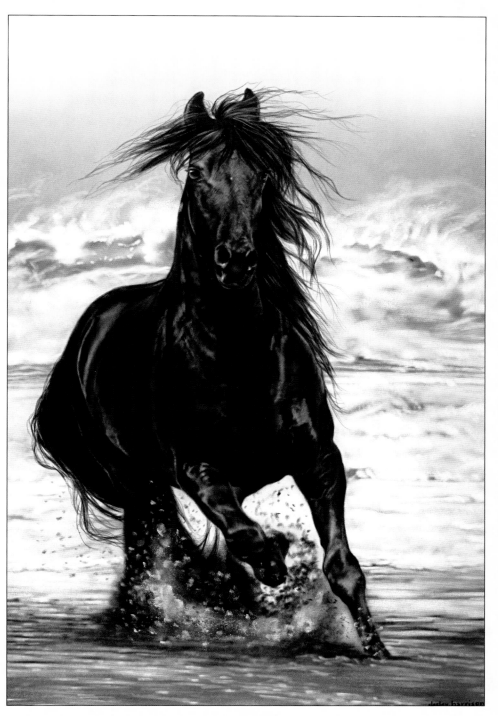

STEP FIVE Build the tail and mane starting with dark blue and dark gray before using a soft black. Pick out the highlights with a very sharp light gray hard pastel as you stroke the color in the direction the hair is flowing. Then bring out a Rembrandt black for added contrast and punch in the darkest areas. Bring up the light grays a bit using the edge of your pastel. To finish the sand, cover the whole area with a dark gray soft pastel. Then use the tip of a white hard pastel to add the streaks of water. With the same colors, kick up some water and sand around her feet using short choppy strokes. With water, less is more, so use only three colors for the ocean: light greenish blue, dark greenish blue, and white. Use the smooth sides of your pastels to lightly and quickly lay in color. To achieve the light, airy look of the spray that the wind blows off the top of waves, choose your softest white pastel and just barely touch the surface so the pigment lightly attaches itself to the paper.

The Aristocrat

Many inexperienced artists dislike painting white horses because they appear to be "boring" subjects. This assumption couldn't be further from the truth; not only do their white coats show every little nuance of their anatomy, but they also reflect any strong color that is near them, making them beautiful and sometimes difficult subjects to paint.

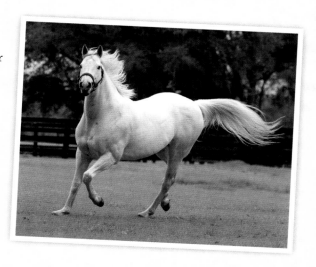

COLOR PALETTE

**black, dark blue, dark gray, light gray,
medium gray, reddish brown, white**

STEP ONE For this white horse, use a light gray velour paper. After transferring your sketch to the paper with a 9B pencil and carbon paper, add more detail in pencil to provide a map for the project. With a sharpened white pastel, mark where his mane and forelock will be.

STEP TWO Start to define the horse's eye as well as some of the blood vessels, tendons, and bones in his face. Carefully begin this process with a 9B graphite pencil and use the side of the lead to shade contours. Then use the tip of a sharpened dark gray pastel pencil to lay down crosshatching on top of the pencil. This will deepen the color and enhance the contours. Then use the side of a soft medium gray pastel to establish a base color in smooth, crosshatching strokes.

✦ TIP ✦

There are never any strong lines except for along the edges of a horse's head. It is the shading of lights into darks that creates the look of contours and shapes throughout the facial features.

→ T I P ←

A white horse will reflect the colors around him. With this stallion, the reddish brown you see on the underside of his face and neck is a reflection of the ground upon which he is standing.

With the tip of a white NuPastel, gently crosshatch color in between the shadow areas. Be careful not to paint over all the detail you worked so hard on earlier.

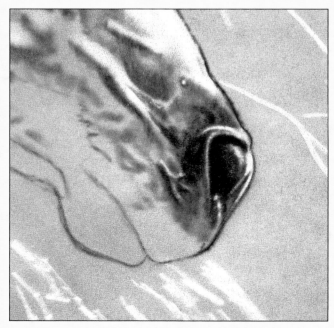

Use a dark gray NuPastel (#259) to define the darkest areas of the muzzle: in the nostril, under the veins, and on the outside of the nostril. Using the tip of the pastel and crosshatch strokes. The whites and light grays nearby are left untouched.

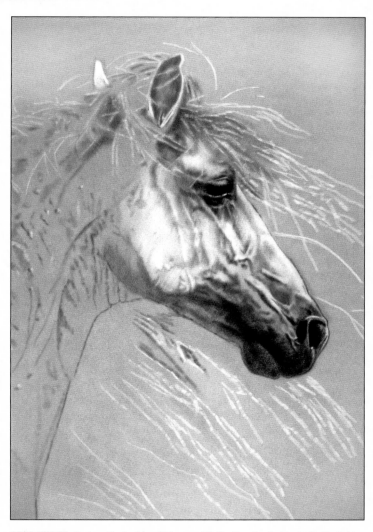

STEP THREE Darken the inside of his ear with the tip of a dark gray NuPastel. With a soft pastel, add some tints of reddish brown on his upper neck, forelock, and under his chin by gently rubbing the smooth side of the pastel until just a bit of color comes off on the paper. Then take your dark gray hard pastel and define the actual shadow of his cheek line with small crosshatching marks.

→ T I P ←

The horse's veins are showing in his face and neck because he was moving around quickly while being photographed. This vascular look is always the sign of a fit and gorgeous athlete; if you like this look, try to photograph your subjects after they've been excercising.

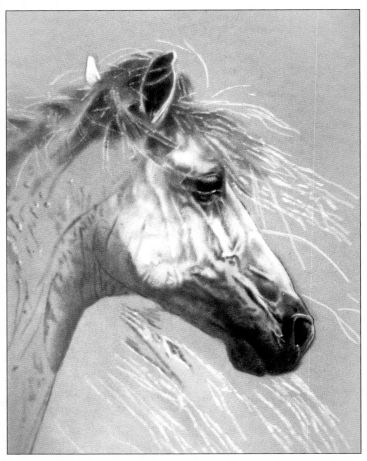

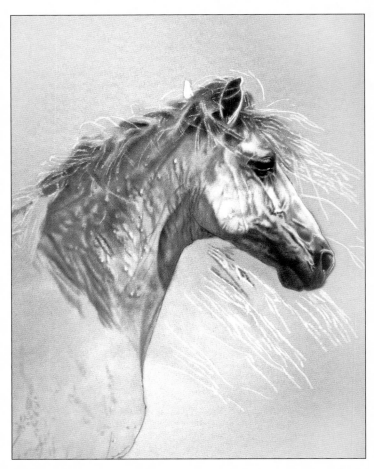

STEP FOUR Continue building the color under his jaw with a reddish brown pastel. This is also a good time to use the tip of the dark gray NuPastel on his ear and very top of his head to start darkening the area. This will allow the detail of the hair to show up later.

STEP FIVE With the side of a dark gray soft pastel, start adding the deep shadows under his jaw and below his mane. Use your sharpened light gray NuPastel to add detail on the neck, just as you did earlier on the face. Once again, use crosshatching to depict the smoothness of his coat. The side of a 9B graphite pencil is also helpful for darkening the deepest shadows.

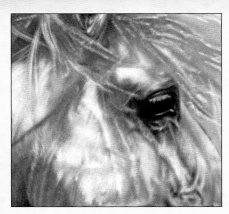

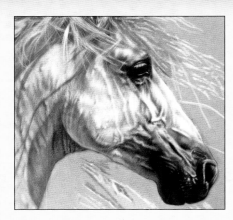

Up close, you can see that there is not a lot of detail in the eyeball itself but a lot around it to define its shape. Use a black hard pastel for the eyeball. With the sharpened tip of a white hard pastel, stroke in eyelashes on the upper eyelid and define the top and bottom of the eye. Press down a little harder to add the white in the corner of his eye.

Use a very sharp white NuPastel to draw in the individual hairs of his mane and forelock. As the edges wear down, re-sharpen your pastel to keep the hairs very fine and thin.

Since you have already laid down dark grays in the muzzle area, get out a sharpened black hard pastel to finish the area. Fill in the inside of his nostril with solid black. Then use the same pastel to give the area behind his nostril some nice deep shadows. Continue with the black hard pastel on the upper and lower part of his mouth. Since his mouth is in shadow, there is no need for detail here.

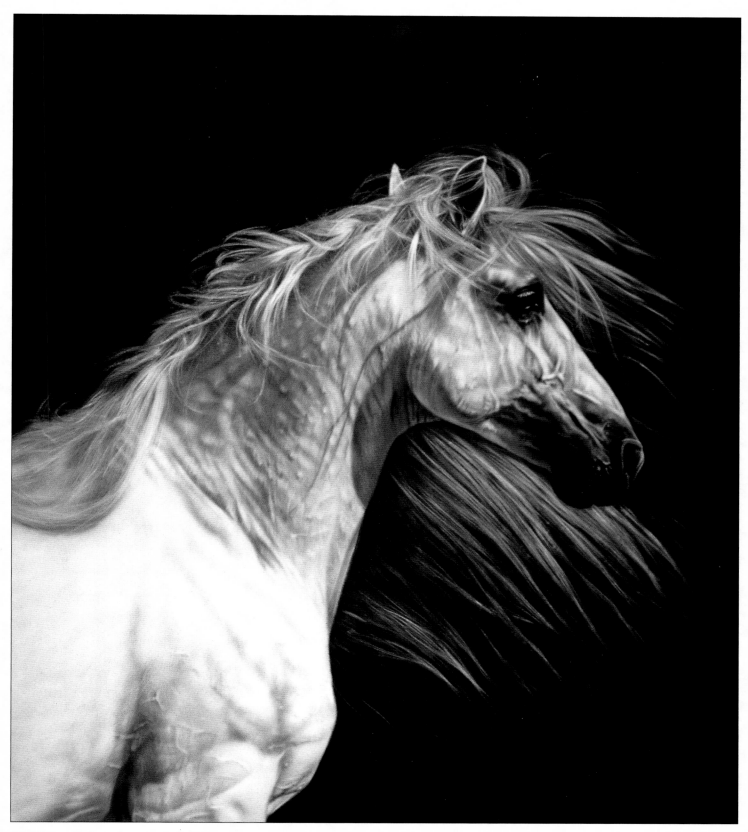

STEP SIX In the final stages, finish the shoulder area in much the same manner as the head and neck. On the larger muscle groups, use a soft dark gray pastel. The shadowing under the muscle is just a soft contour, so use light pressure and crosshatching. Then go back in with the top edge of the same pastel and put a little more color in the deepest shadows simply by pressing down a little harder. As with the other paintings, use the whitest white and blackest black on top of any light or dark areas at the very end for added pop. For the background, use the side of a very dark blue pastel first and then black on top of that. Strive for an even look with no ridges or roughness.

Childhood Magic

The interaction that children have with animals is fascinating. Years ago, this fiery Polish Arabian named Fleetie turned into a docile horse when a three-year-old boy hopped into the saddle. Horses are much smarter than most people think, and along with his big, kind heart, Fleetie is the perfect example of this.

The gorgeous buckskin pony in this painting patiently endured a four-hour photo shoot with four children climbing on him, lassoing him, washing him, and, finally, the owner's daughter sitting with him.

COLOR PALETTE

black, blue, brown, chocolate brown, dark blue, dark gray, deep gold, light beige, light gold, light gray, light pink, pale blue, pale gold, pale orange, pale yellow, reddish brown, and white

STEP ONE Use a pale gray velour paper because the little girl's face will be the lightest part of the painting, and you don't want to try to paint flesh tones over beige. Gray is more neutral and will accept the flesh tones better. Transfer your sketch onto the velour with a 9B graphite pencil and carbon paper.

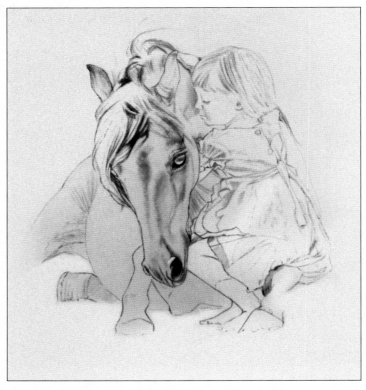

STEP TWO Put in the base color for the buckskin pony using a light gold soft pastel. Use the side of the pastel to apply color in nice smooth strokes.

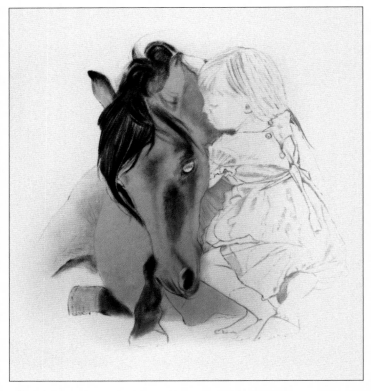

STEP THREE Build up the layers of color all over the pony's body and hoof by adding a deep gold on top of the light gold. Apply dark blue to his mane, tips of his ears, nostrils, facial features, and legs with the tip of a soft pastel.

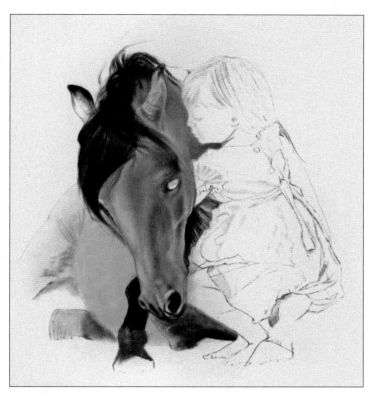

STEP FOUR On top of the blue, use a dark gray (#259) NuPastel that's broken into a smaller piece with a rounded edge on one end. Shadow the contours of the pony's face with a sharpened dark gray pastel and crosshatching strokes.

STEP FIVE A sharpened black hard pastel offers the right amount of control for going over the mane and the black points on his legs. Be careful not to deposit too much pastel onto the paper. Go back in and work on the visible part of the hind leg. Use a sharpened dark gray hard pastel to gently and lightly emphasize the existing pencil lines. Short little lines of crosshatching start to shade the area. The bottom part, which is farthest away from the light, is a deeper shade of gray, which you can achieve by pressing down harder with the same pastel.

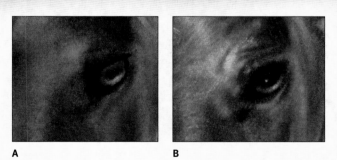

A B

The eye area is always a bit delicate to work on, especially if it's small. Go in very slowly and carefully with sharpened hard pastels so a lot of color does not come off on the paper. Start with (A) chocolate brown for the iris and black for the pupil. Then crosshatch a little bit of light in the bottom of the eye with a pale orange or gray. Next (B) darken the upper and lower lids by drawing a strong, dark shape close to the eye. Then use lighter strokes to darken the area beneath the lids. This area should be lighter than the area right next to the eyeball to help set off the eye.

→ TIP ←

The shape of the pupil and the eye color vary from animal to animal, so it's important to study your subject matter before you paint. Nothing will give away that you don't know your subject as much as incorrectly depicting the eyes.

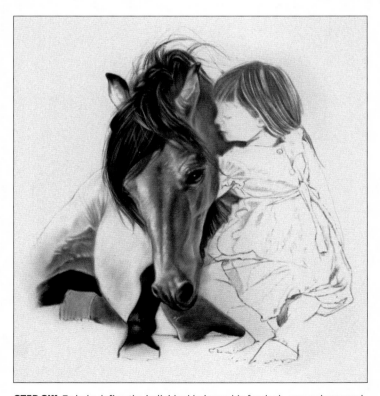

STEP SIX To help define the individual hairs on his forelock, use a sharpened light gray NuPastel to stroke in some of the hair, going in one direction with a sharp side and not the tip. Once you're happy with the level of detail on the horse, switch to the little girl. Put in a base color of brown for her hair and a light pink for her lips. Both colors are hard pastels.

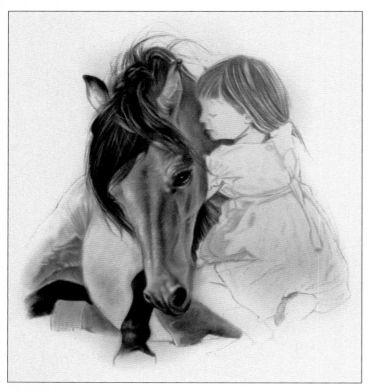

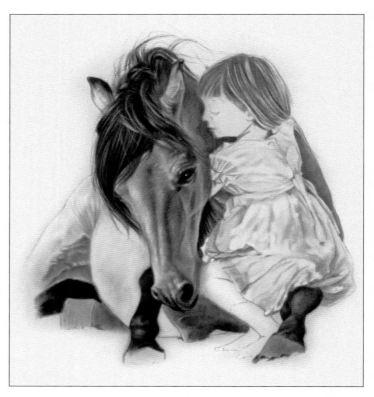

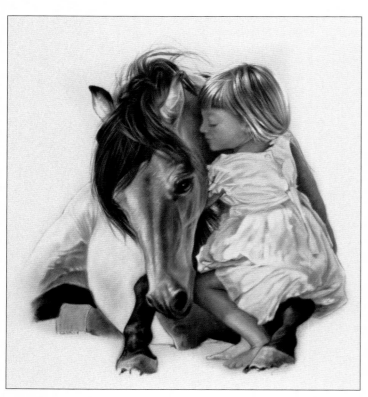

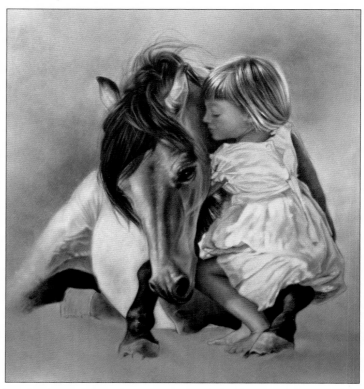

STEP SEVEN Choose a soft pastel in pale blue for the girl's dress and lay in the color with the side of the pastel. Then choose the next darker color to start showing the shadows on the material.

STEP EIGHT Continue developing the shadows on the dress. Then use the tip of a very soft white pastel to pop out the highlights. At this point, don't worrying much about the shape. The horse's foreleg that she is sitting on gets the same treatment as the other legs. First use blue, then dark gray, and, finally, black. The hoof starts with a soft medium gray then finishes with a black hard pastel.

STEP NINE For the flesh tones, first use a light pink NuPastel in crosshatching strokes for the base color. Then add light beige on top of that using the same technique. For the shadow areas, use a reddish brown and a warm gray. Next, use a very sharp dark gray (#259) NuPastel for her eyebrows, eyelashes, and the deeper shadow areas. With a sharpened hard pastel in pale yellow, add highlights in her hair.

STEP TEN The background shouldn't fight for attention with the horse and little girl, so use the sides of soft pastels to first stroke in a light gold and then deep gold. Then add a dark gray on top. The look here is smooth, without ridges or edges, but also a little mottled. Achieve this by NOT crosshatching as much so that your hand is moving more in a single direction. This way the color comes off the pastel and leaves pigment in a smaller area.

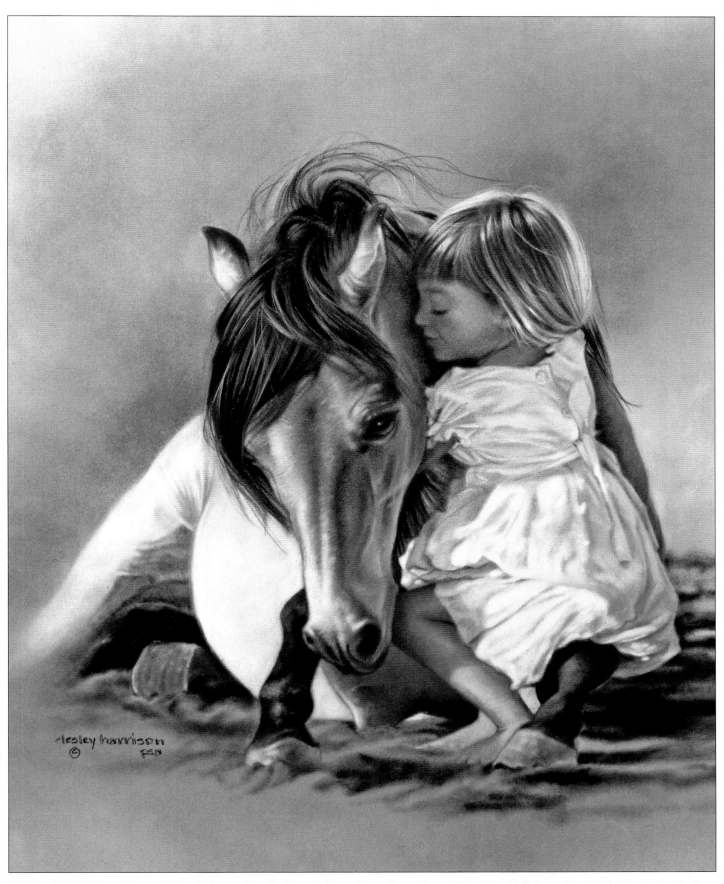

STEP ELEVEN The final touch is adding shadows using a dark gray soft pastel. Use the end for smaller areas with little touches of a black soft pastel in the darkest areas. This helps the background recede and brings the pony and child forward for the viewer to appreciate.

Sunrise

Not only has this gorgeous stallion won many, many awards in Dressage, but he also stops traffic wherever he goes. This particular image of him is jaw-dropping—always a sign that it must be painted.

COLOR PALETTE

black, brownish violet, chocolate brown, dark blue, emerald green, golden yellow, lemon yellow, light brown, light gray, light green, light orange, medium blue, medium orange, white, and yellow-green

STEP ONE Since this guy has lots of white on him, use a light gray velour paper. While transferring your sketch with carbon paper, take care not to press down too firmly with the 9B graphite pencil. If the paper indents too much, you won't be able to correct it. Fill in a few more details in pencil on the velour so that you will be familiar with where everything goes. Then use a hard pastel to highlight some of the smaller areas of white.

STEP TWO With the side of a medium light gray soft pastel, evenly stroke in color over the entire body of the horse. Cover everything but his eye.

Isolate the mane with a frame of black construction paper, both to keep your focus and protect the finished portions of the painting underneath. Angle your paper so the motion of adding each individual hair in one long stroke is comfortable for your hand and arm. Start with a sharpened 9B graphite pencil and lightly draw the hairs as they flow away from his neck. Then use a very sharp light gray hard pastel to start dragging the hair in very thin strokes from his neck out into the wind. Finally, punch up the background color in between the clumps of mane with my golden yellow soft pastel.

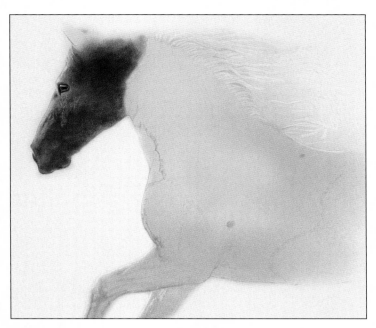

STEP THREE Begin to prepare the undercoats for the areas that will hold black as the final color. Start with his face and use smooth strokes of a brownish violet soft pastel on top of the gray. Then use a dark blue soft pastel on its side in the same manner.

STEP FOUR Develop the dark spots on his neck, chest, and barrel with the same process and colors used for his face. Once you've developed all of these dark spots, lay a black soft pastel on top. Use the side of the pastel in crosshatching strokes. Then take the side of a light brown soft pastel and very lightly tint the area at the base of his mane, the top of his neck, and around the forearm. Use a little of this brown on the top of his head and around his eye.

STEP FIVE With the side of a white soft pastel, start filling in the areas on his neck that haven't been darkened. Use a light touch so some of the light brown that you put in earlier still shows. Carefully bring the white into the dark spots to overlap the color just a bit at the edges. At the same time, use a sharpened light gray hard pastel to crosshatch highlights into his face. The light gray defines his underlying bone structure. Then use the same light gray to add just a few highlights in the forelock.

STEP SIX Continue bringing the white down his neck and shoulder and into his forelegs. Allow the gray of the muscles and bones to show. Use the side of the pastel for broader areas and the tip for smaller ones. Carefully begin to weave the background colors into his mane and around his face and neck with soft pastels, starting with a golden yellow and then a medium orange on top. Then continue to smoothly fill in the background, and add the rising sun with your soft white pastel.

⇥ TIP ⇤

Hair is never uniform and lined up like little soldiers. Remember to slightly vary the direction and shape of it as you go.

STEP SEVEN Cut out a round circle from a white piece of paper and move it around the painting until you decide where you want to place the sun. Use a camera blower brush to remove the first sun and paint over it with golden yellow and medium orange. Then repaint the sun in its new location using a lemon yellow soft pastel. Add a few yellow clouds around the sun.

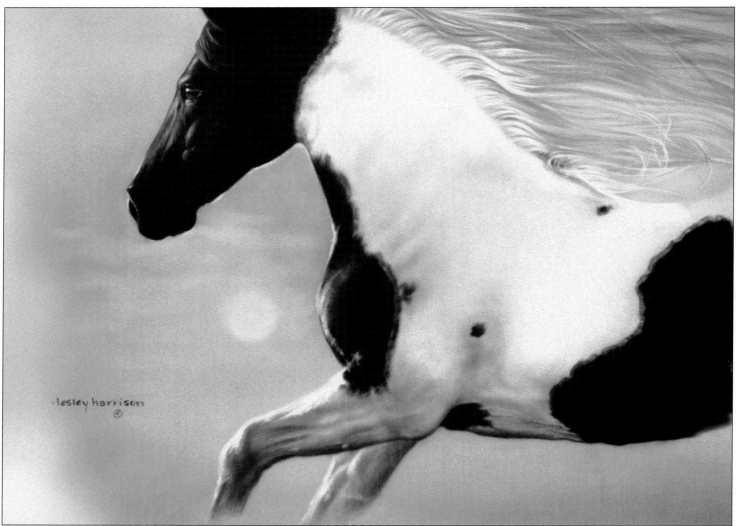

lesley harrison

STEP EIGHT Add more yellow soft pastel around the sun and, to balance that, just above his back. Rim the underside of his head, neck, chest, and foreleg with the same yellow for a backlighting effect.

About the Artists

PATRICIA GETHA

A graduate of the University of Cincinnati, Patricia Getha worked in the graphic arts industry as a pre-press professional for more than 20 years before pursuing a lifelong desire to paint and draw one of her favorite animals, the horse. As a young girl, she spent many summers looking after and showing horses. Drawing played a large role in Pat's life, but it was a love of horses that enabled her to master the subject.

Pat is proficient in a variety of media, including watercolor, graphite, oil, and colored pencil. She exhibits both her art and photography in juried competitions and has won national awards for her exquisite work in both venues. Pat currently resides in Ohio and works primarily as a commission artist.

JANET GRIFFIN-SCOTT

Janet Griffin-Scott is the successful artist behind the Hoofbeats and Pawprints greeting card, stationery, and gift line, which she launched in 1996. Janet also runs a gallery and framing studio out of her home on Lake Ontario in Canada. As a student at York University in Toronto, Ontario, Janet studied drawing, painting, and photography to earn a bachelor's degree in fine art in 1983. She spent the next 10 years working as a commercial artist. Today, her cards, stationery, and gifts are available in 650 stores and 12 countries.

Born in Toronto, Janet grew up in Midland, Ontario, where she found an outlet for her love of horses at an early age. Janet and her family, including her husband, James, and their two children, realized their dream of caring for their own horses when they moved to their 10-acre farm in 2000. Janet rides and coaches young riders as she continues pursuing her passion for drawing and painting horses. In 2010, she designed a coin featuring the Royal Canadian Mounted Police for the Royal Canadian Mint.

LESLEY HARRISON

Lesley Harrison has now been painting in pastel professionally for more than 30 years. Throughout her career, her love of animals has inspired a continuing series of remarkable animal portraits. An affinity for the animals she paints and a strong command of the medium of pastel allows her to capture the spirit of each animal and to convey to each viewer its individuality, grace, and strength. For further information on Lesley's workshops or artwork, visit her website at www.harrison-keller.com or her blog at www.lesleyharrison.net.

CINDY LARIMORE

Cindy Larimore was born and raised in Dayton, Ohio. She attended the Art Institute in Dayton, but she is predominantly self-taught. She has won many local and national awards for her animal paintings. Cindy's professional experience includes freelance animal portraits, layout, paste-up, illustration, and design. Prints of her horse paintings are sold by several well-known galleries, and her work is exhibited at many animal shows, fairs, and racetracks throughout the United States. Cindy now lives in Jamul, California. An animal lover, she produces Western, wildlife, and racing art for free or at cost for animal welfare and rescue groups. Cindy says, "Animals have been good to me, and this is one way I can help them in return."

ELIN PENDLETON

Elin Pendleton has been painting since the age of 9, and she has been selling her paintings since 1983. When she was in her teens, she was recognized for her artistic talent by the late Millard Sheets, and since then she has studied and painted in South America, Central America, and Mediterranean Europe. She is traditionally trained, with a bachelor's degree in fine art from San Diego University. Elin's award-winning paintings are found in both private and corporate collections throughout the United States and Europe. She has studied with noted artists, and she is a skilled teacher who conducts workshops for aspiring painters. Elin's home and studio are located in the mountainous terrain north of the Temecula wine country of southern California. She lives with her husband, a university professor, and a variety of domestic animals, all of which have found their way into her paintings.

Index